P9-DDY-372

Culture and Commentary

Laurie Anderson

Siah Armajani

Francesco Clemente

James Coleman

Tony Cragg

Katharina Fritsch

Robert Gober

Jenny Holzer

Jeff Koons

Sherrie Levine

Yasumasa Morimura

Reinhard Mucha

Julian Schnabel

Cindy Sherman

Jeff Wall

Culture and Commentary
An Eighties Perspective

Kathy Halbreich

with commentaries by

Maurice Culot
Vijak Mahdavi and Bernardo Nadal-Ginard
Michael M. Thomas
Sherry Turkle
Simon Watney

Hirshhorn Museum and Sculpture Garden
Smithsonian Institution
Washington, D. C.

Hirshhorn Museum and Sculpture Garden
Smithsonian Institution

BOARD OF TRUSTEES
Sydney Lewis, Chairman
Jerome Greene, Vice Chairman
Robert T. Buck
Agnes Gund
Robert Lehrman
Robert Rosenblum

Ex officio
William H. Rehnquist, Chief Justice of the United States
Robert McCormick Adams, Secretary of the Smithsonian Institution

STAFF
Director's Office
James T. Demetrion, Director
Stephen E. Weil, Deputy Director
Ruby Davis, Secretary to the Director
Carole Clore, Secretary to the Deputy Director
James Hilton, Safety Manager

Department of Painting and Sculpture
Ned Rifkin, Chief Curator for Exhibitions
Amada Cruz, Assistant Curator
Valerie J. Fletcher, Curator of Sculpture
Frank B. Gettings, Curator of Prints and Drawings
Phyllis D. Rosenzweig, Associate Curator
Judith K. Zilczer, Curator of Paintings
Barbara J. Bradley, Publications Manager
Crystal D. Smith, Editorial Assistant
Anne-Louise Marquis, Museum Technician
Frances Woltz, Museum Technician

Administration and Museum Support Services
Nancy F. Kirkpatrick, Assistant Director
Carol Parsons, Special Assistant to the Assistant Director
Rose Ann Tilton, Budget Analyst
Nancy A. Kaiser, Administrative Assistant
Carolyn Lewis, Office Assistant

Anna Brooke, Librarian
Wendy Mazo, Library Technician
Jody Mussoff, Library Technician
Maureen Turman, Library Technician
M. Ellen Davis, Secretary

M. Lee Stalsworth, Chief Photographer
Wendy Vail, Photographer
Katherine Hopper, Museum Technician

Sidney Lawrence, Public Affairs Officer
Dale Vanderheyden, Public Affairs Assistant

Conservation
Laurence Hoffman, Chief Conservator
Lee Aks, Sculpture Conservator
A. Clarke Bedford, Painting Conservator
Susan Lake, Painting Conservator
Meredith Wippman, Paper Conservator
Bruce Day, Museum Technician
Roni Polisar, Museum Technician

Department of Education
Edward P. Lawson, Chief
Kelly Gordon, Education Specialist
Teresia Bush, Docent Coordinator

Department of Exhibits and Design
Edward Schiesser, Chief
Robert Allen, Visual Information Specialist
Daniel Murray, Exhibits Specialist
Jonnette Butts, Museum Technician
Albert Masino, Museum Technician

Registrar's Office
Douglas Robinson, Registrar
Brian Kavanagh, Assistant Registrar
Peggy Dong, Assistant Registrar for Loans
Barbara Freund, Assistant Registrar for Exhibitions
James Mahoney, Museum Registration Specialist
Penelope Brown, Museum Registration Technician
Roy Johnsen, Art Packaging Specialist

Building Management Office
Frank Underwood, Building Manager
Rosetta Hawkins, General Foreman
Provident Peterson, Custodial Foreman
Robert Ellis, Exhibits Specialist
Natt Ferguson, Exhibits Specialist
Larry Keller, Exhibits Specialist
Charles Tanner, Exhibits Specialist
Charles Shields, Maintenance Mechanic
David Cheeks, Maintenance Helper
Eugene Jones, Laborer
Arnold Kirby, Laborer
Avoid Riley, Laborer
Mary Jackson, Custodial Leader
Clyde Newton, Custodial Leader
Harris Bright III, Custodial Worker
Wanda Dreher, Custodial Worker
Chester Hall, Custodial Worker
Susie Henry, Custodial Worker
Barry Johnson, Custodial Worker
Louis Morgan, Custodial Worker
Antonio Trusdale, Custodial Worker
Connie Tyson, Custodial Worker
Ronald Williams, Custodial Worker

Exhibition Dates
February 8–May 6, 1990

Dimensions, as supplied by lenders, are given in inches (and centimeters), height preceding width preceding depth.

Library of Congress Catalog Card Number 90-30064

Library of Congress Cataloging-in-Publication Data
Culture and commentary : an eighties perspective. Kathy
 Halbreich : with commentaries by Maurice Culot . . . [et al.].
 p. cm.
 Catalog of an exhibition held at the Hirshhorn Museum,
 February 8–May 6, 1990.
 ISBN 0-9623203-2-3
 1. Art, Modern—20th century—Exhibitions. I. Halbreich,
 Kathy. II. Hirshhorn Museum and Sculpture Garden.
 N6487.W3H5725 1990
 709'.04'8074753—dc20 90-30064
 CIP

 ISBN 0-9623203-2-3

Copyright © 1990 by the Smithsonian Institution. All rights reserved. No part of this book may be reproduced without written permission from the publishers.

Contents

Lenders to the Exhibition

Siah Armajani, St. Paul
Alain Clairet, New York
James Coleman, Dublin
Elaine and Werner Dannheisser, New York
Eli and Edythe Broad Collection,
 Los Angeles
The Estate of Andy Warhol, New York
Iris and Ben Feldman, New York
Tetsutada Fukunishi, Ehime, Japan
Winnie Fung, Hong Kong
Robert Gober, New York
Jenny Holzer, New York
Robert M. Kaye
Leonard and Jane Korman,
 Fort Washington, Pennsylvania
Pamela and Arnold Lehman, Baltimore
Sherrie Levine, New York
Susan and Lewis Manilow, Chicago
Yasumasa Morimura, Osaka
Paul and Camille Oliver-Hoffmann,
 Chicago
Al Ordover, New York
John and Mary Pappajohn, Des Moines
Donald and Mera Rubell, New York
Saatchi Collection, London
Sanders Collection, Amsterdam
Silvio Sansone
Julian Schnabel, New York
Martin Sklar, New York
Lise Spiegel, New York
Stefan T. Edlis Collection, Chicago
Clodagh and Leslie Waddington, London
Private collections

The Corcoran Gallery of Art,
 Washington, D. C.
Emanuel Hoffman-Stiftung,
 Museum für Gegenwartskunst, Basel
Fundació Caixa de Pensions, Barcelona
PaineWebber Group, Inc., New York
Philadelphia Museum of Art
Whitney Museum of American Art,
 New York

Thomas Ammann, Zurich
Mary Boone Gallery, New York
Paula Cooper Gallery, New York
Konrad Fischer, Düsseldorf
Galerie Baudoin Lebon, Paris
Galerie Johnen & Schöttle, Cologne
Barbara Gladstone Gallery, New York
Marian Goodman Gallery, New York
Jablonka Galerie, Cologne
Lunn Ltd., New York
The Pace Gallery, New York
Sonnabend Gallery, New York
Thea Westreich Associates, New York

T-cells infected with the AIDS virus.

Acknowledgments

A guest curator, something like a hired gun, often never comes to understand the inner workings of the hosting museum before firing the first shot. There is some usefulness in being shielded from such matters. It is possible to ask again questions that those who work at the museum long ago gave up asking. I was fortunate in that the difficult questions I posed about procedures and possibilities always were received with grace. The exhibition benefitted from the fact the usual response was positive. Large institutions, even those that operate as part of the federal government, are not faceless. I am particularly grateful to Jim Demetrion, Director of the Hirshhorn Museum and Sculpture Garden, who offered unflagging support. It is Ned Rifkin, Chief Curator for Exhibitions, however, who asked me to undertake this project and who became a constant advisor, careful listener, compassionate adjudicator, and wry sidekick. While this exhibition will doubtless reflect the weaknesses of my own thinking and stubbornness, its strengths are owed to Ned's rigorous testing of my concepts and principles. I will miss our frequent conversations enormously. Ned and I knew from the beginning that, despite occasional doubt and fashionable rhetoric, we both believe art matters. We came to realize how thinking about art together also could forge friendship. Others at the Hirshhorn Museum who deserve my thanks are Barbara Bradley, Anna Brooke, Penelope Brown, Amada Cruz, Nancy Kirkpatrick, Ed Schiesser and his staff, and Francie Woltz. Closer to home, Becky Hunt and Jennifer Loviglio offered the kind of administrative support and research expertise one dreams of but rarely finds in waking. They tracked down articles in obscure foreign publications, capable translators, and an international group of authors who had written cogently about the topics we collectively agreed were most pressing in the 1980s. Maurice Culot, Vijak Mahdavi and Bernardo Nadal-Ginard, Michael M. Thomas, Sherry Turkle, and Simon Watney provided the elegant and insightful commentaries I hoped would set the social frame of reference for the decade. I remain struck by each author's ability to work within the limits of time and space provided. These are troubling issues addressed by independent yet sonorous voices.

At the Boston Museum of Fine Arts, which I joined midway through this project, my staff deserves special mention as they shared my load when it grew especially heavy. Trevor Fairbrother, Associate Curator of Contemporary Art, appeared able to read my mind and repeatedly helped fill in the blanks while Cathy Modica helped me with the daily responsibilities of learning a new job while completing an old one.

Several friends helped me refine my thinking; Gary Garrels, Sue Graze, Marjory Jacobson, Kasper König, Karen Marta, Elizabeth Murray, Joan Simon, and Patricia Van der Leun provided unstinting support, often in the form of faith. I am grateful to Jack Lane, now Director of the San Francisco Museum of Modern Art, but who, as Director of the Carnegie Museum of Art, invited me to serve on the advisory board for the 1988 Carnegie International. I benefitted enormously from the insights of that international group of colleagues. John Kohring, my husband, was the most generous of colleagues. He listened to my theories well into the night, and when I was gone pursuing them, he provided our new son, Henry, with the love of two parents.

I was assisted enormously by Steve Cohen of Original Artists, which represents Laurie Anderson, as well as Holly Solomon, who showed Anderson's work early on; Max Protetch and his gallery, which has shown Siah Armajani since the late 1970s; Angela Westwater of Sperone Westwater, which has hosted numerous exhibitions of Francesco Clemente; Marian Goodman, Jill Sussman Walla, and Rosemary Erpf helped me locate particular works by and information on James Coleman, Tony Cragg, and Jeff Wall; Donald Young and Konrad Fischer were extremely kind in offering support along the

way; Nicholas Logsdail of Lisson Gallery helped me thread my way through recent British art history; Jorg Johnen and Gertrud Blum of Johnen & Schöttle, along with the Jablonka Galerie, helped Katharina Fritsch realize her work; Paula Cooper and the staff of her gallery were as usual a pleasure to work with and made assembling the materials on Robert Gober easy; Richard Flood of the Barbara Gladstone Gallery coordinated all efforts with Jenny Holzer, making such efforts effortless; Antonio Homen of the Sonnabend Gallery helped locate the pertinent sculptures by Jeff Koons; Ron Warren of the Mary Boone Gallery, which represents Sherrie Levine, made certain I had everything required; Fumio Nanjo, Director of the Institute of Contemporary Art in Nagoya, Japan, and his assistant Yumi Hojo helped communicate my intentions to Yasumasa Morimura; Lawrence Luhring of Luhring, Augustine Gallery first introduced me to Reinhard Mucha's work and helped coordinate my efforts with Max Hetzler and his assistant Madeline Ferretti; Douglas Baxter and Audrey Unger of the Pace Gallery, which represents Julian Schnabel, were generous allies; and Helene Winer and David Goldsmith of Metro Pictures answered all questions pertaining to Cindy Sherman with alacrity.

Finally, it is the fifteen artists whose endeavors make up the exhibition who merit my most profound thanks. I spent several hours with most of them, looking, analyzing, and delving. I asked probing questions and always received thoughtful answers. Realizing it is difficult to find a comfortable frame of reference for one's work, I appreciate the trust these artists offered me by agreeing to participate in creating this picture of the decade. While I hope I have not twisted anyone's intentions by locating them within this conceptual outline, I believe all the work in the exhibition is strong enough to survive even willful misinterpretation. Clearly, it is art—not curatorial fancy—that makes such exhibitions as this possible, and I hope noteworthy. I am particularly pleased that Siah Armajani agreed to make a reading room for the 1980s as his contribution, that Sherrie Levine and Robert Gober eagerly collaborated on a room-size installation that unites their mutual explorations of the "other," and that Reinhard Mucha added to an earlier sculpture in making a new work for this exhibition.

I also am indebted to the many individual and institutional lenders. Their generosity made it possible to select each artist's work so that one object echoed aspects of another. When appropriate, each artist is represented by a group of works that span the decade. The wide variety of disciplines—sculpture, painting, drawing, photography, video, multiples, and fresco—included in this exhibition occurred naturally. I think it signals the final abandonment of traditional hierarchy of media and visually supports my sense that each deserves equal attention despite the conventional dynamics of the market that values a bronze cast over a C print. My focus on the social role assumed by artists and the cultural change embodied in the making of their art during this decade was the matrix I discovered, and then developed, to narrow my topic. But I visited with many talented artists and looked at the work of more before I found a lens that seemed particular to the 1980s. I learned an enormous amount from this research and only wish I believed it were possible to organize a group exhibition such as this without having to curb my catholic taste.

I hope when this hired gun leaves for home she is fondly remembered for applying pressure in all the right places.

Kathy Halbreich

Foreword

The beginning of a new decade affords a convenient if not necessarily the most advantageous standpoint from which to look back upon the decade just past. It is not the most advantageous position, of course, because political history, science, sociology, and art exist in ongoing continuums with their own pace and rhythm, and these never coincide with the neatness and seeming certitude that astronomers, geographers, clockmakers, and calendographers have ascribed to time. (Even so, one feels a sense of perverse satisfaction to learn that adjustments of a few seconds need to be made occasionally by those in charge of the "world's clock" at Greenwich near London).

Thus the Roaring Twenties ended abruptly on Black Monday, October 29, 1929, and not on New Year's Eve of that year; the tumultuous cultural revolution that we simply refer to as "the Sixties" had its traumatic birth in Dallas on November 22, 1963; and when in May 1989 Hungarian border guards cut open the barbed-wire fence that had divided Europe for over four decades and set off a chain of dramatic events throughout the East bloc, one sensed that not only had the Nineties begun, but also an entire new era.

Guest curator Kathy Halbreich has taken on the daunting task of defining the key issues that concerned artists during the past ten years. Not surprisingly, some of those issues surfaced in the 1970s and others will most probably continue to engage artists in the years ahead. The fifteen artists that Ms. Halbreich has selected (their average age is forty as this decade ends) and the ideas generated by their art are at the crux of the intellectual and artistic concerns of our time. Art, of course, does not exist in a vacuum, and many of those same concerns are of paramount interest to scientists and others who comment on the human condition, as evidenced by the provocative commentaries that follow. We trust that they will add to the dialogue of their 1980s perspective.

James T. Demetrion
Director

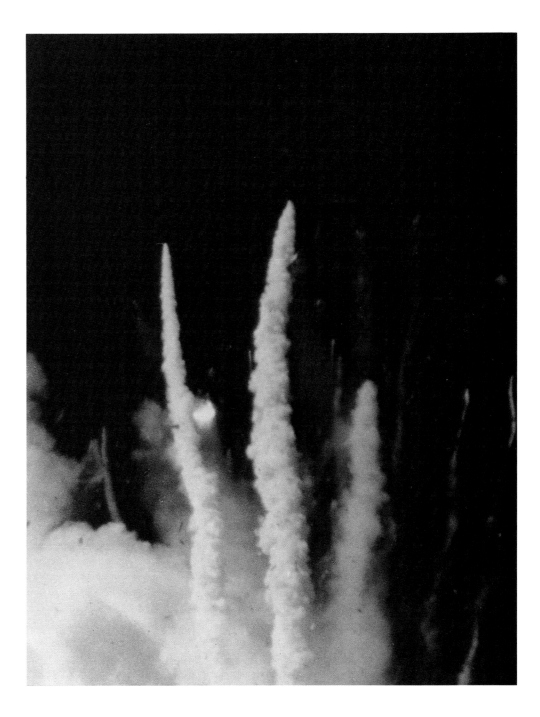

On January 28, 1986, the space
shuttle *Challenger*, on the first
shuttle mission with a civilian crew
member, exploded shortly after
takeoff. This photograph was
taken by a 70mm tracking camera
at 11:39:17 eastern standard time.

Culture and Commentary: An Eighties Perspective

Kathy Halbreich

The reason I'm painting this way is that I want to be a machine.
Andy Warhol, "Andy Warhol," *Artnews* 62 (November 1963): 26.

The avant-garde poet or artist tries in effect to imitate God by creating something valid solely on its own terms, in the way nature itself is valid, in the way a landscape—not its picture—is aesthetically valid; something *given*, increate, independent of meanings, similars or originals. Content is to be dissolved so completely into form that the work of art or literature cannot be reduced in whole or in part to anything not itself.
Clement Greenberg, *Art and Culture: Critical Essays* (Boston: Beacon Press, 1968), p. 6.

[Pierre] Cabanne: One has the impression that every time you commit yourself to a position, you attenuate it by irony or sarcasm.
[Marcel] Duchamp: I always do. Because I don't believe in positions.
Cabanne: But what do you believe in?
Duchamp: Nothing, of course! The word "belief" is another error. It's like the word "judgment," they're both horrible ideas, on which the world is based. I hope it won't be like that on the moon!
Cabanne: Nevertheless, you believe in yourself?
Duchamp: No.
Cabanne: Not even that.
Duchamp: I don't believe in the word "being." The idea of being is a human invention.
Cabanne: You like words so much?
Duchamp: Oh yes, poetic words.
Cabanne: "Being" is very poetic.
Duchamp: No, not at all. It's an essential concept, which doesn't exist at all in reality, and which I don't believe in, though people in general have a cast-iron belief in it.
Pierre Cabanne, *Dialogues with Marcel Duchamp* (New York: Viking Press, 1971), pp. 89-90.

This is the extreme position of the outsider. Hence the atmosphere of desperation and craziness, matched only by the desperation of science as it exists today. This [sculpture titled *Barraque Dull Odde*, 1961–67] is an attempt to work with the driftwood and beachcombings of science to try to transform the residue. Desperation can be a good starting point.
Joseph Beuys, quoted in Caroline Tisdall, *Joseph Beuys* (New York: Solomon R. Guggenheim Foundation, 1979), p. 80.

I'm interested in the ideas that are actually there *in reality*. I want to create a new space for this idea. I don't want to impose my own personal stylistic preferences on things in any way.
Joseph Beuys, quoted in "If Nothing Says Anything, I Don't Draw," interview by Heiner Bastian and Jeannot Simmen, *Drawings* (Berlin: Nationalgalerie; Rotterdam: Museum Boymans-van Beuningen, 1979), p. 99.

The 1980s are so much like the '60s it's sort of peculiar. Time is sort of funny. I don't understand it. Today the kids are painting the same way we did twenty years ago, like it's new to them or something. When Salvador Dali used to come around in the '60s, he thought he had done everything we were doing. We thought it was new, but we were doing things he had already done.
Andy Warhol, quoted in Carter Ratcliff, *Andy Warhol* (New York: Abbeville Press, 1983), p. 108.

"Culture and Commentary: An Eighties Perspective" focuses on the work of fifteen artists from Western Europe, Canada, Japan, and the United States whose expressive voices have developed fully during the decade—Laurie Anderson, Siah Armajani, Francesco Clemente, James Coleman, Tony Cragg, Katharina Fritsch, Robert Gober, Jenny Holzer, Jeff Koons, Sherrie Levine, Yasumasa Morimura, Reinhard Mucha, Julian Schnabel, Cindy Sherman, and Jeff Wall. The effort is not to survey the artistic comings and goings of the 1980s as much as to locate a particular set of intellectual concerns that have informed the cultural dramas of the past ten years and influenced the artists whose work best comments on those societal changes.

The Social Frame

In America, the decade that began with paeans to the technicolor of pluralism ends with dirges to the stark polarities that remain. The country, sold a false and bellicose image of strength over sensitivity, found comfort in nostalgia, retreating to a kinder, gentler memory of times past. The retrograde designs of couturier Ralph Lauren (whose advertisements often featured such symbols of American life as the stars and stripes) and architect Robert A. M. Stern (whose style was a perfect mime of old standards) reflected this turn in taste as well as a yearning among the newly rich for costumes that would turn them into the aristocracy, a class that existed in America only as an ersatz variant of an ancient system now almost forsaken in Europe. As the rich got richer, the Earth poorer, and those sick with AIDS closer to dying, faith in the future, which failed to trickle down from a president made in Hollywood, wavered. Everywhere—from Wall Street to Gdańsk to the Kremlin to Tiananmen Square to Tokyo—money spoke louder than any ideology, including "nice" capitalism and "bad" communism. East Berliners traveled freely through the wall to marvel for the first time in decades at cars other than their little Trabants (which translates as "satellites"). Trading became its own form of politics, with the promise of a unified European market only one indication of the consolidating force of cash; advertisers debated about the possibility of developing a common language; and rumors of a single currency were floated. The value of works of art was measured in the marketplace along with other goods and fantasies, and value was no longer ascribed simply to such Modernist notions as intrinsic excellence or uniqueness. Rather, extrinsic factors such as desirability—once linked to sexual possession, now to the potency of owning safe and inanimate objects—governed the transactions in which single works by living artists traded internationally for millions of dollars.

Art served to glorify not only the aesthetic acumen of its patrons but, as an instrument of investment, their financial prowess. While the institutional frame became the subject of much work, it was the individual or corporate collector as well as the art dealer rather than the museum curator who controlled the market in the 1980s. While women dealers and curators rose to prominence, the majority of buyers remained male. "Strategy," "position," "situation" . . . these words from the financial and military worlds marked the shifting ground on which artists, dealers, collectors, and museums stood in the 1980s. Cocaine, the drug of choice for the poor, rich, and some Central American dictators, matched the antiseptic speed and danger with which money and images moved electronically.

Material Girl, sung by Madonna, was the perfect song for a moment in which art, money, and politics dovetailed electronically. Part of Live Aid's global mid-decade

effort to exchange the collective power of television and rock music for dollars to feed Africans, Madonna's blatantly sexual contortions and capitalistically inspired words contrasted painfully to the pictures of black bodies racked by starvation. No more hideous testimony to the fact that the medium really did not recognize its message could be imagined. By the end of the decade pop musicians such as Tracy Chapman (twenty-five years old and *Talkin' 'Bout a Revolution* in which "poor people gonna rise up / and take their share"), Elvis Costello (thirty-three years old and promising to *Tramp the Dirt Down* on British Prime Minister Margaret Thatcher's grave), and Lou Reed (forty-six years old, a former member of the group Velvet Underground, singing about the need for a *Busload of Faith* when "you can depend on the worst always happening") mirrored in their music the anxieties, inequities, and disillusionment of the decade. Entertainment as escape or philanthropic balm was not good enough. Public Enemy, perhaps the most misanthropic and racially exclusive of the rap groups, excoriated television in *She Watch Channel Zero?!* for brainwashing black people into accepting the whitewashed world broadcast into their homes, "her brains retrained / by a 24-inch remote." Like the presidential campaign of Jesse Jackson, the first mainstream African-American candidate, the momentum of the group's message stalled when they were accused of supporting an anti-Semitic position. The spirited idealism of the 1960s was replaced by pessimistic, even cynical protests bred out of the frustration and disillusionment of the 1980s.

We swallowed our information and measured our politicians in sound bites. We made our own narratives out of VCR clips and eliminated television advertisements by pushing buttons on our remote control units. Watching on ABC nightly news an "exclusive video" (complete with an electronic time bar and the seemingly authentic grainy picture of a hidden camera) of United States diplomat Felix S. Bloch passing a briefcase to a Soviet agent, we mistook paid actors for the real participants, the staged re-enactment for the real event, and a docudrama for responsible journalism. Three months after the network acknowledged it had simulated the drama, Bloch remains an alleged spy, although the media effectively convicted him before his trial. Paradoxically, the technologies that were thought to connect us one to the other served, instead, to create another hierarchy of literacy. Domesticated technologies—personal computer, microwave oven, cellular telephone—helped young professionals juggle the complexities of modern life but did not help the underclass master the information age. Without underscoring the poignant irony, *Time* magazine in 1983 featured a computer on the cover of its man of the year issue; for 1988, the editors selected a grim cartoon of the planet depleted of natural resources and overgrown with garbage.

Technological tragedies multiplied: the explosion of the space shuttle *Challenger;* the reckless pollution of the people of Bhopal, India, the waters of the Rhine, and the shores of Alaska by commercial ventures; the meltdown at Chernobyl in the Soviet Union; the knowing depletion of the ozone layer and consequent greenhouse effect; and the elusiveness of a cure for AIDS. Technology, a dependency on which led some in the latter part of the century to replace the prevailing belief in a heavenly God with a sense that our fellow travelers could colonize the solar system, failed us as we failed to monitor it. We were naive, careless, and arrogant in believing the cosmos was just another border. Most of the tragedies involved pushing the mechanical systems beyond what they were capable of doing because the professionals had, as one journalist wrote, "become so enthralled by the sheer splendor of the technology at their command that they neglected

its limitations, putting their trust in an image of mechanical perfection rather than in a less perfect reality."[1]

Perhaps not so curiously, the field of biogenetics reflected strategies similar to those of the art world regarding individualism and originality: original material was appropriated in order to create new species as well as clones. While some artists began to explore areas of scientific investigation such as fractals, chaos theory, and gene splicing as a means of understanding other modes of representing information, still others toyed with archaic forms such as alchemy, resigned to the fact that our faith in the infallibility of technology was excessive.

Outsiders were out. Everyone wanted to be in where it was warm. The mammoth spaces of discos shrunk to copies of private men's clubs. In architecture, the ransacking of history as practiced by many Postmodernist architects reached its zenith in 1980, following decades in which jurors for the annual awards from the magazine *Progressive Architecture* had declared the single family house "no longer of any social significance"[2] (the mid-sixties) and building reuse central to the practice of architecture (the mid-seventies). By the mid-eighties, with service and information industries fueling the growth as manufacturing had a hundred years earlier, a new urban form—the outer city—became identifiable internationally. Following the corporate executives who in the 1970s had moved their headquarters to the suburbs, closer to where they lived and to the malls where they shopped but farther from those workers who most needed employment, high-rise buildings invaded the commercial centers of the suburbs, the density of which began to rival that of traditional downtowns. In Orange County, California, and Paris, France, the countryside became citified, more high-tech and less dependent upon the urban center for either cultural or commercial needs. Unlike an earlier generation of studio moguls and stars, who protected their privacy behind gates and foliage, Beverly Hills television magnates built palaces so vast they were visible from the main streets.

In almost all realms of daily life, distinctions between the public and private evaporated, just as advertising promised by mixing sex and selling and the government warned in its debates on pornography, abortion, and gay rights. Artists seized the information.

The Picture Within

During the decade, American curators widened their scope to include artists from other countries, a change perhaps paralleling the decentralization of global markets and financial centers. The information age blurred geographic boundaries, allowing artists to travel and have their work seen widely and quickly in international exhibitions and journals. Coinciding with this diminution of a unitary and Western-dominated view of the world was a growing mistrust of the utopian and self-reflexive rigidity of Modernism. Artists began a self-conscious appropriation of Modernism's formalist mannerisms in order to critique a style that increasingly was equated with the separation of art from culture and associated with a prescriptive, repressively mainstream vision. By questioning the primacy of authorship, uniqueness, and formalism, some artists, both female and male, pictured themselves outside a system that valorized the supposedly heroic antics of white men. Investigations of the "other" became pronounced.

As a reaction to the reductive aesthetics of the 1970s (which the corporate world ultimately accepted because abstraction proved more docile than art with a message), a

self-consciously expressive handling of materials and figurative imagery resurfaced briefly early in the 1980s. Along with text, photography, which had been considered a commercial stepchild of art and of secondary importance, was used in conceptually based work that proved more lasting. It often reflected an ambivalence about the voracious demands of the art market and the manipulative tendencies of the popular media. This blending of high art and popular culture drew on the lessons regarding the subversiveness of the everyday taught by such compassionate skeptics as Marcel Duchamp, Joseph Beuys, and Andy Warhol.

Women, those "creatures" supposedly trapped by nature, grasped most directly the uses of Conceptualism, the art form most clearly associated with the workings of the mind. Following the 1970s in which many feminist artists, thrilled by the liberating possibilities of self-examination, used images of female anatomy as a way to turn the object into subject, women artists in the 1980s turned away from the body and toward language. Their work took on a decidedly cooler emphasis, with its quasi-scientific dissection of conventional systems of representing quotidian "realities"—the way the mass media assigned and pictured women's roles. Women such as Laurie Anderson, Katharina Fritsch, Jenny Holzer, Sherrie Levine, and Cindy Sherman adopted a multitude of voices to speak about sexism, consumerism, and the history of masterpieces made by masters.

As the decade wore on, and doubt often gave way to irony and cynicism, the ability of art to comment on social and economic systems was treated with both seriousness and suspicion as the marketplace, which was held accountable for draining the spiritual from art, absorbed the critique. Yet by focusing on the context in which art is made, the materials of which it is made, the place for which it is made, and the spectator or participant for whom the work may become a reflection of self, artists found they had not exhausted the options for making art. With the demise of formal abstraction's autonomy and the return of image-based subject matter, questions arose concerning the supposed neutrality of those activities that envelop the artwork—from its viewing to its installation. For such artists as James Coleman and Jeff Wall, the act of interpretation became part of the creative process—sometimes the overt subject, sometimes the technique, sometimes the mechanism by which it can be seen. Once artists rejected as false the distance between the product and how that product was consumed, the consumer of the image became part of its frame of reference. Put another way, the viewer stepped farther into the picture. It is no accident, then, that during the 1980s the field of public art became increasingly public—an attempt to underscore the general public's access and comfort as well as create a genuine function for art. The most successful public projects, such as those undertaken by Siah Armajani, often replaced an elegant object, made in the studio and mirroring the artist's expressive signature, with a useful environment, often relating to the desires of the audience and made in collaboration with architects.

Once the romantic mission of Modernism faded along with its neatly geometric and symmetric view of the universe, the self-conscious replaced the subconscious, the area of the mind previously linked by Surrealists and Futurists to freedom of expression and political action. The personal mixed with the archaeological, the intimate with the social, and the generic with the special. With the demise of romantic visions of the artist, which resulted in a mostly unrequited desire for collective identity and individual responsibility,

the central question for artists became how to continue . . . how to create work that, while reflecting the potency of mechanical production, the ubiquity of reproductions, and the subjective ideologies of various systems of representation, still asserted faith in the possibility of making a 'mark.' Some artists, such as Robert Gober who joined with Sherrie Levine to create an installation for this exhibition, entered collaborative partnerships in which the singularity and individuality of their style was subordinated to a blending of artistic personalities, a quiet way of disrupting conventional definitions of authorship. Other artists blatantly used found imagery—ranging from Yasumasa Morimura's appropriation of Edouard Manet's early Modernist depictions of women to Sherrie Levine's copies of characters from George Herriman's comic strip "Krazy Kat" to Jeff Koons's facsimiles of advertisements to Katharina Fritsch's taxidermic artifact—as both a beginning point for their process and a point of entry for their public. Once the preciousness of the artist's idea, hand, and material were undermined to this degree, artists were freer to make use of the vernacular and familiar. Duchamp's urinal and feminine alter ego, Beuys's manifesto and lard-coated chair, and Warhol's Brillo box and celebrity portrait returned in such guises as a portrait of the artist as Rrose Sélavy, Duchamp's fictional and female alter ego (Yasumasa Morimura); a pair of mass-produced basketballs suspended in a vitrine (Jeff Koons); a rephotographed Walker Evans photograph (Sherrie Levine); a revision of movie stills and publicity photographs representing the stereotypical roles available to women (Cindy Sherman); a common chair made by a craftsman precariously balanced next to industrial objects from the museum technician's storeroom (Reinhard Mucha); a dog's bed with a hand-painted pillow (Robert Gober); and a nearly life-size resin cast of a madonna, placed between a church and store in the "like new" postwar West German city of Münster (Katharina Fritsch). Found or fabricated, the value of an object was the same.

Many artists such as Tony Cragg and Julian Schnabel aligned the natural and artificial, recklessly splicing what exists with the invented to create a new order of forms and meaning. Once reproduction confuses the original with its representation, no single image of reality can be reconstructed. But the mirror (or simulacrum) is not the thing itself, and the shattered parts (or following generations) offer a bigger picture, encompassing the viewer's conditions, the maker's picture, and the system of signs employed. The French psychoanalyst Jacques Lacan, who has greatly influenced recent discourse surrounding the formation and reading of sexuality, suggested that "the self is an illusion done with mirrors," and that the self becomes part of a larger social order only by initially seeing itself as external or separate from it.[3] Narcissus, the beautiful youth who fell in love with the image of himself in the water, never understood the mechanics of the mirror. As we see in the work of artists such as Francesco Clemente, James Coleman, and Reinhard Mucha, the paradox is a painful one given the desire to connect.

While the authenticity of personal touch, imperative of stylistic consistency, strength of the eccentricities of an artist to convey universal meaning, and communicative power of self-expression were all challenged, it would be a mistake to think this conceptual framework led to work that was automatic and not individual or personal. The romantic and mostly male myths regarding the artist struggling to make something original and unreferential while starving in a garret became the stuff of parody, replaced by a cooler and more androgynous version of professional reality. Artists such as Laurie Anderson wrestled with success and still made work that addressed in personal ways their

place in and understanding of the culture. European artists, living in a world in which both antiquity and the evidence of two world wars remained palpable and present, seemed drawn to memories of things. Following Joseph Beuys's inspirational teachings, which married politics and art, as well as Marcel Broodthaers's preoccupation with what surrounded art, some artists retained the belief in art as a transgressive force more powerful than the marketplace. German artists who were children during the Nazi regime tend to question a model that canonizes one vision of beauty or truth. For example, Gerhard Richter, who along with Sigmar Polke exerts an enormous influence on a younger generation of artists such as Julian Schnabel, has emphasized since the early 1960s a multitude of models, submerging questions of style and representation in a larger search for meaning. Similarly, Polke's steadfast fascination with the psychology of style is not a narcissistic interest in his own mental make-up but in the inner workings of the systems of representation that present us with our views of women, fascism, humor, religion, and art. For European artists, perhaps conscious that some their countries are in 1992 to join forces in the European Market, life and art seemed to form a more positive allegiance than they do for their American counterparts.

Television, along with Modernist painting, came of age in America during the 1950s, and many young American artists, whose work retained the shine of a newly milled or recently developed reflective surface, looked to the immediate past of a media-saturated culture. Paralleling the innovations of Richter and Polke were those of Robert Rauschenberg, Claes Oldenburg, and Andy Warhol. In 1953 Rauschenberg challenged the primacy of the Abstract Expressionist's decidedly European model, with its emphasis on self-importance and the inner struggle finding an original outer expression, by erasing a drawing by Willem de Kooning. By framing in gold what Rauschenberg called "his drawing," he signaled the historical source of his claim and gently poked fun at its preciousness. Like adolescent rebellion, willful misinterpretation is central to one generation's necessary dismissal of the motives of its parents. Building on Duchamp's readymades, which art historian Alfred Barr described as artful to a disappointed artist, and Kurt Schwitters's environmental *Merzbau,* Rauschenberg soon incorporated into his paintings vestiges of a life lived—an old tire, reproductions from the front page of newspapers, and anonymous geometric quilt most likely made by a woman—and shifted the focus of art from the visual to the textual, from inner struggles to the social torques of the world at large. Oldenburg's mingling of functional environments, utilitarian forms, everyday imagery, conceptual public projects, and live performances allowed for humor, slyness, and critique to enter the realm of high art. Warhol, who said he yearned to be a machine, showed that mechanical processes, which at first appeared impersonal and without the tactility we had come to expect from painting, were, just as the human hand, unable to reproduce perfection. His obsessive intermingling of love and death was linked to the promiscuity of the eye itself. Today's glamorous star is tomorrow's aged beauty; all fashion, every style, is ephemeral.

This decade witnessed the proliferation of repeats, reprocessing, reproduction, and repression. A sense of renewal was hard to summon. Yet, in turning back we remind ourselves what we have learned from history. And, while we often feel obliged to repeat ourselves as we daily remake our identities, the meandering path of evolution and the associative power of psychoanalysis suggest otherwise. We build new identities, new pictures of ourselves, out of a self-awareness based on a critical reassessment and

acceptance of the old. It is still possible to long for, even believe in, authenticity although traditional definitions may be too authoritative, too narcissistic, too bound to notions of individuality, and too tied to myths of linear progression. As the artists in this exhibition suggest, while doubt is fatiguing, its existence signals we have not relinquished all faith even as we abandon the search for perfection. There is comfort in the variety and complexity that is permitted when such illusions fall. As we approach the year 2000, millennia that curiously shadow this decade and conjure apocalyptic associations drawn from science fiction and film, we will need to measure abundance with such self-conscious definitions.

Notes

1. Timothy Ferris, "The Year the Warning Lights Flashed On," *Life* 10 (January 1987): 67-68, 70.

2. John Morris Dixon, "P/A Awards Thirty-five Years at the Frontier," *Progressive Architecture* (August 1987): 7.

3. See Kate Linker, "When a Rose Only Appears to Be a Rose: Feminism and Representation," in *Impolsion: A Postmodern Perspective* (Stockholm: Moderna Museet, 1987), p. 190.

Laurie Anderson

Siah Armajani

Francesco Clemente

James Coleman

Tony Cragg

Katharina Fritsch

Robert Gober

Jenny Holzer

Jeff Koons

Sherrie Levine

Yasumasa Morimura

Reinhard Mucha

Julian Schnabel

Cindy Sherman

Jeff Wall

Laurie Anderson

Most of the work that I do is two-part stereo, not monolithic at all, so there's always the yes/no, he/she, or whatever pairs I'm working with.[1]
Laurie Anderson

In the 1960s artists such as Robert Smithson sought to understand the network through which art became a commodity, to examine the link between art and the surrounding world in order to undercut the isolation of the artist from his or her audience, and to reveal the point at which distinctions between such seeming opposites as subjectivity and objectivity become problematic. In making *Enantiomorphic Chambers,* a seminal work from 1965, Smithson posed a question of potential conflict, a cast of mind central to all his pursuits, "If art is about vision, can it also be about nonvision?"[2] The wall-mounted mirror sculptures appear to be a finely fabricated Minimal series until one looks into the chambers. Because the mirrors are placed at oblique angles, the viewer never locates his or her image in the repeating reflections. The rational and irrational merge in this disembodied experience in which the individual's power to see or place him- or herself within the world is challenged. Later, Smithson created site-specific earthworks that, because they were located in inaccessible areas far from such conventional art-viewing settings as a gallery or museum and because they existed primarily in the form of documentary photographs with text, would challenge traditional notions of what it meant to perceive a work of art. His interest in Marcel Duchamp's concerns, including studies of N-dimensional geometry, became clear.

During the 1980s many artists mined those social and aesthetic explorations by eradicating the artist's touch in order to underscore the civic, confusing functional objects with artworks in order to encourage the viewer to adjudicate value, and exposing how the intertwining of market and media manipulates our sense of identity and systems of belief. But in doing so, some turned back to the commercial world in order to use those mechanisms by and communication technologies through which the largest number of people could be reached. To such artists as Laurie

Anderson, the insularity of the art world audience seemed unnecessary in the age of satellite transmission, telephone answering machines, and miniature televisions. Anderson lamented how American artists resisted working with popular media and material while in Europe there existed "a much greater attempt to integrate into the culture what artists are doing. I always thought it would be great if the American artist would try and enter his/her own culture in some way."[3]

Over the last thirteen years, Anderson gradually has relinquished the identities of sculptor and solo performance artist to assume that of an entertainer with a commercial record contract, demanding schedule of tours for increasingly operative productions, and the ability to produce ambitious films and videos. Beginning in the early 1970s, Anderson began to create live performances which in the 1980s gained in narrative drive, visual complexity, and technological sophistication. By 1979 with *Americans on the Move* (which as Part 1, "Transportation," of the seven-hour extravaganza *United States,* 1983, preceded "Politics," "Money," and "Love"), Anderson had presented her material at New York City's Carnegie Recital Hall rather than in a museum, a site not associated with theatrical conventions, or on the street, a site that allowed her proximity to the public. With this work, commissioned by art dealer Holly Solomon to celebrate her husband's fiftieth birthday, Anderson steps onto a stage, paradoxically both distancing herself from and expanding her audience. Appearing for the first time in her androgynous black suit and haircut, she slipped in and out of the shadows, slide projections, and animation—a disembodied figure cradling a wired violin, which as both a partner and surrogate self was something like Charlie McCarthy, ventriloquist Edgar Bergen's dummy. The unpredictable quality adapted from the Happenings of the 1960s merged with Minimalism's attention to setting and mesmerizing structures. With her release in 1981 of *O Superman,* a pop music single produced by 110 Records/Warner Brothers that rose to the number two position on the British charts, Anderson crossed-over from the art to the entertainment world. She had found a way to broaden the audience for her winsome, yet

Still from performance of United States *at the Brooklyn Academy of Music in New York, February 1983.*

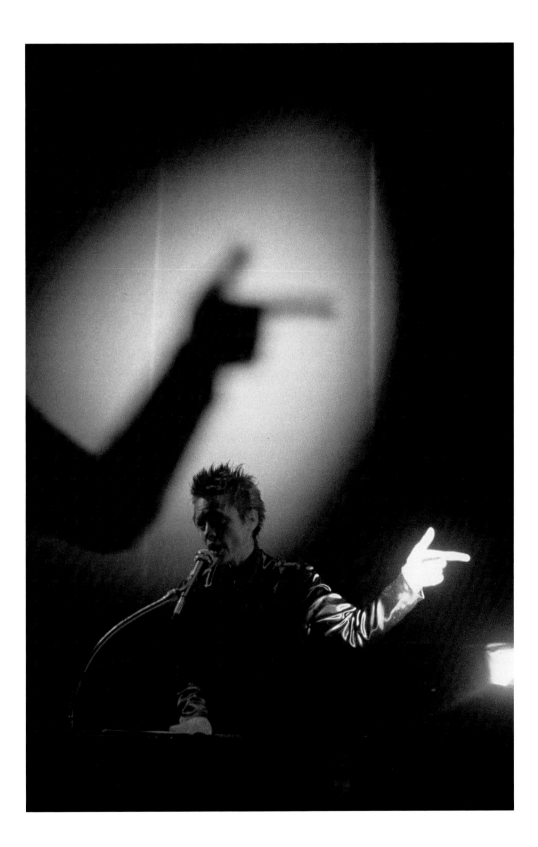

instructive tales without losing the interest of Soho denizens such as Vito Acconci whose support she had depended on throughout the 1970s.

By producing records and expansive multimedia performances, Anderson willingly set aside an involvement with unique and precious artworks. But, given that her real material always has been language, her process one of recycling and splicing, her subject the flirtatiousness of meaning, and her signature a voice that electronically jumps genders and pitches, this transition seems almost inevitable. From the beginning, her involvement with the mix and plasticity of things and sexual identities, including the woman- and machine-made as well as the diverse pattern of signs such as physical gestures, dialects, jargon, logos, maps, grids, clocks, and ideograms, lent her work a Duchampian charm. A storyteller who studied with Sol LeWitt, in her earliest works Anderson presents a careful blending of visual and verbal sequences with autobiographical and cultural dramas. A chameleon, assisted in her changes by technology that her crew has made user-friendly, Anderson can adapt any figure of speech to suit shifts in subject matter. Her style is fluid, fluctuating between the confessional and corporate, between the intimate and authoritarian.

In *New York Times, Horizontal/China Times, Vertical,* 1971–76, Anderson sliced the front pages of two newspapers into strips and then wove them together to create a single interlocking system out of two adversarial or incompatible ones. Because both versions of truth were suspect, neither dominated the nearly illegible final version. The deft synthesis of a woman's craft, the Minimalist's devotion to vernacular material, and the Pop artist's will to reproduce works create a subtle political statement. By turning language into a shadow of its former self, a picture of something larger than either text emerges. *Dearreader,* a film from 1975–82, uses the conventions of 1940s *film noir* to comment on the antiquated but still pervasive sexual stereotypes of the mass media. The opening sequence shows a man and a woman from the waist down, embracing. Fully clothed, in the next scene they are tumbling into bed. The pages of a calendar spin by, and nine pages (or months) later, the sound of a baby is heard. The title reflects a nineteenth-century literary convention in which the author interrupts to comment intimately and directly to the reader, a device that Anderson has continued to use as she glides from girlish to seductive to imperious characters.

In *O Superman,* which was adapted from *O Souverain,* a tenor aria from *Le Cid* (1885) by French composer Jules Massenet, the distinctions among what is said, what appears to be happening, and what is intended are collapsed as the song progresses. Technology is used to create a punkish round, the simplicity of which is not at all simplistic. Anderson weaves together personal politics with popular idioms in a nine-minute promotional video, released in 1982, in which she appears alone in a variety of anonymous settings, by and large devoid of worldly detail. A hypnotic, breathy "ha, ha, ha," which sometimes "reads" as pale laughter, other times as a mocking refrain, drifts throughout. She begins by invoking "mom and dad," those characters most record-buying adolescents, alienated by expressions of affection that often seem to them designed to stifle their freedom, love to hate. Mom calls, connects with an answering machine, and leaves a message designed to provoke uneasiness if not guilt: "Are you there? Are you coming home?" Implicit in this plaintive questioning is "Are you trying to fool—avoid—me?"

The confusion builds as styles of speech collide with the expected associations. An authoritarian voice (Anderson's own, manipulated) claims, "You don't know me, but I know you." Mom transmogrifies into mother country, a malevolent superpower whose "long arms" are electronic and petrochemical weapons that promise only a morbid embrace. With equal measures of despair and irony, Anderson locates comfort inside the might of the military and market, a tune often sung by speech writers for paternalistic politicians who also confuse might with right. Anderson says after love goes, then justice. Despite the introduction of so-called specialists in communication—from the mailman to mom—mixed messages and misunderstanding are the central

themes. From the personal to the political, communication systems are as subject to distortion as the pulsating grid—that symbol of analytical power — in front of which Anderson stands. Myths, after all, are unreliable legends, designed to reflect, through stories of the superhuman, the collective wishes of a society in need of belief. Momentarily confusing roles and realities, we remember Superman (whose mild-mannered reporting is reminiscent of Anderson's) committed suicide only to remind ourselves the dead man was George Reeves, the actor who played Superman in the television series from the 1950s. Christopher Reeve, the 1980s version whose latest performance is a magazine advertisement for women's lingerie, revived the myth of a superman who knows right from wrong but still cannot reveal himself permanently to the woman he loves lest her knowledge of his humanity place both of them in danger.

Using projections of drawn imagery as a sign language, Anderson moves from the man in the moon to a coin to a cartoon of the continents, purposefully overlapping fairy tales, economic myths, and intimations of global disruption. Literally singing a verse of the song in a bubble, which appears like a picture beside the anchor on a news show, Anderson speaks to those who ordinarily are shut out, who hear through their eyes. While she assumes all vocal roles—male and female, victor and victim, parent and child, altering the style of her voice as required—her arm and hand as well as reflections of them are also protagonists in this video. By using shadows, those fleshless clones, as a medium, Anderson, like many of her contemporaries, toys with the picture of the thing, including herself, rather than the thing itself. Her orchestration of light and dark—the stuff of both theatrical and photographic illusion as well as the tones that symbolically stand for good and evil—mirrors her exploration of the twins, representation and distortion. It is an exploration in which issues coloring current analysis of aesthetic and political concerns overlap. As in a child's shadow play, the projections made by her fingers are mutable. In ranging from the dream to the nightmare, a rabbit turns into a gun that becomes a fist while an accusatory finger transforms into a hand held out and then to a wave, which as Anderson has sung before is the American sign for hello and goodbye.

An idealistic performer, neither super man nor woman, Anderson knows as well as Tipper Gore that rock and roll is a powerful medium.[4] Because of its punch and the millions of adolescents who buy into that power, she desires to speak through the popular media about stereotypes most dangerous and dear. As she said in referring to her most recent performance, *Empty Places,* 1989:

To me, the legacy of the last eight years is very powerful. It's left people with a desire for they don't know what. But they know they have this desire. Desire is the consciousness of a certain kind of emptiness that has to be filled. But all of these are statements that are too big for what I really want to say."[5]

Notes

1. Laurie Anderson, quoted in Janet Kardon, *Laurie Anderson: Works from 1969 to 1983,* exhibition catalog (Philadelphia: Institute of Contemporary Art, University of Pennsylvania, 1983), p. 19.

2. Robert Smithson, quoted in Robert Hobbs, *Robert Smithson: Sculpture* (Ithaca, N.Y., and London: Cornell University Press, 1981), p.13.

3. Anderson, quoted in Philip Smith, "A Laurie Anderson Story," *Arts Magazine* 57 (January 1983): 61.

4. In 1985 Tipper Gore, the wife of Senator Albert Gore, founded the Parents Music Resource Center, an organization that provides consumer information on alleged links between rock music and drugs, violence, and Satanism.

5. Anderson, quoted in Catherine Texier, "Laurie Anderson Sings the Body Electronic," *New York Times,* October 1, 1989, sec. H, p. 41.

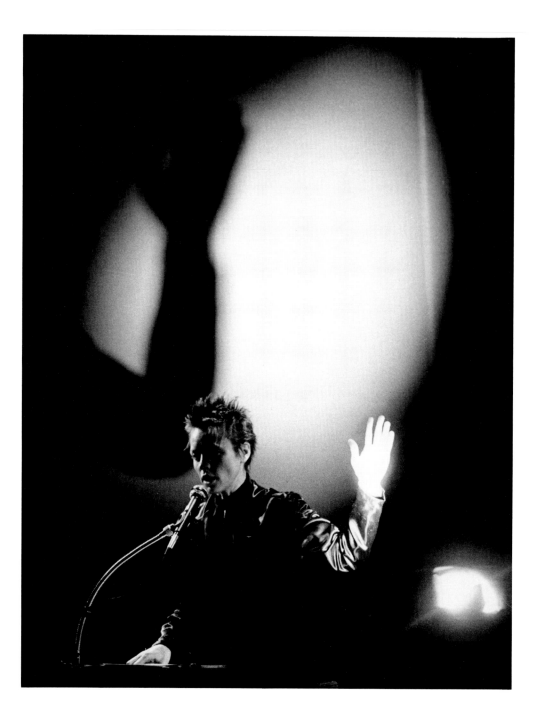

Laurie Anderson.
Still from performance of
United States *at the Brooklyn*
Academy of Music in New
York, February 1983.

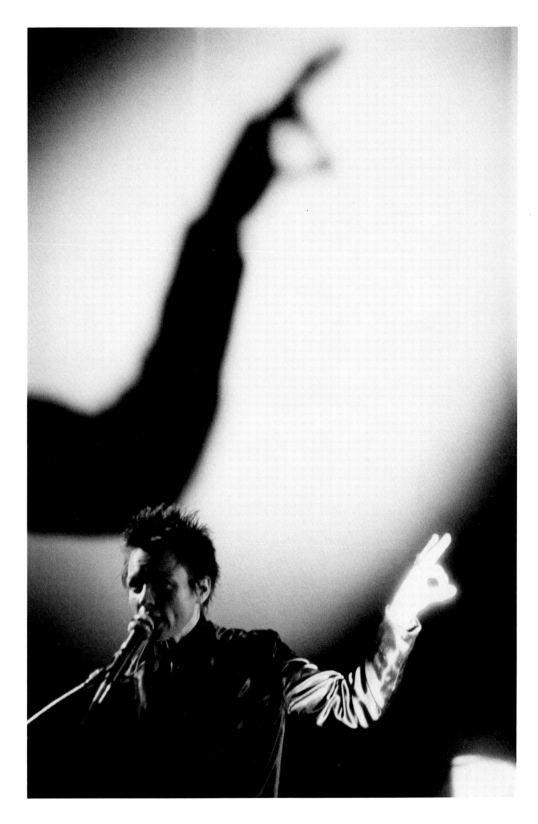

Laurie Anderson.
Still from performance of
United States *at the Brooklyn
Academy of Music in New
York, February 1983.*

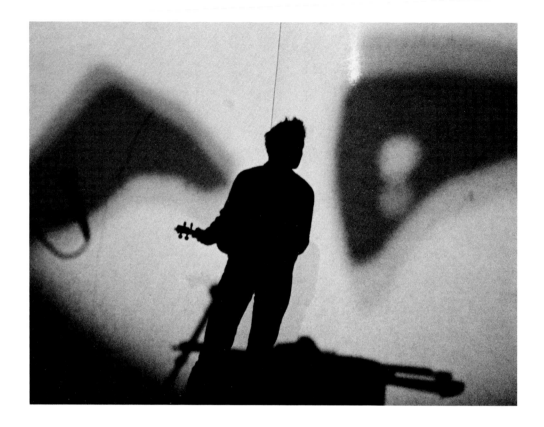

Laurie Anderson.
Still from performance of
United States *at the*
Brooklyn Academy of Music
in New York, February
1983.

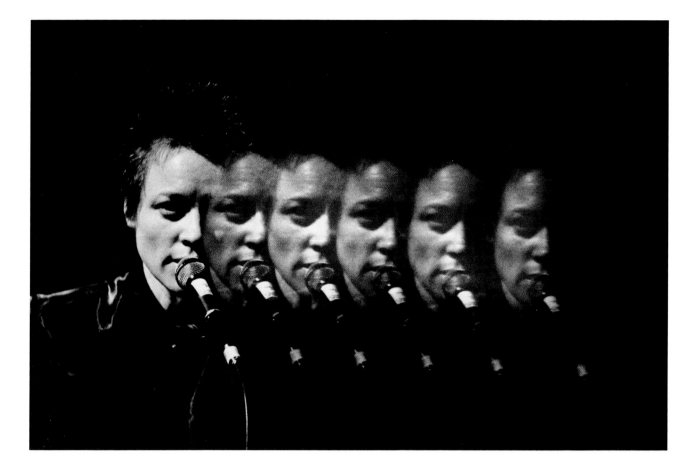

Laurie Anderson.
Still from performance of
United States *at the*
Brooklyn Academy of Music
in New York, February
1983.

Siah Armajani

A true democracy does not provide "heroes" as it requires each citizen to participate fully in everyday life and to contribute to public good We are trying to replace metaphysics with anthropology, philosophy with poetry; and we advocate the unity of the collective approach to the common problem, rather than the individual approach because we feel that the notion of individuality is a barbaric one and collaborative work is the ultimate methodology to identify and solve public problems.[1]
Siah Armajani

Born in Persia in 1939, Siah Armajani set down roots twenty-one years later in Minnesota, the American heartland that produced moderate Democratic party presidential candidates Hubert Humphrey and Walter Mondale. At Macalester College in St. Paul, Armajani studied mathematics, a fascination he exploited in the 1960s, using computers to construct a series of conceptual speculations on landmarks, including Mount Vesuvius, an infinite tower for North Dakota, and the Tower of Babel (based on Franz Kafka's statement, "If it had been possible to build the Tower of Babel without ascending it, the work would have been permitted"[2]). Known best for a series of permanent, public commissions of quasi-domestic environments, beginning with *Reading Room #2* installed at Ohio State University in 1979, he prefers to be called a "public artist" and "modern populist" rather than a contemporary sculptor.

Armajani's emphasis is on community, as both a location where many social activities intersect and an audience that expands traditional definitions of those interested in experiencing art. Agreement is the crucial element in constructing any compelling gathering place, and Armajani focuses on forging formal and social relationships that allow the private and public domains to meet. Language is an important descriptive and denotative tool in this process. He first introduced text into his work in *Meeting Garden,* built during the summer of 1980 at Artpark, as a way to accommodate another kind of perceptual experience—reading—and thereby join the deciphering of language and physical elements. Over three windows, Armajani placed in chunky,

legible print a credo of philosopher and educator John Dewey, "As long as art is the beauty parlor of civilization, neither art nor civilization is secure," which also comfortably represents the artist's principles. Since then he has drawn often from other favorite authors such as Ralph Waldo Emerson, Herman Melville, and Walt Whitman. All share a sense of connection to the natural world, to the pleasurable facts associated with being part of a larger system.

Public art is a tool for action, and Armajani often assumes the role of performer, using words to help his audience connect the history of art and ideas to daily experience. The critic Walter Benjamin underscored the social mission of storytelling, the intertwining of political and personal imperatives. A magnetic storyteller whose allegories are intricate and homespun, Armajani proselytizes for an art that is nonmonumental, based on the history of the site, and responsive to the purposes and functions required by its users. Unlike many Modernist artists who believed their artistic identity was dependent on solitary efforts, resulting in a unique visual language of brooding expressiveness that represented the externalization of internal states or emotions, Armajani does not believe his individual idiosyncrasies or ego should be expressed through his work. His efforts are not those of a traditional studio artist, private and hermetic. He champions usefulness rather than originality and believes the artist is not the god-like giver of meaning. The composition and vitality of his work depends upon the interplay with his audience, to whom he listens carefully. The roles of maker and viewer are interchangeable.

Mindful of the diversity of his adopted country, Armajani sees hopefulness in the pluralism that is the foundation of a country transformed by immigrants. His embrace of the impossibility of universal meaning is mirrored by his desire to create structures capable of accommodating multiple uses not unlike a small-town church, which often serves as community center, school house, day care facility, and religious dwelling. A builder of literal and metaphorical bridges, Armajani's sources reflect the interlocking of theoretical models and practical solutions from

Irene Hixon Whitney Bridge, 1988. Painted steel. Commissioned by the Walker Art Center for the Minneapolis Sculpture Garden, gift of the Minneapolis Foundation/ Irene Hixon Whitney Family Founder-Advisor Fund, the Persephone Foundation, and Wheelock Whitney, with additional support and services from the Federal Highway Administration, the Minnesota Department of Transportation, the City of Minneapolis, and the National Endowment for the Arts. (not in exhibition)

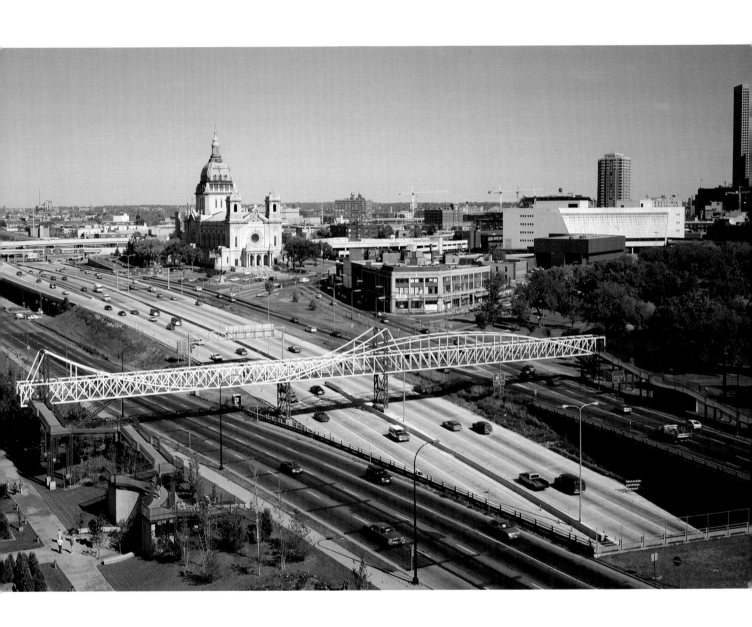

transcendentalist texts to architect Robert Venturi's *Complexity and Contradiction in Architecture,* from such vernacular building systems as post-and-lintel construction to the collective clarity of Leonardo Fibonacci's mathematical order, and from traditional American log cabins to Thomas Jefferson's Monticello, "the first attempt to adapt European conventions to create an indigenous American architecture."[3] Armajani sees public art as an attempt to secure an American frame and identity for Modernism, a movement brought to this country by such European artists as Marcel Duchamp, who fled the changes brought on by World War I, as well as by young Americans who came home from Paris after studying Franz Kupka's early abstractions, Pablo Picasso's first collages, and Filippo Martinetti's Futurist manifestos.

It is the utilitarian adaptation of Modernism generated by such Russian artists as El Lissitsky, who stressed the integration of art and society, and Vladimir Tatlin, who wrote that he struggled to gain control over the forms encountered in our everyday life, with which Armajani feels most kinship. The work of this decade has evolved into a series of functional environments such as the 3.5 acre waterfront plaza for the Battery Park development in downtown New York, a collaboration with architect Cesar Pelli and artist Scott Burton that began in 1983. Even an early project such as *Reading House,* built in 1979 for the Lake Placid Olympics, suggests the process by which function is both a measure of criticality and a means of providing some seating, shelter, or information. Armajani first placed his benches and tables, then determined where the windows would provide the most illumination, and finally built the four different facades of this shelter into which the windows were placed. While some confuse Armajani's methods with those of an architect, *Reading House* clearly suggests the quiet inversion of both architectural and artistic practice at the heart of this artist's work. In fact, those distinctions underscore the fact that so much contemporary architecture emphasizes decoration over performance and why so many Postmodern architects call themselves artists. Armajani shies away from the indulgent self-expression and lavish materials of Postmodern architecture,

replacing personality with persons and the special surface with standardized materials found at a local store. Yet he does not create oases of cushy comfort. Rather, through research and observation, Armajani assembles spartan places that encourage watchfulness, physical engagement, and communication . . . qualities needed to keep democracy—a form of government in which power is invested in the people—alive.

Notes

1. Siah Armajani, quoted from a public discussion with the architect Cesar Pelli at the San Francisco Museum of Modern Art on January 22, 1986.

2. Franz Kafka, quoted in Jean-Christophe Ammann's introduction to *Siah Armajani* (Basel: Kunsthalle; Amsterdam: Stedelijk Museum, 1987) (unpaginated).

3. Patricia C. Phillips, "Siah Armajani's Constitution," *Artforum* 24 (December 1985): 74.

Siah Armajani.
Meeting Garden, *1980.*
Wood, corrugated translucent
plastic, paint; dimensions
variable. Installation at
Artpark, Lewiston, New
York. (not in exhibition)

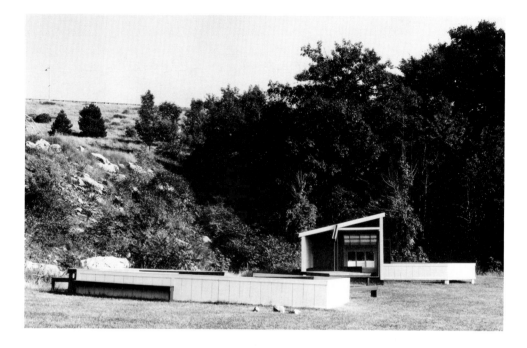

Siah Armajani.
Meeting Garden, *1980.*
Wood, corrugated translucent
plastic, paint; dimensions
variable. Installation at
Artpark, Lewiston, New
York. (not in exhibition)

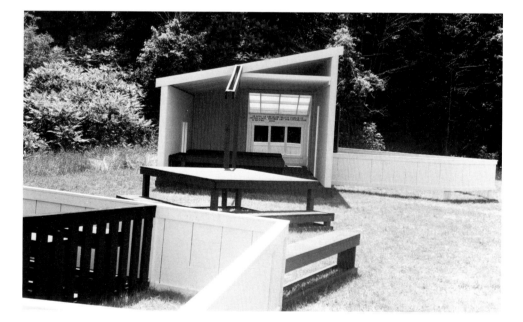

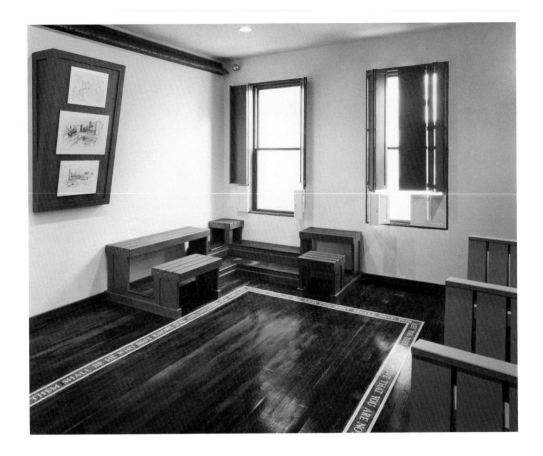

Siah Armajani.
Louis Kahn Lecture Room,
*1982. Painted wood,
plaster; dimensions variable.
Samuel S. Fleisher Art
Memorial, Philadelphia,
Pennsylvania. (not in
exhibition)*

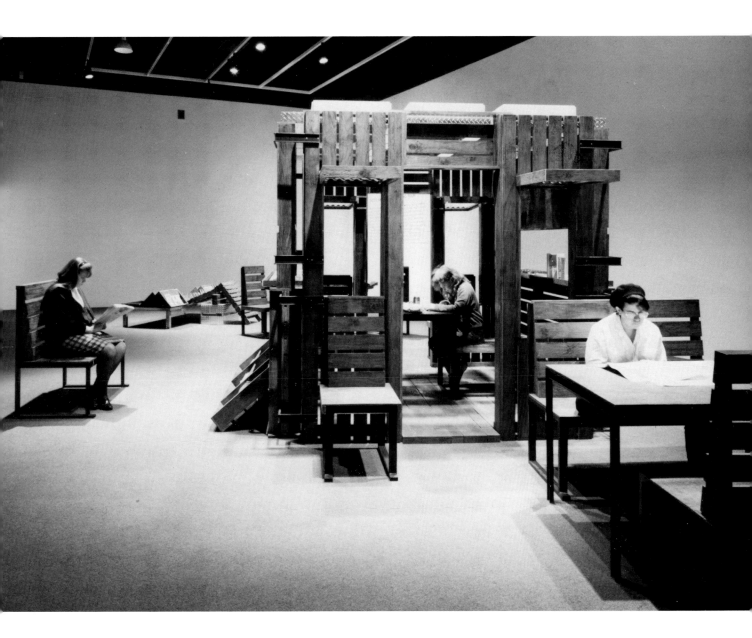

Siah Armajani.
Sacco and Vanzetti
Reading Room #2, *1988.*
Painted steel and wood,
aluminum, bricks;
dimensions variable.
Installation at List Visual
Arts Center, Massachusetts
Institute of Technology,
Cambridge, courtesy Max
Protetch Gallery, New York.
(not in exhibition)

Francesco Clemente

I trust all those who have "thought" with their bodies.[1]
Francesco Clemente

Francesco Clemente's work first was seen in the United States in 1980 along with a flood of work by other European artists, all of whom focused on the figure and were called Neo-expressionists. That label now seems oddly confining for Clemente, despite his self-conscious allusions to classical imagery. True to his roots in the theories of Arte Povera, in which the artist-alchemist transmutes base elements into valuable ones, Clemente revels in adapting the styles of many cultures in order to find a universal solvent that will dissolve such distinctions as folk and high art.

Clemente is a modern-day fabulist—the oracle of orifices—whose sensuous and disquieting tales picture the search for cultural distinctions represented in myth and fixed in the memory of a time before colonialism and television. Across the continents, the focus of desire has become so generic as to create a kind of cultural aphasia. The global overflow of mass-produced products manipulates tradition. Tribal people in Africa, for example, thread Volkswagen keys as decorative elements on the talismanic creations they carry with them for protection. In an age that threatens sameness, Clemente has sought "otherness" as the appropriate model for the artist. He willfully exposes himself to dislocation and self-consciously adopts the detached yet accepting perspective of someone who does not belong. Simultaneously, he is inside looking out and outside looking in. His imagery often exhibits an existential fretfulness reminiscent of the introspective pull that sometimes follows coitus. He knows the artist's peregrination is, at it's outset, circular and without relief. As the critic Francesco Pellizzi has written:

For him, America is like an anchor, a balancing pole at the edge of the world—the world, today, having no focus, can only be grasped in its entirety from one of its extremities. It is from here that he can seize, in a single and constantly shifting look of eery tranquility, of acceptance and stupefaction, those very conditions responsible for creating discrepancies and incongruencies, the fragmenta-tion of postmodern and posthistorical imagery.

It is both a "time" in which the Subject itself—in an absolute sense and also of course as subject of representation—has become a radically questionable entity, and still, barely perhaps, a time when one can throw a last glimpse into the elusively traditional, infinitely fragile and unmovable depth that is the mythological texture of places like India, while possibly feeling something of what was and precariously continues to be their millenarian nourishment and substance.[2]

In the paintings, frescoes, sculptures, books, and drawings on varied surfaces he makes in abundance and without regard to the traditional hierarchy of media that places paper below canvas, Clemente repeatedly produces liquid portraits of himself in a trance-like state or some part of his physiognomy, wounded. He is a voyeur of his own homelessness, and his sexuality gives him his portable dwelling, the shelter of identity. In Hindu fashion, he often portrays evanescent or out-of-body experiences reached (paradoxically, in Western terms) through a widening of orifices and erotic possibility. This opening of the senses to the world creates a visage alternatingly vulnerable, terrified, resigned, and preterhuman. Like speech, inner organs connect to external circumstances. Entrails and bodily excretions, like Persian script, curl from the anus or vagina. Often the animal and the human share a moment of connectedness, an image suggesting that the instinctual erotic pleasure of our progenitors may be repressed rather than remote.

Clemente is a narcissist who has taken his feverish obsession with self (as the originator of awareness and, consequently, reality) into a larger, more public, and social arena. Even in the 1980s explicit representations of the male body could summon calls for censorship, whether they are Robert Mapplethorpe's photographs of gay couples or Clemente's onanistic hallucinations. Clemente's depictions of self are neither heroic nor idealized; his body rarely is anchored and often androgynous. The artist is constantly without security or place: as a Westerner in Madras, an Indian city founded by Westerners, using materials made on Ghandi-inspired communes;

Miele, Argento, Sangue
(Honey, Silver, Blood),
1986. Fresco; three panels,
each 118⅛ x 78¾ (300.0
x 200.0). Fundació Caixa
de Pensions, Barcelona.

as an Italian from Naples in New York; as a male who imagines himself female, the "other"; as an artist imbued with the grandeur and beauty of classical traditions who is suspicious of his own love of the antique; and as a fine artist with an affection for the literary and crafts. His face and body are framed by different decorative mannerisms quoted promiscuously from sources as seemingly diverse as Indian folk art and Hellenistic Greek fragments, the Bhagavad Gita and Ezra Pound's *Cantos*. Again, the distinctions between high and low, sophisticated and instinctive, collapse with the cultural appropriation—the lifting of sources and methods as well as insights—that informs much of his work. In fact, several series of drawings were made by Indian artisans under Clemente's guidance. While the subject matter is a curious blend of autobiographical concerns and historical tracings, it is clear that the artist's own hand is missing from these works. This is not plagiarism as much as an attempt to reproduce beautifully the exquisite pain of the Postmodern dilemma: the schizophrenic desire for and suspicion of oneness. It is a blocked search for anything beyond the self-conscious, beyond the artful presentation of the loss of innocence, and beyond a fractured sense of self. It is swimming toward reincarnation.

Notes

1. Francesco Clemente, quoted in Giancarlo Politi and Helena Kontova, "Francesco Clemente," interview, *Flash Art* 117 (April - May 1984): 17.

2. Francesco Pellizzi, in "Through India to America: Notes on Francesco Clemente," in Michael Auping, *Francesco Clemente*, exhibition catalog (New York: Harry N. Abrams; Sarasota, Fla.: John and Mable Ringling Museum of Art, 1985), pp. 158-59.

Francesco Clemente.
Hunger, *1980. Tempera on paper mounted on cloth; 93½ x 96½ (237.5 x 245.1). Promised gift of Marion Stroud Swingle to the Philadelphia Museum of Art.*

Francesco Clemente.
Porta Coeli, *1983.*
Gouache on linen; 103 x 93
(261.6 x 236.2). Stefan T.
Edlis Collection, Chicago.

Francesco Clemente.
Perseverance, *1982. Oil on canvas; 78 x 93 (198.1 x 236.2). PaineWebber Group, Inc., New York.*

Francesco Clemente.
Sun, *1980. Tempera on paper mounted on cloth, 91 x 95 (231.1 x 241.3). Philadelphia Museum of Art, Edward and Althea Budd Fund, Katherine Levin Farrell Fund, and funds contributed by Mrs. H. Gates Lloyd.*

James Coleman

Art can never totally be reduced to a concept of simple acts of self-expression.[1]
James Coleman

James Coleman's elaborately scripted film, slide, and video installations are neither documentary records nor clones of entertainment cinema or television, although the artist is comfortable lifting methods and mannerisms from each. Rejecting the self-sufficiency of formalist criticism, Coleman wants his work to penetrate the time and space occupied by his public. He insists that his installations, like paintings, be sited in galleries rather than theaters where one sinks into a seat and dissolves into the screen, with the relationship between the fiction represented and the viewer lasting for the duration of the film. Instead, Coleman demands a more active participation. He uses moving pictures not to create the illusion of a world closer to reality so much as to capture in real time the daydreams that drift up from the surface of things. Light, the substance or material of his work, is as immaterial yet pressing as thought. His projections of light (and meaning) suffuse the viewer's space. His increasingly complex and dramatic works, which in their fractured lyricism summon the shock and languorous sensuality of language as invented by James Joyce, still reflect the underpinnings of Conceptual Art, with its emphasis on reflexivity or the union of object and subject. In Coleman's work, however, this union is a provisional one because the gallery setting as well as the disjointed nature of his narratives create in viewers a self-consciousness that distances them from the spectacle invented by the artist.

Coleman's earliest installations from the 1970s tended toward phenomenological experiments in which time, cast as a central character, demanded the viewer's direct involvement in the drama. For example, in *Stereo,* 1972, the viewer enters an empty room in which two texts, taped and transmitted from speakers hidden at opposite ends of the room, alternate at various intervals, creating gradually a sense of a complicated dialogue in time. As the viewer adjusts to being a listener rather than a spectator, the experience of being in the room becomes akin to stepping

inside the artist's head. *Notes for 'Habitual Object,'* 1971, investigates the interlocking relationships of the thing observed or made, the artist, and the viewer through three film projections (one in black and white, with two distant shots of a landscape with the object, and two in color, one without the object). The work includes a list of compositional devices that have become pivotal to Coleman's work and to the experience of it, "intervals / positions / spaces / timings / image size / colour / duration of / loops."[2] Most of the ingredients allude to the movement of time or to its lack of conclusiveness. Through the manipulation of expectancy Coleman plays real time off of psychological time, making the viewer act as interpreter rather than simply as receiver of information. In *Playback of a Daydream,* a film from 1974 that alternates drawn images of an ambiguous duck and rabbit that, with a shift of attention, read as the other, he uses an old textbook trick to show the distance between perception and the way perception can make mockery of knowledge. Critic Michael Newman tellingly specifies the distinctions between Coleman's and Ludwig Wittgenstein's concerns by reminding us that while the philosopher used the same images in his discussion of "seeing as" he "left the identity of the perceiving/thinking subject intact," while "Coleman is concerned with the relationship between the identities of subject and image as they are mutually conditioned or caused through time."[3]

Coleman's focus always has been on perception and its operations: how information has concentrated on who we are and how we got that way. The drama is that of the modern age in which both collective and individual reason are suspect. If the question of identity can be answered only subjectively, and if that individual perspective is conditioned outside of the self, what can be considered an authentic, socially responsible response to this loss of freedom? Coleman's answer, really more of a suggestion than a definitive statement, mirrors his attempts to engage the viewer in an active rather than passive pursuit that exercises the need to develop a tolerance for multiple meanings. In choreographing these antitheatrical (in the sense that one does not dissolve into the story or illusion) stagings, Cole-

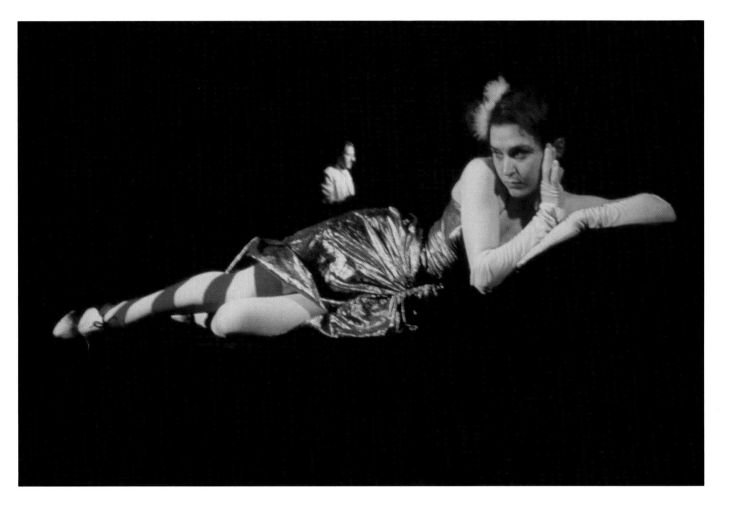

So Different . . . and Yet,
1979-80. Video installation,
45 minutes; narration
performed by Olwen Fouere
and Roger Doyle, music
composed and performed by
Roger Doyle. Courtesy
Marian Goodman Gallery,
New York.

man clearly denies the idea of linear progression because the multiple story lines result in numerous interpretations. While artists often isolate images in order to give them form or body, he knows the whole is a modern myth. His work is about connection and isolation, about being fixed and unstable, there and missing, portrayed. Memory is a constant companion and character, although an unreliable accomplice.

As Coleman's work has grown more dramatic or operatic in the 1980s, it has come to embrace reflections on how the history of his country, Ireland, has been represented along with the psychological, philosophical, and perceptual references that informed his earlier work. These historical allusions range from a seventh century Irish king (in the performance of *Guaire,* 1985, in which a woman plays the male royal) to the present religious and political bifurcation of Ireland (in the video installation *So Different... and Yet,* 1979-80). While the references are used in a highly self-conscious manner—for example, the audience is reminded by the patent fakery of the costumes and sets designed by Dan Graham that artifice rather than historical accuracy is central—Coleman's work is devoid of the slyness and coolness that surfaces in much contemporary pastiche. His is an effort not to report on so much as resuscitate tired genres, which in the world of painting we know to represent scenes from ordinary life. What Coleman sees as a primary motif of the life lived is the troubled and troubling relationship between genders, between those who look and those who are looked upon.

Drawing on the stereotypes promoted in literature, film, pornography, and fashion as well as the traditions of Rococo painting, Coleman exposes in *So Different . . . and Yet* how male desire renders women the "other" because inherent in the complicated relationship is both a delight in the spectacle of seduction and a fear that, in lacking a penis, the woman threatens castration in consummation. According to Jacques Lacan, whose reading of Freud's Oedipus complex has served many theorists of recent visual practice, in order to escape that fear man's unconscious invents a symbolic order in which woman functions as fetish or beautiful but pas-

sive artifact. The muse is acquiescent, the maker active. This focus on sexual division parallels the politics of an Ireland dominated by English rule.

The installation features a woman, wearing a green cocktail dress and one red striped stocking, lounging like Edouard Manet's Olympia in an artificially flattened space colored a mechanical blue. A performer who indulges in excessive gesture, she is accompanied by a male pianist with horns, a satanic as well as sexual symbol. Both actors speak with exaggerated French accents. Each shift in her preening position records a switch in the enormously complicated, fractured, and confusing narrative, making her movements the force that propels the intertwining stories of a newly created dress, robbery, terrorism, assumed identities, and attempted adultery. While Coleman bases these narrative bits on such popular fiction as romance novels, detective stories, and the French farce, the true tale, as it unravels, lies in double meanings. For example, Norman, described as "an arm of the law" as well as a "knight in shining armour," is identified coyly by Vanna, a shop attendant whom he chases in private—calling her an "emerald of the beautiful isle"—but pretends not to know in public, as a schoolmate from "Battle Abbey at Hastings." The references, which occur over time in the installation, finally foster a haunting sense of the snug fit—an almost Hegelian synthesis—between sexual and social politics. The dilemmas of gender are placed within the context of the communal or social. At the Battle of Hastings in 1066, William of Normandy defeated the Anglo-Saxons, installing the French culture in England, and the descendants of the Normans invaded Ireland in the twelfth century. As Michael Newman writes, "If *So Different... and Yet* works as an allegory with literal, historical, mythical, and psychoanalytic interpretations, the green dress is the emblem at which these readings intersect. It is the signifier around which the story turns and through which it achieves a denouement; it symbolizes the 'Emerald Isle,' Ireland, and is a metonymical substitute for the women who do likewise; it is also an attribute of feminine identity as masquerade, a signifier of the image of woman that is itself a signifier. The red band wound around the leg of

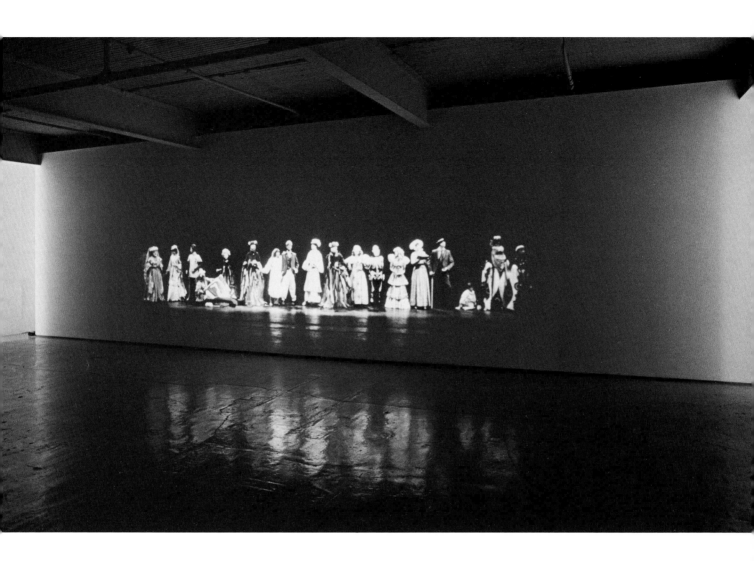

James Coleman.
Living and Presumed
Dead, *1983–85. Multiple*
slide projection with sync
sound tape, 25 minutes.
Courtesy Marian Goodman
Gallery, New York.

the woman on the screen emphasizes the fetishism of body."[4]

As it turns out, the newly made dress is not an original, but an old one redone to appear fashionable, a definition that suggests Coleman's suspicion of the urge to create uniqueness without reference. Similarly, the viewer, in one installation variation lounging at a safe distance on a couch placed in front of a monitor imbedded in the wall, is implicated as a voyeur. The excessive artifice deflects the gaze, however, rendering it silly if not impotent. The narrator plays at many roles, signifying both the seduced and seducer. Charmed by her tale but unable to chart its turns, the spectator follows her voice, just as Eurydice followed her husband Orpheus out of Hades only to lose him when he violated Pluto's orders not to glance back at her.

Notes

1. James Coleman, quoted in *Richard Kearney,* "Interview with James Coleman," 6, no. 2 (1982): 130.

2. See *James Coleman,* exhibition catalog (Milan: Studio Marconi, 1973)(unpaginated).

3. Michael Newman, "Allegories of the Subject: The Theme of Identity in the Work of James Coleman," *James Coleman: Selected Works* (Chicago: Renaissance Society at the University of Chicago; London: Institute of Contemporary Arts, 1985), pp. 26 - 27.

4. Ibid., 35.

James Coleman.
Seeing for Oneself,
*1987–88. Multiple slide
projection with sync sound
tape. Lannan Foundation,
Los Angeles, courtesy Marian
Goodman Gallery, New
York.*

James Coleman.
Seeing for Oneself,
*1987–88. Multiple slide
projection with sync sound
tape. Lannan Foundation,
Los Angeles, courtesy Marian
Goodman Gallery, New
York.*

Tony Cragg

These last years I have been working over a thematical area and set of interests which includes the ever increasing gap that exists between the visible world and the information world. . . . Man functions in everyday life without knowing what the objects around him are, he is hardly aware of the political situation, the social reality, the chemical problems, and even basic things like what electricity is. People are constantly talking about progress, yet they seem to forget that the progress they are talking about is only material, whereas man himself, his basic condition, hardly evolves. . . . We should not let the prime function of our lives just be materialistic, get rich, be powerful. . . . Perhaps with more attention to visual culture, which was widely ignored for a long time, we can discover freedom of a more cerebral nature.[1]
Tony Cragg

At a time when many fear the immediacy of their own feelings, adopting instead a posture in which the numbing niceties of nostalgia replace personal response, Tony Cragg believes in the power of art to elicit emotion from both the maker and the viewer. He is searching for ways to invest the things that populate our culture, including art, with the power to arouse, to stir us from our narcissistic sleep by re-forming the link between the abstractness of mental schema and the palpable expressiveness of the thing itself, between the reality inside and outside of the individual. His own struggle to bend the iconography of his found materials to his own needs—to give new meaning to industrial rubbish and consumer goods that no longer function as they did when first produced—subtly comments on the problems facing highly developed countries that are choked by their own addiction to conspicuous consumption and planned obsolescence. His primary focus has been on materials already depleted, an exploration that resulted from earlier work with natural materials such as twigs and rocks found along the English coast. While his work from the early 1970s referred to the meandering of a prior generation of artists such as Richard Long, in abandoning the romantic role of the itinerant artist recording the variety of nature, Cragg plunged back into the complexities of today's world. In that environment the

artificial intertwines with the natural, and a mussel found growing on a piece of polystyrene stimulates the imagery for a sculpture. Having come of age during the 1970s when the antinarrative stance of Minimalism and the antiobject character of Conceptualism dominated the making of art, Cragg seeks through the union of the sensory and social to open his art to the possibility of associative imagery.

Something of an urban archeologist, Cragg studies how we live and what we value by cultivating the materials we discard. Yet he makes no moral judgments about a society that consumes more than it can digest, spewing forth the industrial waste—plastic, metal, and wood scraps—that he collects and often uses as his primary material. He finds beautiful and suggestive the plastics that wash ashore near his studio in Wuppertal, the first European city to be industrialized. Chemically stable, decomposing ever so slowly, they are the dinosaurs that will remain from the microchip age. Cragg is not interested in mystifying the present state of ecological depletion facing the civilized world or romanticizing a pre-industrial time of candlelight and handmade tools. He searches for associations rather than differences. For example, rather than considering his synthetic materials of less merit than bronze, he relishes how their character mirrors the essential artificiality of aesthetic representation. While the artificial is the natural material of this generation of reproduction and mass production, it is also an appropriate replacement for traditional artistic materials, given Cragg's critical way of looking at works from the past. He finds that "it is things outside of art like sexuality, for example, or politics and architecture that give symbols the importance they have."[2]

He arranges things that he has collected or made with keen observational skills and an erotic obsession with craft, joining the analytical methods of science to the sensuality of making objects. His inquiry into the life of his materials is both intimate and extensive. For example, he examines the atomic structure of a given material because it gives him important facts about the things he can make out of that substance. The morphology of his sculptures reflects the form

Real Plastic Love, 1984. Plastic fragments; 73 x 33 (185.4 x 83.8). Martin Sklar, New York.

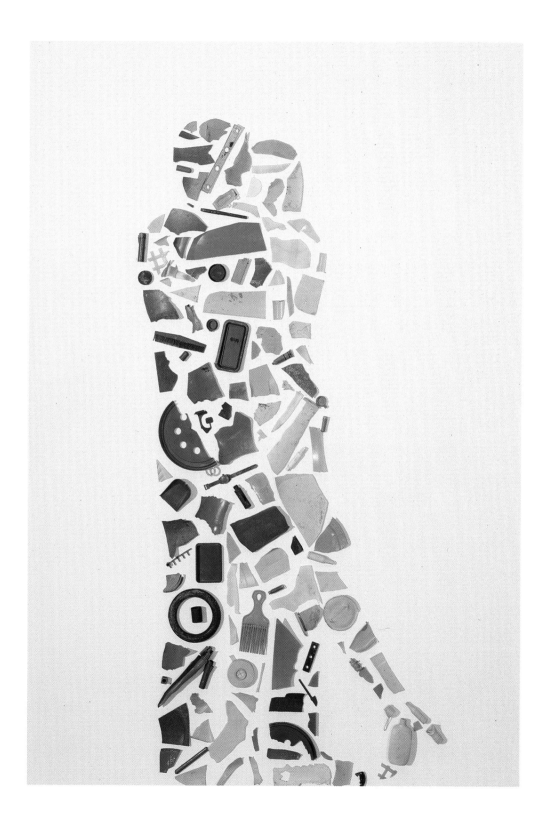

and structure of the materials of which they are made. Content is drawn from his obsessional way of working, beginning with an image, struggling with the reality of his material, and finding in the resulting object a synthesis of mental and physical realities.

New Stones Newton's Tones, 1978, the first piece Cragg made after moving to Germany in 1977, is named after Sir Isaac Newton. One of Cragg's heroes, Newton formulated the law of gravity (any sculptor's central physical concern) while deeply interested in the pseudoscience of alchemy. Cragg's own process is alchemical, transforming spent and mundane matter into something new and valuable. Similarly, he turns such three-dimensional objects as plastic bottles, cigarette lighters, and syringes into pictorial reliefs, representing, as in *Real Plastic Love,* 1984, a pink and blue couple embracing. Clearly, the notion of reality is subjected to a number of transmutations: the imagery of the found objects underlies the newly invented picture; trivial elements make a more substantial whole; once seductive items that called out from the supermarket shelf become colorful strokes in a tableaux about the depiction of romance, a depiction of the generic, faceless version of personal engagement absorbed from the media; mass-produced becomes a part of the handmade. Perhaps most ironically what was consumed, fulfilling its short life expectancy, comes alive to be consumed again as part of a salable art object. While Cragg explores the intricate politics of the marketplace, a work such as *Mercedes,* 1982, turns to a moment in history when former Secretary of State Henry Kissinger visited West Berlin, prompting a near riot. Instead of his customary plastic flasks and bits, Cragg used the debris left from the demonstration, the bricks and bottles marking some Germans' discontent with American policy. One cannot help but see the use of those materials to create the corporate logo for the automobile that symbolizes Germany's postwar prosperity as Cragg's comment on the interdependence of American and European economic systems. Driving along Route 128, a Massachusetts road known as "America's Technology Highway," one could be fooled into thinking of the Mercedes as the Volkswagen of the 1980s. The chang-

ing political climate is perhaps best and most sadly expressed by a recent poll of high-school students from Beverly Hills, California, many of whom thought the peace symbol from the 1960s was the Mercedes logo.

Cragg constantly posits questions concerning definitions of permanence—ranging from those having to do with evolutionary systems to those relating to human passions—in an age when the disposable, the sixty-second sound bite, and fast food suggest a need to dispense with everything quickly. While willing to accept mutations, knowing they appear in nature as well as the test tube, he stresses the need to invest our senses with sense, to fight rather than sink into the comfort of consuming without collecting our thoughts.

Notes

1. Tony Cragg, quoted in "Interview with Demosthène Davvetas," in *Tony Cragg,* exhibition catalog (Brussels: Société des Expositions du Palais des Beaux Arts, 1985), p. 31.

2. Ibid., 32.

Tony Cragg.
Mercedes, *1982. Bottles
and stones; 118⅛ (300.0)
in diameter. Konrad
Fischer, Düsseldorf.*

Tony Cragg.
Mortar and Pestle, *1987.*
Cast aluminum; 37¾ x 77
x 28 (95.9 x 195.6 x 71.2).
Private collection,
California.

Tony Cragg.
Generations, *1988. Plaster*
of Paris; 43 x 55⅛ x
70⅞ (110.0 x 140.0 x
180.0). Marian Goodman
Gallery, New York.

Katharina Fritsch

The goal of all structuralist activity, whether reflexive or poetic, is to reconstruct an "object" in such a way as to manifest the rules by which the object functions. Structure is therefore a simulacrum of the object, but a directed, interested simulacrum, since the imitation brings out something which remained invisible, or, if one prefers, unintelligible, in the natural object. . . . This addition has an anthropological value, in that it stands for man himself, his situation, his freedom and the very resistance which nature offers to his mind.[1]*
Roland Barthes

If you did not suspect that Katharina Fritsch was pursuing perfection or at least trying—like someone in the middle of psychoanalysis who has passed through the heat of pain in the present tense—to freeze the flight of deeply felt memory, you would think she made art the easy way: by buying it in a novelty or department store. In fact, there is nothing ready-made about any of Fritsch's madonnas, money boxes, or animals. She often struggles to find a way to make, and make explicit the particular quality of, those objects that on first approach seem so ordinary. In what at first also seems paradoxical, their specialness derives from the quotidian nature of their sources. In other words, the idiosyncratic character of her sculptures resides in the fact that they are drawn from lived experience rather than intellectual strategies.

But, as in childhood, the acts of imagining and remembering work together, revolving around the idea of things. Fritsch's objects preserve the flicker of sensations—the impulsive stutter of imaging and sorting—that comes when confronted with not knowing something well enough to name it precisely. Her work is not about generic classifications or verbal designations—the name tags by which we group things and often are done with them. The poignancy of her work derives in part from the relationships that have accumulated around her society of objects, for example, the unburned, virgin candles; redbound books lacking text and, consequently, committed thought; and bloodless, hauntingly light brains separated from their bodies. But empathy also is drawn from the viewer's visceral experience of the artist's almost fearful need to control the shape of things as suggested by the insistent repetition of objects. With each yellow, not quite golden, madonna, comes the imagined whisper, "This time I'll get it right." Given the difficulty of maintaining faith in this profane age, that may be the only response possible.

Before being made, an object is mentally worked over, examined critically, and broken down to component parts such as color and density of hue, material and degree of finish, profile and body, size and weight. While early works were handmade because it was too expensive to produce them any other way, Fritsch now handles only a model, a prototype that is handed over to a factory for production. Even with her fretful oversight, sometimes the resulting object does not match the one remembered and imagined, and she begins again. With breathtaking craft and according to almost maniacal specifications, Fritsch has made multiples that, when stacked, make sculptures produced in limited editions. Three towers, for example, are each composed of 300 madonnas, balanced one atop another without additional support. When installed singly, they refer to the larger family of reproduced objects.

A number of inversions occur in Fritsch's work. Industrial production methods, usually used to make many things efficiently, are pushed to produce nearly perfect objects that, in turn, are used to make something hovering between the rare and the mass-produced. Running counter to the myth of the artist/craftsperson, industrial processes as practiced by a team of workers in a factory promise greater technical competence and a higher standard of finish than those methods employed by an artist working alone in the studio. By undermining the myth of the sacredness of the handmade and individual, Fritsch simultaneously challenges uniqueness as a final measure of "goodness" and art as an activity estranged from ordinary life. It is as if, in the age of instant information and advertising, the exotic no longer resides in the unfamiliar, and art no longer needs to be considered an artifact contemplated by only a few. A green elephant on a gray oval pedestal, a one-to-one model of a specimen

Unken (Toad) *1988. Single record; 7¹/₁₆ x 7¹/₁₆ (18.0 x 18.0). Private collection. (The object represented in this photograph is not the work in the exhibition.)*

found in a natural history museum, brings many visitors to an exhibition who normally would go elsewhere for a weekend outing. Perhaps, as executives fly off to hike in Tibet, our appetite, our desire, consists only of what we know somewhat. Sadly, the truly exotic in the 1980s resides on the street corner, homeless and forgotten.

Regen (Rain), 1987, plainly exhibits the delicacy, stubborn resolution, and chameleon qualities of Fritsch's objects, all of which are as exquisitely tuned to the context in which they are placed as they are produced. During the summer of 1987 Fritsch spent several weeks waiting with a sound engineer to record water dropping on the individual leaves of a specific rhododendron. She was trying to retrieve a link between sound and image she remembered from childhood. Although theoretically Fritsch was simply transcribing fact, this research phase was as nerve-wracking and time consuming as any bout with a blank canvas might be. The recording finally was completed late one night. Fritsch then produced "Regen," a record made in an edition of 500, which was played continuously as part of an installation prepared for Haus Lange, a home in Krefeld designed by Mies Van der Rohe that now hosts temporary exhibitions. Despite its current function, Haus Lange remains a series of domestically proportioned rooms, punctuated in back with large glass windows that overlook a garden. The inclusion of nature was clearly a vital ingredient of the architect's scheme. Fritsch—whose involvement with the repetition of forms, mass production of well-designed goods, and utopian drive to re-engage the viewer mirrors the functionalist direction and rational methods of the Modern movement in the 1920s—subtly reported on the sternness of Mies's aesthetics and the prior domestic uses of the site in defining her installation. She covered the living room walls with paper she had designed in 1980, in a pattern reminiscent of 1950s organic abstraction, and set in the middle of the room a boxy table on wheels with a grid-like trestle for sides, on top of which sat a silver angel and a long-necked green bottle, carefully aligned. The soft sound of rain permeated the airy rooms, even when the sun shone, leaving one to wonder about the accuracy of one's senses. When it rained, the work of art and the architecture that housed it fused with an outside reality, both momentarily losing their distinctness. The zen-like quality of the work reinforced the Japanese aspect of the Modernist's dictum "less is more." It also points to new demands placed on the audience: in order to understand what is seemingly self-evident, the viewer must become a listener, must become holistically involved and attentive.

Still it is difficult to know with certainty whether what one heard is composed or common, precise or casual, an object or phenomenon. But these questions are not limited to the experience of art. Like *Madonna*, 1982, we find ourselves stuck somewhere between a house of worship and a Postmodern department store. Doubting the usefulness of either direction, vigilant observers still seek, as the Coke advertisement tempts, "the real thing." Yet Fritsch's work exposes the fragility of the paradigm, a primary example of which the American College Dictionary states is "a boy's boy." In its stead she places the place, with its particular human history and consequent systems of collective belief. But the sadness at the heart of Fritsch's work suggests that the systems on which Western culture is based—religious, financial, representational—no longer provide certainty of faith, which while potentially oppressive, is reassuring. Faced with Fritsch's many madonnas, money boxes, and black cats we invent and inventory again the sense of loss, false desire, and superstition that spring from our need to consecrate and consume. We also confront the perils of our collective acts—murder, imperialism, and the separation of black from white.

Note

1. Roland Barthes, quoted in Jean-Christophe Ammann, *The Intuitive Logic of Katharina Fritsch,* (Basel: Kunsthalle Basel; London: Institute of Contemporary Arts, 1985), p. 7.

Katharina Fritsch.
Gehirn (Brain), *1981-89.*
Plastic; 4¾ x 5⅛ x 5⅞
(12.0 x 13.0 x 15.0).
Courtesy Galerie Johnen &
Schöttle and Jablonka
Galerie, Cologne.

Katharina Fritsch.
Katze (Cat), *1981–89.*
Plastic; 6¹¹/₁₆ x 6¹¹/₁₆ x 2³/₈
(17.0 x 17.0 x 6.0). Courtesy
Galerie Johnen & Schöttle
and Jablonka Galerie,
Cologne.

Katharina Fritsch.
Warengestell mit
Madonnen (Display Rack
with Madonnas), *1987–89.*
Aluminum, plaster; 106⁵/₁₆
(270.0) high, 11¹/₁₆ (82.0) in
diameter. Courtesy Galerie
Johnen & Schöttle and
Jablonka Galerie, Cologne.
(not in exhibition)

Katharina Fritsch.
Schwarze Vase (Black
Vase), *1984. Plastic; 16½*
(42.0) high, 7⅞ (20.0) in
diameter. Courtesy Galerie
Johnen & Schöttle and
Jablonka Galerie, Cologne.
(not in exhibition)

Robert Gober

A friend called me at my studio the other day and I used the opportunity to complain on and on about the difficulty of writing this [article for Parkett] or of writing anything lucid or useful about AIDS. He told me how much the phenomenon had transformed his own life, but he wasn't certain if the disease had transfigured the times or if the response to the epidemic wasn't in fact a symptom of a larger public malaise, a broader political shifting of cares and cures. Look for example at longevity. During Reagan's two terms the life expectancy for white Americans has continued to rise, while for black Americans longevity has begun a strong steady decline.[1]
Robert Gober

Marcel Duchamp brought the bottle rack, urinal, and chocolate grinder from the store to the gallery, thereby changing all notions of what could be valued or construed as art. He allowed the factual vitality of life to flood the gallery, undermining the bourgeoisie pleasure of shopping for and collecting fine and rare objects. While his readymades and other visual references to the vernacular carried some autobiographical associations (he said the image of *Chocolate Grinder*, 1913, was based on childhood memories of displays in stores in Rouen), he probably also chose them because they appeared anathema to art and brazenly suggested bodily acts—drinking and inebriation, the fountain-like release of the bladder, and the grinding of gears to make sweets, an act that in *The Large Glass*, 1915–23, came to signify the bachelor's sexual mechanics. Robert Gober has wandered across the erotic terrain Duchamp charted and returned to a beginning point that permits feeling to re-enter the landscape and to re-engage the need to make things.

Gober's world is essentially domestic, although the home created by mentally arranging all the pieces is disembodied, filled only with troubling dreams, parts rather than wholes, and an overriding sense of absence. It is difficult to date the period or style of the "furnishings," although they float in self-consciously modern environments. In his first collaboration, done in 1986 with painter Kevin Larmon for the now-defunct East Village gallery Nature Morte, nineteenth-century fragments of a headboard and chair made by the Roycrofters (followers of William Morris, who championed a return to craft and community while turning away from the industrial age) were installed along with two new sinks made by Gober. The objects he makes—the sinks, urinals, armchair, crib, playpen, beds (including a hand-woven rattan one for man's best friend, the faithful dog, which includes a hand-painted pseudocushion depicting a white man sleeping on his stomach, face covered, dreaming what one assumes is a nightmare of a black man, hanging)—refer to the kitchen, bathroom, and bedroom as well as the human body and its habits. One would like to see these objects as expressing needs that, once met, would allow for a feeling of freedom and ease—urinating, relaxing into soft pillows, sex. But the bed is that of a monk—neat, tight, stern; the armchair, its canvas slipcover painted tenderly with a bird alighting and botanically correct renderings of spring flowers such as pansies and daffodils, is devoid of cushion and comfort. Most of the objects associated with beginnings, with childhood, often refer to conditions imposed upon the body from outside. The playpen confines infants as a penitentiary does adults.

While suggesting function, these objects cannot be used. Leaving our bodies behind, we inhabit Gober's classic, almost archetypal objects by imagination only. His laboriously, if obscurely, handmade objects fool you into thinking they are, first, the things they remind you of (the original) and, second, exact copies (reproductions) of those things. They are neither, and a poignant ache rises from this incongruity. We experience something that looks painfully like something else, but the identity of this anthropomorphic creature has been short-circuited, repressed, just as some of Gober's sinks and beds look as if they have been pressed into the wall, too full of meaning to be allowed visibility. "Almost like" seems like almost known and, consequently, off the mark. Equivalence means equality, a quality Gober searches for just as James Baldwin, an author the artist has expressed interest in as well as deep ambivalence about, sought racial and sexual equality in and finally out of America.

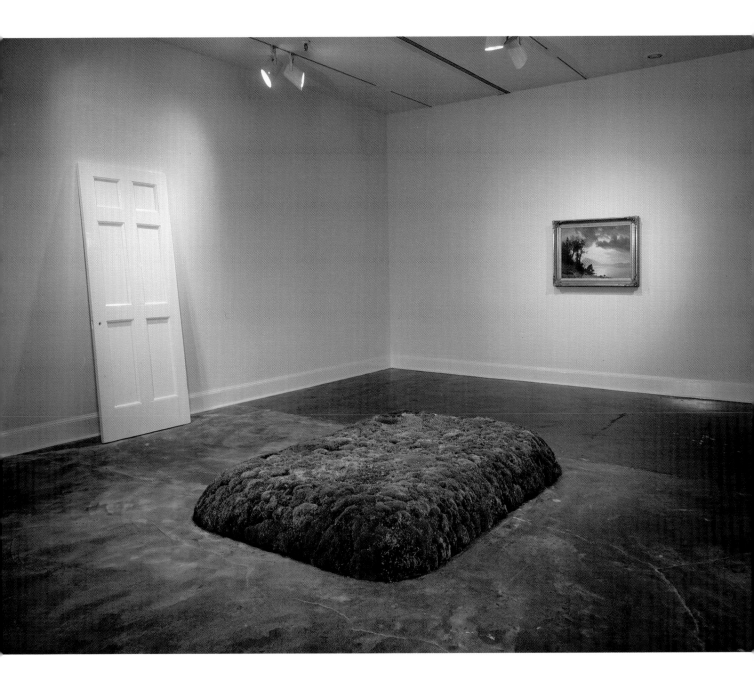

Utopia Post Utopia, *1988.*
Installation view, Institute
of Contemporary Art,
Boston. Gober developed the
overall concept and
architecture; the moss
mound is by Meg Webster,
the painting by Albert
Bierstadt. (not in exhibition)

Gober's sink, dismembered and missing its intestinal plumbing and hole, could never contain or swallow the waste a typical sink would. Not equal, it is equivocal, ambiguous, susceptible. What is a sink anyway . . . Duchamp's dandy subversion, a baptismal font where a child is spiritually dedicated (before sinking into sin?) or a place for dirty dishes, guilty hands, to be cleansed? Gober's work always seems to question how to locate or identify corresponding value and significance.

Gober's affection for repetition, seriality, and construction materials (such as plaster and lath) are reminiscent of the strategies of Minimalism. Yet his application of those methods leads to a different conclusion than it did for an artist like Donald Judd. Reacting against the Abstract Expressionist focus on the artist's angst and dramatic gesture, Judd turned to the utopian notions of Russian Constructivism outlined by such artists as Vladimir Tatlin, who attempted to merge art and industrial production. Judd wanted to concentrate the viewer's attention on the facticity of the object. The viewer, rather than the object, became the subject of the experience. Gober wants both possibilities to inform his work: his sculptures clearly are personal, if reticent declarations that speak to the self-consciousness of the viewer. By re-examining and elaborating on everyday objects, he encourages associative readings, narrative. The facts of life are central to his concerns. Gober speaks of appreciating the moral investigations undertaken by Barbara Kruger and Sherrie Levine, whose art made visible their skepticism about the myths of white male superiority and the systems that keep those myths intact. In linking, perhaps unconsciously, his work to theirs, he surreptitiously upends womanly crafts such as interior decoration, upholstery, and cooking in order to understand the feminine side of masculinity.

As the culture learns to respond to the AIDS pandemic, his sculptures in some respects work to mobilize the viewer, to construct consciousness not so much around perception or optical glory but around fragmentary stories of loving and dying and waste. Gober's work suggests that, while this is a time of anxiety—a doubting period in which one's faith in originality and authenticity is tested—this is not the time to abolish the hand. Instead, this is the moment to reintroduce the intimacy and directness that accompany touch.

Note

1. Robert Gober, "Cumulus from America," *Parkett* 19 (March 1989): 171.

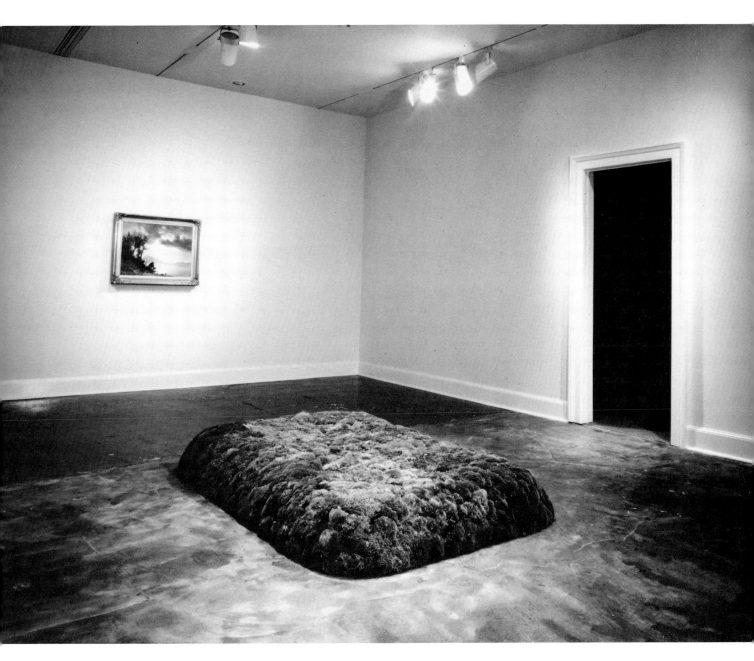

Robert Gober.
Utopia Post Utopia, *1988.*
Installation view, Institute
of Contemporary Art,
Boston. Gober developed the
overall concept and
architecture; the moss
mound is by Meg Webster,
the painting by Albert
Bierstadt. (not in
exhibition)

Robert Gober.
Three Urinals, *1988.*
Wood, wire lath, plaster,
enamel paint; three pieces,
each 21¾ x 15¼ x 15
(55.2 x 38.7 x 38.1).
Private collection. (not in
exhibition)

Robert Gober.
The Ascending Sink, *1985.*
Plaster, wood, wire lath,
steel, semi-gloss enamel
paint; two pieces, each 30 x
33 x 27 (76.2 x 83.8 x
68.6). Private collection.
(not in exhibition)

Robert Gober.
Untitled, *1988. Rattan,*
flannel, fabric paint,
enamel; 19 x 38 x 29 (22.9
x 96.5 x 73.7). Private
collection. (not in
exhibition)

Jenny Holzer

Language is legislation, speech is its code. . . .
To utter a discourse is not, as is too often
repeated, to communicate; it is to subjugate. . . .
Language—the performance of a language
system—is neither reactionary nor progressive;
it is quite simply fascist.[1]
Roland Barthes

Jenny Holzer's art is site-specific, an impassioned yet coolly conceived investigation of the intersection of public and private in the age of Big Brother electronics, congressional attacks on freedom of speech, and a fading federal social conscience. She says her subject is "love, sex, and death within the socio-political sphere."[2] For an artist whose devotion to the vernacular has been linked to a particularly American faith in democracy, the assumptions of meaning through which language operates must be resisted in order to be renewed. Contradiction is liberating.

Despite an early attraction to the sublimity achieved in paintings by Mark Rothko and Morris Louis, Holzer, fearing second-hand divinity, abandoned painting after graduate school. Instead she began to manipulate language and the authorial voice, subtly adjusting the nonverbal components of vehicle, type, and format to suit the content of the texts she wrote and the context in which they appeared. Her first texts, a series titled "Truisms," surfaced in 1977 in the form of terse pronouncements, adapted from readings provided by the Whitney Museum's Independent Study Program, which Holzer attended. While she shares with earlier language-in-art practitioners such as Joseph Kosuth and Lawrence Weiner an interest in ideas and in how language works as a representational system, Holzer is not interested in commenting on the conditions of art as much as on the state. In place of esoteric analysis appealing only to the cognoscenti, she seeks the textual explicitness, directness of approach, and diversity of audience similar to that of Bruce Nauman.

Typed, then offset as signatureless posters to be slapped up alongside advertisements and graffiti on New York City walls, the cheaply produced, underground format suited perfectly the alternative information provided by such newly minted truisms as "Murder has its sexual side" or "Abuse of power should come as no surprise." The T-shirts and hats printed with similar slogans provide a mobile and functional format, borrowed from the advertising industry, which in the 1980s hawked clothing with corporate logos as a method of selling everything from beer to tractors. With the "Living" series ("It takes awhile before you can step over inert bodies and go ahead with what you were wanting to do"), Holzer began in 1980 to ask permission to site her work in public spaces such as corporate lobbies. The bronze plaques (modeled after the discretely ostentatious, purportedly old-world signs posted outside offices on New York's Upper East side) she used as the ground for her texts reflect the change in process and tone. In *Under a Rock,* a 1986 installation that Holzer calls her "chapel of doom" and that some see as commenting on the government's refusal to inform the public about or forcefully acknowledge the issues surrounding AIDS, she used the commercial LED (light emitting diode) sign and stone benches incised, with a poetry rancorous and mournful, in the script found on government memorials. The seamless speed of the computer-driven display, which flows relentlessly, suggests the loss of memory, if not the impossibility of holding onto meaning in an age of complex, competing, and contradictory information based on the microchip's capacity to store vast amounts of data. The material, functionality, and weight of the benches, however, imply the opposite: the organic, comforting, and permanent. Similarly, the Times Roman typeface she often favors is the typeface used by the *New York Times,* which on its front page states, anonymously and in quotes, "All the News That's Fit to Print."

As a child Holzer drew continuously, focusing on "big moments in history"[3] such as the inhabitation of Noah's ark and the making of the Model T. Her interest in the possibilities of communal action remains. As a member of the artists' group Collaborative Projects, Holzer was involved in organizing the 1980 "Times Square Show," which offered any artist who wished an opportunity to create an installation in an abandoned building in the center of New York's entertainment district, known for big movie houses and prostitu-

Selections from THE
SURVIVAL SERIES,
*1987. Electric LED sign.
Installation at Candlestick
Park, San Francisco,
sponsored by Artspace, San
Francisco. (not in
exhibition)*

tion. Abandoning polite venues for viewing art, the group also agreed upon an administrative structure that obviated the need for curatorial authority. Not surprisingly, many of the installations were polemical, addressing the environmental or political issues surrounding the site.

One of Holzer's best-known public works, produced during the 1984 presidential election, was *Sign on a Truck,* a collaboration with Keith Haring, the graffiti artist who left the streets and subways, began showing in galleries, and in 1986 opened the Pop Shop, which sells his wares. A monumental electronic screen, the kind usually found at rock concerts, sporting events, and conventions, was positioned so tapes by twenty-one artists could be aired in highly visible, urban arenas, here and abroad. Passersby also were invited to talk about the candidates while seeing themselves larger than life on the television screen. It was art as soapbox or a fulfillment of the fantasy of celebrity. The man on the street was, for a moment, as captivating and powerful as any politician.

Holzer considers all truth arbitrary. Her "Truisms" sound obvious and correct, but, in fact, the reader's own experience covertly invests the work with particular value judgments. The author purposefully provides multiple perspectives. Individual sentences are suspect, the circular and collective sense of the series central. Often, like poetry, the lines work as couplets, partners in meaning. Certainty, the confidant and dangerous inflection of all authoritarian speech, is the enemy. Yet the poignant ambiguity of 200 sentences competing for dominance was overlooked when her first public commission—a set of double-sided "Truisms" posters facing in and out of the lobby window of the Wall Street branch of the Marine Midland Bank—was removed quickly. Some bankers could not stomach "It's not good to operate on credit" although "A lot of professionals are crackpots" apparently rang true enough. Holzer links public wrangling over, for example, nuclear weapons, with personal struggles such as those surrounding the fear of intimacy and death. Is it not predictable that, while financial practices provided the context for censorship early in the decade, sexual commerce, particu-

larly relating to images of the male, furnished the frame for members of Congress to attack artists and institutions late in the decade? Power—sexual or monetary or political—often is insecure, and those who possess it in need of assurances and truth with a capital "T."

Holzer has approached feminist politics as those systems relate to the issues of control, authority, and subjugation. She often has been classified—some would say dismissed—as a woman artist along with others who have adopted what Holzer calls "real-world subject matter" and "peripheral or media-related media."[4] Holzer has moved out from the early feminists' introspective preoccupation with the body into the world of signs and systems. Holzer's voice was often androgynous, a pose paralleling her disdain of authorship, which she thinks "blows your cover."[5] Yet, while her early aphorisms suggested the work of a populist Samuel Beckett, bleak yet streaked with black humor, Holzer's recent tone is increasingly urgent, as intensely colored and agitated as the digitized type of the LED. Her exploration of the power and pervasiveness of the media—of the anonymous voice in the public space that, like the television voice-over, says in subversively paternalistic tones "Do this" or "Hear this" or "Buy this"—has lead her to a more complex understanding of the controlling methods, distortions, and abuses imbedded in the text. It is as if she can no longer afford to stand behind the voices, behind the seductively minimal boxes housing the mechanical memory that powers her text, but must come forward, before expression is prohibited and imagination censored.

Notes

1. Roland Barthes, "Lectures in Inauguration of the Chair of Literary Semiology, Collège de France, January 7, 1977," *October* 8 (Spring 1979): 5.

2. Jenny Holzer, quoted in Abigail R. Esman, "Jenny Holzer," interview, *New Art International* 2 (February - March 1988): 52.

3. Holzer, quoted in Bruce Ferguson, "Wordsmith: An Interview with Jenny Holzer," in *Jenny Holzer: Signs,* exhibition catalog (Des Moines: Des Moines Art Center, 1986), p. 65.

4. Holzer, in Esman, "Jenny Holzer," 51.

5. Holzer, in Ferguson, "Wordsmith," 71.

Jenny Holzer.
Selections from
TRUISMS, *1982. T-shirt
worn by John Ahearn, New
York. (not in exhibition)*

Jenny Holzer.
Sign on a Truck, *1984.
Electric LED sign. A
collaboration with Keith
Haring in which artists
donated material to be
shown on a large screen.
Artist Vito Acconci's tape is
on the screen in this
photograph. Project
sponsored by the Public Art
Fund, Inc., New York. (not
in exhibition)*

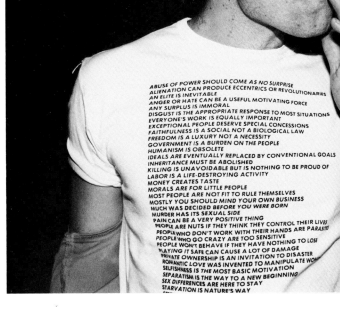

Jenny Holzer.
Selections from TRUISMS
("ABUSE OF POWER
COMES . . ."), *1987.*
Danby royal marble; 17 x
54 x 25 (43.2 x 137.2 x
63.5). Edition 2 of 3.
Private collection, courtesy
Thea Westreich Associates,
New York.

Jenny Holzer.
LAMENTS, *1989.*
Thirteen sarcophagi and
electric LED signs.
Installation at Dia Art
Foundation, New York. (not
in exhibition)

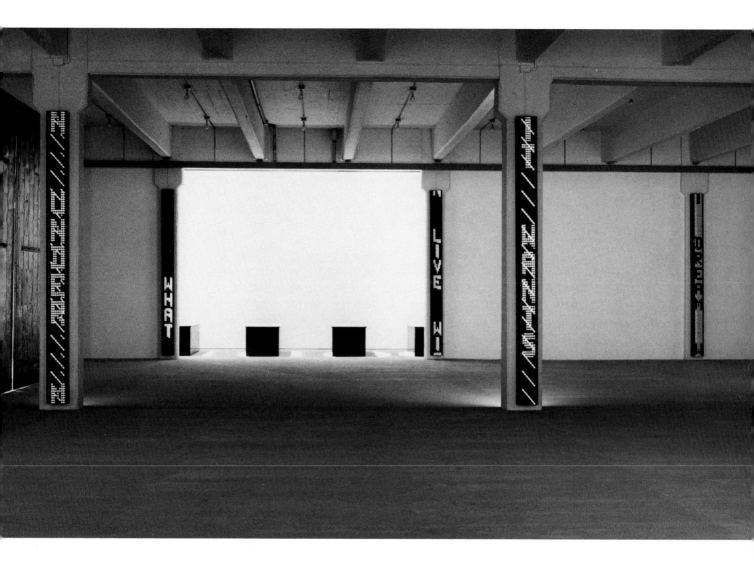

Jeff Koons

If art is not directed toward the social, it becomes purely self-indulgent, like sex without love.[1]
Jeff Koons

We worry that our affection for the familiar will expose a lack of sophistication and undercut our superiority. We value the original because it makes us feel special. Yet we are addicted to the rerun, redone. Jeff Koons confuses, willfully distorting the definitions that make us secure by holding a fun-house mirror up to the philosophical, economic, and biological systems by which we define security. His is a punning, adrenalin-laced presentation that tests for leaks along the shared edge of extremes . . . between the picturesque and sublime, dead and immortal, poised and unbalanced, mass-produced and carefully crafted, pristine and dirty, innocent and perverse, desired and digested, gendered and androgynous—between criticism and collusion. Something of a magician, he always has some trick up his sleeve. Unlike the skilled technician, however, who pretends to saw a seductive maiden in half and then restores her, whether Koons can or even wants to fit all the pieces back together is questionable. Perhaps this loss of a sense of unity is the true victim of the death of Modernism.

His meaning, like his cropping, is emotionally and psychologically charged. The twin basketballs sealed in an equilibrium tank balance like mutant embryos in an other-worldly condition that, given what we have learned about technology during the 1980s, is a fragile culture. When functioning, vacuum cleaners suck in dirt, a boon to anyone who has to clean. Koons sanitizes those machines by putting brand new specimens in Judd-like vitrines, thereby embalming the Minimalist's romance with industrial materials, methods, and products along with the belief that technology is liberating. His recent cartoonish characters, many gilded or glazed with cinematic color, point to a Disney world any child would sense was titillating and out of balance.

Koons challenges the simple, romantic notion of the artist (inevitably, the mythic cast is male) who is poor most of his life because his work is too difficult to be understood by more than a few cognoscenti. Like the white porcelain icon he has made of the world's highest paid entertainer, Michael Jackson, Koons has turned himself into something else, and that something is something of a fiction. Prepared by pop star David Bowie's hairstylist and photographed by the same commercial photographer who produces Jackson's album covers, Koons as seen in 1988 in the posters advertising his three simultaneous exhibitions has the airbrushed unreality of a game show spokesmodel. Jackson is a self-made man who, in his poignant desire to acquire the characteristics of a corrupt vision of white perfection, assumes the fairy tale characteristics of an eternally youthful, chimpanzee-cuddling princess. (Here the taboos multiply. Blacks often are villously referred to as apes, suggesting that they are not quite human. Jackson could be hugging himself or playing both the servant and the served in Edouard Manet's *Olympia*, 1863. The animal closest to us in the evolutionary chain is a more real, less modified version of ourselves.) Like Jackson, Koons only resembles his original self.

As much as any of the objects Koons produced in triplicate for those 1988 exhibitions, he is the art. His reproduced surface is as unblemished and brittlely beautiful as the porcelain sculptures artisans make to his specifications. Auditioned like chorus-line kickers to find those with the greatest virtuosity, the craftspeople become an element in Koons's three-dimensional assemblages. The artisans are found, like Marcel Duchamp's readymades, to make Koons's inventions something more than a concept. The fabricator's almost anonymous hand and signature joins with that of the creator in Koons's collage of images lifted from sources as diverse as biblical tales, soft porn, movie magazines, and his own imaginings. He infuses the craft with content while confusing its decorative and social function. The most guileless image can become threatening, corrupted by a shift in context, size, or material. In *Rabbit,* 1985, Koons turns a child's mass-produced inflatable plastic animal into a tough and reflective sculpture—a fertile but lifeless sex toy, a dead rather than simply dumb bunny. Yet the viewer, not the artist, projects new meaning on those objects. While

Bear and Policeman, 1988. Polychromed wood; 85 x 43 x 36 (215.9 x 109.2 x 91.4). Courtesy Sonnabend Gallery, New York.

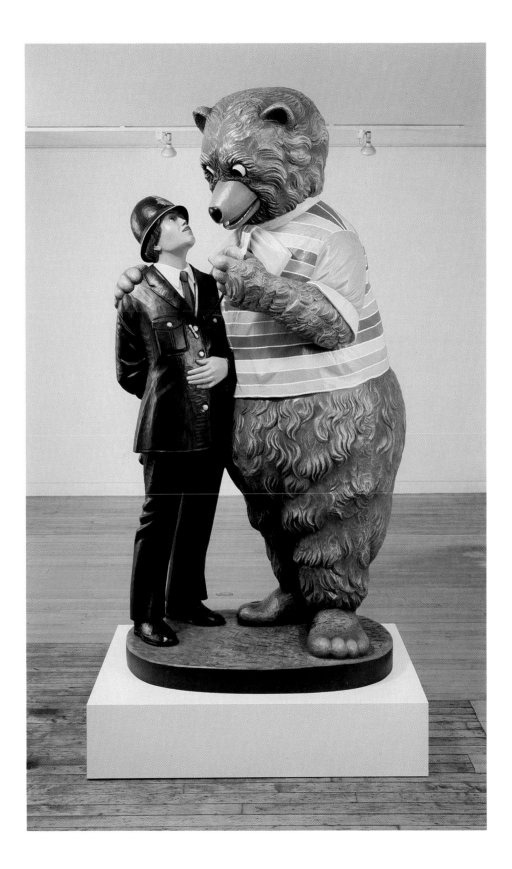

Koons claims the works are about "all the souls betrayed by capitalism,"[2] his method may be as ambiguous as the message.

In a sense his works are capitalist relics, personal memorials to what remains of a system that, through the prophets of advertising, promotes a ravenous desire for more desire. Desire, like the search for perfection, must remain unrequited, poignant. By playing on our own needs to be more (sexy, alike, connected, powerful, rich), each group and class can be sold, in its own language, the useless and the poisonous, as suggested in Koons's series of alcohol-related works (*Jim Beam J. B. Turner Train*, 1986) contained in a 1986 exhibition titled "Luxury and Degradation." It is interesting to note that in the late 1980s African-American parents began to demand that liquor companies stop billboard advertising, which promised a life of charm, ease, and glamor, in impoverished communities where alcohol addiction was a serious problem.

Koons seems to take an almost childish pleasure in purloining and purveying his goods. He plays with the powerful pull of the mass media, with the anxious consumer, and with the desire for newness as if all were plastic materials. His fetish for finish gives the banal an exquisite appearance, making the ordinary, elevated by such refinement, a sure sign of decadence. There's something both sly and infantile about this reverse alchemy, this flip-flopping of dross and gold, of the pliant suggestiveness of rubber and the hard gleam of proletarian stainless, of the anonymous kitsch trinket and ego-organized art object. In exposing the link of art, ownership, and high finance, Koons (a former commodities trader) brings back-room whispers into everyday speech. Investment is not a subtext, and, despite what they remind us of, Koons's sculptures are not intended to sit quietly on the mantle. They speak back, sometimes mockingly, and their physical voluptuousness is hard to accept in these increasingly puritanical times. The surface that both entices and repels barely masks latent sexual issues, some taboo: delight in masturbation, virginity wasted, bestiality, the rumored physical superiority of African-American men, cock-teasing. The Freudian link between work and sex is appropriated, twisted, and rendered dysfunctional except in fantasy. This, after all, is art for a generation not raised on television as much as on a critical understanding of how the media works. In this age workaholics prize inanimate possessions, perhaps because possessing another is risky, both politically and physically. Koons's work points out "the tragedy of unachievable states of being."[3] The bronze life jacket, Aqua Lung, and lifeboat from 1985 suggest an equilibrium lost, a Darwinian place where there is room only for one, a condition in which its hard to catch your breath.

Notes

1. Jeff Koons, quoted in Giancarlo Politi, "Luxury and Desire: An Interview with Jeff Koons," *Flash Art* 132 (February - March 1987): 72.

2. Koons, quoted in Miriam Horn, "The Avant-garde: Moving into Middle America," *U.S. News & World Report* (May 1987): 60.

3. Koons, in Politi, "Luxury and Desire," 75.

Jeff Koons.
New Shelton Wet/Dry
5-Gallon, New Hoover
Convertible Doubledecker,
1981–87. Vacuum cleaners,
plexi glass, fluorescent tubes;
99 x 28 x 28 (251.5 x 71.1
x 71.1). Elaine and Werner
Dannheisser, New York.

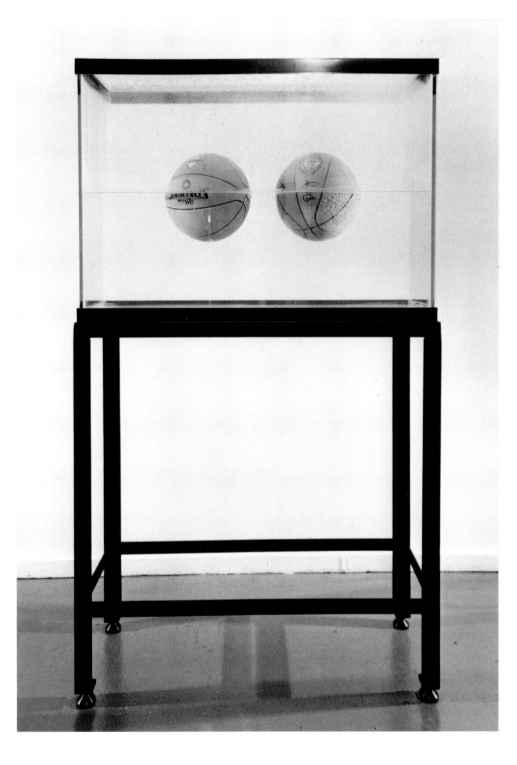

Jeff Koons.
Two Balls 50/50 Tank, *1985. Basketballs, glass, iron, water; 62¾ x 36¾ x 14¼ (159.4 x 93.3 x 33.7). Susan and Lewis Manilow, Chicago.*

Jeff Koons.
Jim Beam J. B. Turner
Train, *1986. Cast stainless
steel; 9¾ x 116 x 6¾ (24.8
x 294.6 x 17.1). Saatchi
Collection, London.*

Jeff Koons.
Kiepenkerl, *1987. Stainless
steel. Kiepenkerl, a bronze
outdoor sculpture of a
country peddler, symbolized
the self-sufficiency of the
people of Münster, West
Germany. The much-loved
sculpture, and much of the
town, was destroyed during
World War II but re-created
in the 1950s. This version
by Koons was cast in stainless
steel from the original mold,
making the statue a symbol
of false luxury and the new
materialistic needs of the
masses. (not in exhibition)*

Sherrie Levine

The world is filled to suffocating. Man has placed his token on every stone. Every word, every image, is leased and mortgaged. We know that a picture is but a space in which a variety of images, none of them original, blend and clash. A picture is a tissue of quotations drawn from the innumerable centers of culture. Similar to those eternal copyists Bouvard and Pechuchet, we indicate the profound ridiculousness that is precisely the truth of painting. We can only imitate a gesture that is always anterior, never original. Succeeding the painter, the plagiarist no longer bears within him passions, humours, feelings, impressions, but rather this immense encyclopedia from which he draws. The viewer is the tablet on which all the quotations that make up a painting are inscribed without any of them being lost. A painting's meaning lies not in its origin, but in its destination. The birth of the viewer must be at the cost of the painter.[1]
Sherrie Levine

We live in an age of reproduction and replay. Leonardo's *Mona Lisa,* 1503–06, appears on T-shirts, operatic audio tracks sell detergent, and public personalities are murdered by fans whose affection for the celluloid image cannot be satisfied. In the early 1960s such artists as Jasper Johns, Sigmar Polke, Robert Rauschenberg, Gerhard Richter, and Andy Warhol adapted to the bombardment of information characteristic of the electronic age by using images drawn from both high art and popular culture, mixing them without regard to the hierarchy of historical notions of value. In the late 1970s, so-called Pictures artists such as Sherrie Levine questioned the importance of originality, challenging the idea that progress was a linear evolution and that an artist's career should be spent refining a signature style. Working in series those artists moved from one investigation to another, with content mandating changes in style. A self-consciousness emerged about the way in which the history of art has been charted, the gender of those included, and the descriptive secondary sources through which the experience of looking at art often is conveyed. Influences were publicly examined. Traditional media such as painting, the handling of which could be viewed as the equivalent of a personal stylistic fingerprint, were abandoned for

cooler, more anonymous, and apparently less expressionist instruments such as video and photography. Photography involved reproducing images, repeating things rather than making them unique. It was also the dominant medium of the mass media. By absorbing the manipulative tools the media used to construct desire and promote constant change, artists began to examine the societal implications of representation.

Sherrie Levine's *"Untitled" (Ignatz: 1),* 1988, *"Untitled" (Krazy Kat: 1),* 1988, and *"Untitled" (Mr. Austridge: 6),* 1989, are enlarged sections of protagonists pictured in "Krazy Kat," the daily comic strip by George Herriman, a mulatto who found inspiration among the Navajos and drove a Ford because he respected Henry's pacifism, syndicated from 1913 to 1944 in Hearst newspapers. William Randolph Hearst's newspapers provided a curious frame for that inspired, humane comic who commented wryly and ruefully on the frustrations of everyday life as well as on such political realities as the demise of the environment. The term "yellow journalism," which was first applied to the sensationalism of Hearst's methods, came from Herriman's strip "The Yellow Kid." An innovator, Herriman helped define the intricate ways in which text, image, and pictorial space could be combined to create a world vision that writer Jack Kerouac suggested spoke of the "glee of America, the honesty of America, its wild self-believing individuality,"[2] qualities we cannot quite imagine today.

"Krazy Kat" was read avidly by such artists as Pablo Picasso and Willem de Kooning, both of whom became known for their charged depictions of the female form. The comic strip portrays an unrequited love affair between usual adversaries—a cat, a mouse, and a dog. Contemptuous of the passions of the androgynous Krazy, Ignatz, the married but emotionally uncommitted mouse, responds to his suitor's affection by flinging bricks, a complicated quill of passive-aggressive emotional arrows that further fuels the cat's passion. Because he is soft on Krazy, Offisa Pup tries to keep Ignatz in line. Half farce, half tragedy, the story speaks of the slapstick turn of modern life as well as of modern history. When Krazy asks his/her philosopher friend Mr. Bee if

"Untitled" (Mr. Austridge: 6), *1989. Casein on wood; 47½ x 27½ (120.6 x 69.8). Collection of the artist, courtesy Mary Boone Gallery, New York. The painting was installed on* Hanging Man/Sleeping Man, *1989, wallpaper designed by Robert Gober for the room the two artists created for this exhibition.*

what happened yesterday will happen again, that worker, one of a species genetically coded to thrive on the repetition of the assembly line required by a queenly mistress, responds, in a voice that predates that of the late Irish author Samuel Beckett, "It most certainly will Krazy. History, events, accidents, thoughts, jokes, you, I, anything and nothing each must repeat itself, everything is just nothing repeating itself—ashes to ashes is the best repeating act we do."[3] With its repeating grid, returning brick, and obsessive emotional reversals, the strip foreshadowed what was to come after World War II, in life and art.

As most often told, the history of art excludes the accomplishments of women. Generally, little thought has been given to the culturally bound criteria by which such judgments come to be made. The psyche of women has been cast in a supporting role, not serious enough to make art out of or even merit much attention. Like the crazy feline, pleased by even abusive attention, women artists have functioned on the fringe, as outsiders. In order to penetrate the male point of view—to critique generations of masterpieces by men and understand the loneliness of the female perspective—Levine has spent a decade redoing the art of Modernism. In 1981 she began appropriating or reproducing in part some of Walker Evans's exacting photographic portraits of a persevering Southern tenant farm family, a documentary project supported by the Farm Security Administration, which followed soon after Evans's Depression era collaboration with the writer James Agee on the book *Let Us Now Praise Famous Men*. From a well-to-do family, Evans sought to picture poverty and the collapse of the marketplace. He captured the painful distinctions between the American dream and its reality, and he did so with a puritanical streak, not unlike Levine's own unyielding sense of right, which belied both his privileged upbringing and his belief in the dignity of the simple, unvarnished truth. Because he sought to eliminate sentimentality from his posed portraits and fill his frame with those vital patterns of vernacular signs less original artists expunged, he has been called by the critic Andy Grundberg "the first photographer to make photography a critical activity."[4] His photographs of a photographer's storefront, peeling movie

posters advertising "Love Before Breakfast," and the migratory poor whose tarnished self-image mirrored their inability to support themselves were difficult documents of the story that lay behind the image manufactured in America.

Levine often seems to hide her feelings, pushing the brittle beauty of her conceptual strategy to the surface. Given how the mass media teaches that men dominate through the power of their thought while women seduce through the artifice of their bodies, it is not surprising that a woman artist would elect to pose as a man in order to allow her work to be viewed as critical to the discourse and not simply decorative, although Levine purposefully bends that term to her own formal needs. Levine's work, however, is full of emotional clues. It shies away from heroic scale; it is made of opposing materials such as plywood and gold or lead, which is poisonous to touch, testing our desire to possess; it reflects a delicate, curiously tentative hand, which suggests an attempt to look again at something painful or taboo; it flirts with a humor reminiscent of the self-aware, critical, and bittersweet yearning of Charlie Chaplin. As a material, plywood is both quotidian and itself a representation, a picture cropped from a whole landscape. The grain of plywood recalls the graininess of a photograph made from another print rather than an original negative. Full of puns and associations, knot paintings turn a contractor's material into the scene of a drama between the sexes. By covering with gold the artificial tear-shaped plugs that fill the random weaknesses or imperfections found in plywood, Levine purifies—sees through and forgives—what simultaneously fills and sullies. By placing those paintings in box-like frames complete with glass covers, Levine treats them as specimens, removing them from the world of real time and touch, returning them to contemplative objects. Occasionally, your image reflected in the glass interrupts your thought, returning you to the social area.

Levine's real achievement is the fusion of thought and feeling, the covert disavowal of the pernicious dialectic of reason and emotion. Her conceptual maneuvering helps her locate and embody the psychological content that has most

Sherrie Levine.
"Untitled" (Ignatz: 1),
*1988. Casein on wood; 24 x
20 (61.0 x 50.8). Courtesy
Mary Boone Gallery, New
York. (not in exhibition)*

meaning to her. Levine's personal drama as well as that expressed in her art is to learn how not to repress a keen sense of right and wrong—a championing of and care for the underdog—at a time when doubt and ambivalence can paralyze. Ignatz, unable to love what he is not, runs from what makes him feel the most. Levine does not flee, however, and a melancholy plaint runs through the work. You try, you are disappointed, and again the question surfaces: how many times do you repeat your actions, reproduce your faith?

Notes

1. Sherrie Levine, quoted in *Implosion: A Postmodern Perspective,* exhibition catalog (Stockholm: Moderna Museet, 1987), p. 84.

2. Jack Kerouac, quoted in Patrick McDonnell, Karen O'Connell, and Georgia Riley de Havenon, *Krazy Kat: The Comic Art of George Herriman* (New York: Harry N. Abrams, 1986), p. 26.

3. George Herriman, quoted in McDonnell, O'Connell, and de Havenon, *Krazy Kat,* p. 27.

4. Andy Grundberg, "An Evans Show, Fifty Years Later," *New York Times,* February 19, 1989, sec. C, p. 19.

Sherrie Levine.
"Untitled" (Krazy Kat: 1),
*1988. Casein on wood; 18
x 15½ (45.7 x 39.4).
Emily Landau, New York,
courtesy Mary Boone
Gallery, New York. (not in
exhibition)*

Sherrie Levine.
"Untitled" (Golden Knots: 11), *1985. Oil on wood; 20 x 16 (50.8 x 40.6). Alain Clairet, New York, courtesy Mary Boone Gallery, New York. (not in exhibition)*

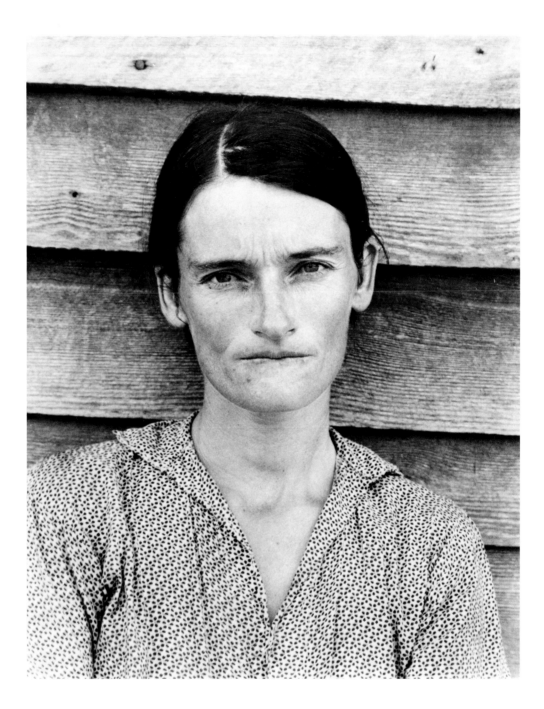

Sherrie Levine.
"Untitled" (After Walker
Evans: 3), *1981.
Photograph; 10 x 8 (25.4
x 20.3). The Menil
Collection, Houston,
courtesy Mary Boone
Gallery, New York. (not in
exhibition)*

Yasumasa Morimura

Always there has been a necessity for circles in my life, for, how do you say, rotation. It is a kind of narcissism, this self-sufficiency, a kind of onanism.[1]
Marcel Duchamp

When one tradition influences another, the word adulterate often is used to describe that culture that has absorbed new practices by subordinating old ones. There is, of course, the dangerously tantalizing suggestion that cultural purity does exist. Yet, clearly the history of early Modernism reflects the absorption of Eastern motifs and spatial constructions. Artists move forward by building on the lessons of history, often not acknowledging the source of their imagery and technique. Japanese artists today are beginning to examine the promise of cross-cultural appropriation as well as the implications of a kind of cultural imperialism that promotes occidental ways and goods as the best, including the surgical alteration of Asian facial characteristics.

Yasumasa Morimura circles back to the French history of art he came to know through rumor and reproduction. It is a history of painted masterpieces that, while revered in Japan, is essentially foreign to a culture whose artists, often referred to as "national treasures," still produce such functional objects as ceramics, textiles, and swords. Although a Western-style of Japanese oil painting exists that reflects the training received by Japanese painters who traveled to Paris in the late nineteenth and early twentieth century, few examples of original work by the artists Morimura has focused on (Marcel Duchamp, J. A. D. Ingres, Edouard Manet, Vincent Van Gogh) can be seen in Japanese museums. However, after Van Gogh's *Sunflowers*, 1888, was purchased by a Japanese insurance company for nearly $40 million in April 1987, the streets of Tokyo soon were filled with people carrying shopping bags or wearing clothing printed with the floral motif. Given that Japanese department stores often support major exhibitions and publication programs within their walls, this further commodification of an already high-priced commodity is perhaps no accident.

Morimura chose to spend a recent visit to Paris observing life on the boulevards rather than visiting the paintings by Manet that he has remade. Given Morimura's interest in Duchamp, the Frenchman most responsible for bringing the discourse of art into the light of life, it should be no surprise that the texture of the real world proved more compelling than pictures of the old. Like Morimura, Duchamp was attempting to change artistic identities—to challenge good taste, the sanctity of the object (particularly painting), and the handmade. In *Doublonnage (Marcel)*, 1988, Morimura has photographed himself as Duchamp was portrayed in May Ray's famous photograph from c. 1921: dressed as his female alter ego, Rrose Sélavy, a pun on the phrase *eros c'est la vie*. Duchamp first assumed the name and costume in 1920 as work on *The Large Glass*, 1915-23, dragged on. Perhaps he was attracted to the image of the artist as a creative androgyne. Like Morimura's restaging of Manet's *Olympia*, 1863, the irony of a man slipping into a woman's world is not tortured or coy. By adopting a new identity and gender—and, in Morimura's case, race because he assumes the role of the brazen young woman of leisure as well as that of her black maid—both artists gain a useful detachment from themselves and what they have created. Duchamp considered eroticism the fourth dimension, and many of his sculptures deal with the problems of accessing desire through vision. The sculpture *Fresh Widow*, 1920, which Morimura has remade and photographed, was registered for a copyright by Rrose Sélavy. While the title plays with the possibility of a naughty (or dirty) new widow, the sculpture is a window with black leather panes that the artist required be polished—caressed—daily to reflect like glass. The vision of the widow—the object of desire—was repressed. Duchamp could peep only through his own imaginings. But for a moment he managed to cast into doubt the moral valorizing of art as a practice and a product. His twin passions—the elevation of eroticism and the demise of the art commodity—suggest one of the critic T. J. Clarke's passages on *Olympia*.

Prostitution is a sensitive subject for bourgeois society because sexuality and money are mixed up in it. There are obstacles in the way of representing either, and when the two intersect there is an

Doublonnage (Marcel), 1988. Type C print; 59¹/₁₆ x 47¼ (150.0 x 120.0). Collection of the artist.

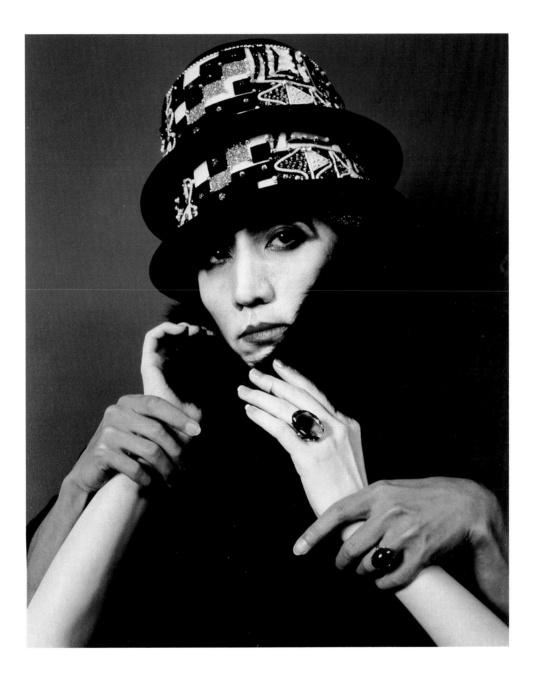

uneasy feeling that something in the nature of capitalism is at stake, or at least not properly hidden. . . . It is specifically a case of bodies turning into what they usually are not, namely money.[2]

Morimura believes the function of art is to help the artist speak out, something Japanese men normally do only after drinking. The history of art functions as a purdah, behind which the artist can act out his desires, sequestered from those who might judge his dressing up least kindly. Japanese society still is rigidly disciplined on the surface, and, as the spate of recent governmental sex scandals suggests, violence against women occurs behind closed doors. Women are just now beginning to talk back.

While the tradition of *onnagata* in Kabuki theater has made female impersonation into a respected and highly stylized art, Morimura crosses over into unconventional areas, blurring disciplines and identities. He holds little sacred, allowing the distinctions between such media as photography and sculpture to collapse along with the traditional differentiation between male and female. He fights off any characterization, denying the stability of genres, genders, and genes in order to uncover a definition of beauty and perfection that he thinks is appropriate to the information age. The artist, Morimura believes, must recognize the impossibility of proscribing postmodern identity with a single picture of self. He believes the simultaneity of information blurs black and white distinctions, allowing one's sexuality to become more ambiguous. Preferring to be called "artist" rather than "sculptor," "painter," or "photographer," Morimura considers his real work an experimental, highly artificial performance in which he assumes at different times all the roles: director, actor, designer, and producer. He performs for the objective lens of a camera. Like Olympia, he is without guile or shame, staring directly at the viewer, deflecting prurient gazes. The resulting photographs, which he reassembles and overpaints in parts, turning a photograph of a meticulously constructed tableaux representing a famous painting back into a painting, are akin to medical records that chart experimental operations in which a foreign limb is grafted onto a new

host. He dissects history, noting that Ingres painted his famous image of a nymph, that symbol of youthful grace and feminine beauty, from a photograph and that his own rendition restores her to her original condition before turning her again to a painting.

The circle mesmerizes. Morimura has returned several times to *L'Apres-midi d'un faun*, the ballet Vaslav Nijinsky based on a poem by Stéphan Mallarmé (first illustrated by Manet in the style of Japanese woodcuts) in making his choreographic debut in 1912. In photographing himself as Nijinsky, the Russian faun dancing in France with a costume of grapes, Morimura has slipped under the painted skin of both the original artist and the character he represents. The photographs are not intended to document so much as startle, reflecting the intentions of the choreographer. Nijinsky's interpretation is based on a sense of the poem, as he said his French was too poor to permit a reading of it. In fact, the ballet was attacked as lewd when Nijinsky, as the faun smitten by the sight of a disappearing nymph, falls upon her veil and appears to masturbate on stage. This sequence does not exist so explicitly in the poem and foreshadows Nijinsky's break with Impressionism and Symbolism. For a Japanese artist learning to live with both the refinement and craft of Kyoto and the bustle and neon of Tokyo and pursuing an understanding of how the West experienced the infiltration of Japanese art into the avant-garde, Mallarmé's poem is pertinent. The historian Jeffrey M. Perl has written:

Mallarmé's faun felt the 'pain of being two' and wanted to be one with a nymph. But the nymphs were in love with one another. Driven to philosophy, the faun wonders —his afternoon now past —if the nymphs existed. . . .The faun's doubt about his afternoon has become the real experience.[3]

Morimura has heightened the sense of artificiality (lighting, set, costume, gesture, make-up, and scale) in order to enable his audience to experience the love, dismay, and doubt of the faun. His many technicolor selves shed the mores of the past as a stripper would her layers. He informs through seduction, through coaxing the truth(s) out of history.

Notes

1. Marcel Duchamp, quoted in Francis Roberts, "I Propose to Strain the Laws of Physics," *Art News* 67 (December 1968): 63; reprinted in *Duchamp* (Barcelona: Fundación Caja de Pensiones, 1984), p. 227.

2. T. J. Clarke, in "Olympia's Choice," *The Painting of Modern Life: Paris in the Art of Manet and His Followers* (New York: Alfred A. Knopf, 1985), p. 102.

3. Jeffery M. Perl, quoted in Anna Kisselgoff, "Tracing the Echoes of Mallarmé's Enigmatic Faun," *New York Times*, April 9, 1989, sec. H, p. 7.

Yasumasa Morimura.
Doublonnage (Portrait C),
1988. Type C print;
47¼ x 47¼ (120.0 x
120.0). Collection of the
artist.

Yasumasa Morimura.
Doublonnage (Portrait D),
1988. Type C print;
47¼ x 47¼ (120.0 x
120.0). Collection of the
artist.

Yasumasa Morimura.
Portrait (La Source 3),
1986–89. Type C print;
94½ x 47¼ (240.0 x
120.0). Tetsutada Fukunishi,
Ehime, Japan.

Yasumasa Morimura.
Portrait (Twin), *1988.*
Photograph; 82⅝ x 118⅛
(210 x 300). Collection of
the artist. (not in exhibition)

Reinhard Mucha

*What Mucha has termed "setting the stage"
implies an attentiveness to the theatrical, to
questions concerning the actual site, linear time,
and the role of the spectator, as well as to the
cultural framework, which the paradigmatic
autonomous modernist sculpture seeks to
suppress or deny.[1]*
Lynne Cooke

Reinhard Mucha creates sculptures that resemble
things found in the world or, rather, in a child's
memory of an earlier world. When seen in the
rarified context of an exhibition, the ordinary
takes on a slightly skewed, ominous proportion.
Transformed into sculptural elements such func-
tional objects as chairs, ladders, light fixtures,
dollies, fans, and vitrines often are used as they
normally would be—to perch on, reach a height
beyond the body's stretch, illuminate, transport
heavy objects, move air, and contain. As the
transitive verbs suggest, motion, precariousness,
and breath suspended become subject matter. It
also helps to know that many of Mucha's sculp-
tures are named after train stations or construc-
tion signs, that schedules and maps inhabit the
studio not the usual reproductions of influential
works of art, and that an electric train, infant's
lamp, and toy piano figure in a number of sculp-
tures.

There is something poignant in this suggestion of
semblance and in the sense that the meaning as
well as the parts of a sculpture may migrate. For
example, in creating a new order, one in which
design does not dictate a chair's disposition,
Mucha first underscores, then deconstructs, and
finally sacrifices the quotidian character of his
materials. This occasional alienation of form
from function may account for both the melan-
choly and supernatural tenor of many of the
works. While the sculptures employ things used
by humans and relate directly to the body, the
industrial nature and tooled purity of many of the
materials disrupt that association. Consequently,
the sculptures metamorphose, like the characters
in stories by Franz Kafka from which Mucha
often quotes, into mechanical bodies, mutants
made up of neither anatomy nor technology,
neither past nor future.

The lapidary exquisiteness of the craft also takes
on an other-worldly demeanor. For example, *Der
Bau (The Building)*, 1984, a three-dimensional
representation of a tunnel passable by vision
only, required 60,000 screws. These connectors
were used to create a nonfunctioning structure
that represented the yearning to join two points.
Because the screws Mucha specified were no
longer being manufactured, the history of the
material and the artist's search for it became part
of the piece. Obsession leads to a kind of eroti-
cism in which the connection between things is
explored with great tenderness and fascination,
showing an almost maniacal need to reiterate—
to take apart, to reassemble, to understand again.

Mucha's work is intensely private, even evasive.
The narrative is in the details, but the whole is
surprisingly mute. Just as the artist controls how
his works are photographed and reproduced—
we come to know them through secondary expe-
riences such as exhibition catalogs, where sec-
tions, rarely the whole, appear photographed in
black and white—he controls how we approach
his works. We are meant to remain outside. What
is inside the steel, handmade frame, which is
often entombed inside a glass case, as in *Untitled
(Aprath, Glogau, Witten, Sagard, Lorsch)*, 1980, is
not knowable or graspable. In Mucha's most
recent installation, *Mutterseelenallein (Mother-
Souls-Alone)*, 1989, each of the photographs of
chairs (used as Mucha's wall label so explicitly
states "for guards or visitors" and "taken in the
annual survey show, the Great Düsseldorf Art
Exhibition at the Ehrenhof art building in Düssel-
dorf, December 31, 1979") is placed behind a
glass window embedded in a case made of steel
and wood. The chairs are sealed off from the
physical world of the viewer by both the enclos-
ing structure and the black and white of the
photograph. Consequently, we can only imagine
inhabiting such chairs, although our imagination
is conditioned by the memory of sitting. The gray
felt inside one of the windows could absorb the
sound of our breathing as it muffles the imagi-
nary music flowing from the gorgeously lac-
quered piano in Joseph Beuys's room installation
Plight. In order to sink even metaphorically into
Mucha's single bed of felt, we must penetrate the
glass. Although it is the most vulnerable of pro-

The Figure-Ground
Problem in Baroque
Architecture (For You
Alone Is Only the Grave),
1985. *Installation;
dimensions variable. Musée
National d'Art Moderne,
Centre Georges Pompidou,
Paris. (not in exhibition)*

tective membranes, glass is an obdurate surface to move beyond. Like a transparent mirror, glass draws the viewer into him- or herself. One catches a glimpse of oneself in the outer layer of glass before losing oneself in the several reflective surfaces embodied in one of the wall-mounted boxes. The reciprocity between viewer and viewed is a delicate seduction that continues without one ever dominating the other. Ruefully, Mucha seems to picture the impossibility of seeing or looking without the painful sensitivity that springs from self-consciousness.

The black, white, and gray of the steel, glass, and felt underscores the loss of color that accompanies the passage of time, the slippage in generation suggested by a newspaper photograph, and the desire to make something legible, clearly black and white, factual. This reliance on fluctuations of value, light to dark, reflects an interest in how things come to be esteemed, change value. Often this interest is linked to the exhibition materials used by and the works contained in museums. Works such as *Calor,* 1986, and *The Figure-Ground Problem in Baroque Architecture (For You Alone Is Only the Grave)*, 1985, and *Astron Tauras,* 1981, contain the temporary walls, vitrines, stanchions, dollies, video equipment, hydrometers, turning them into a single, ephemeral artwork. The journey connects the individual, the institution, and the audience—the spaces between the studio, the museum, and the viewer. The museum's covert methods of presentation and selection, which Mucha makes public, reflect the social, economic, and architectural frames of reference through which the viewer's understanding of such concepts as a particular object's quality, uniqueness, and importance is filtered. He wants us to question what is before us. What is this used for? (More than one function, perhaps.) Why is it here? (To help us see, feel, and understand, perhaps.) Is this a temporary and random collection of things? (Only as fleeting and accidental as daily life, perhaps.) Why am I asked to look at the appliances that separate, contain, rope off, and elevate what is valuable but not at the thing itself? (Without the neck, the head would lack support, perhaps.) Why are some things, such as the Astron Tauras fans, named? (The issue revolves around the distinc-

tion between the generic and the brand name or what is various and valued is named, perhaps.)

The ubiquitous elderberry tree pictured in a suite of Mucha's photographs, which he often displays in a vitrine or finely crafted box as a museum would a rare sculpture or set of prints, fascinates the artist because the tree is so common it normally goes unnoticed. Despite the functional attributes of its fruit, from which wine and medicine are made, the tree is virtually invisible except during the three weeks it is in bloom. By focusing on what is behind the scenes, whether nature's curious drama or that of a museum, Mucha enjoins us to cease traveling so fast that we miss the experience of moving between distinct points and mistakenly dismiss the familiar in our search for the mysterious or precious.

Note

1. Lynne Cooke, "Reinhard Mucha," *Artscribe* 62 (March-April 1987): 58.

Reinhard Mucha.
Lamp, *1981. Fluorescent*
lamp; 33 1/16 x 33 1/16 x 9 7/16
(84.0 x 84.0 x 24.0)
Private collection, Cologne.
(not in exhibition)

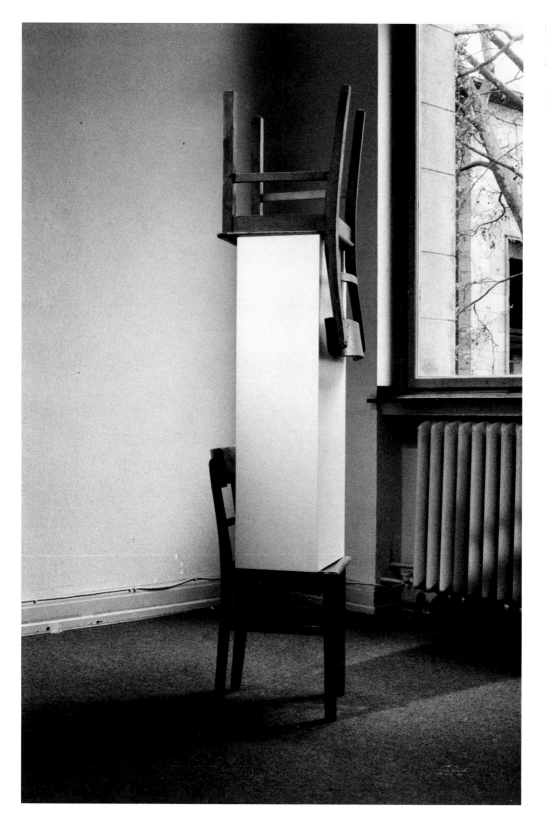

Reinhard Mucha.
T. D. C., *1982. Wood, varnish, paint; 78¾ x 19¹¹⁄₁₆ x 21⁵⁄₈ (200.0 x 50.0 x 55.0) Hans Böhning, Cologne. (not in exhibition)*

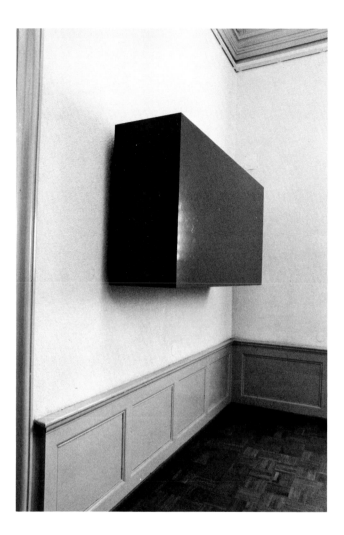
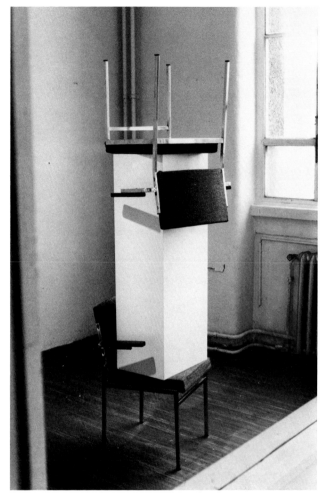

Reinhard Mucha.
Worringer Square, *1984.*
Wood, lacquer; 35⁷/₁₆ x 70⁷/₈ x 17
(90.0 x 180.0 x 43.2).
Albert Oehlen. (not in
exhibition)

Reinhard Mucha.
T. D. C., *1985. Courtesy*
Galerie Max Hetzler,
Cologne. (not in exhibition)

Julian Schnabel

All my paintings have a function, so they're real things in the way that primitive objects might have been real, usable or magical things to the Indians in Mexico.[1]
Julian Schnabel

With the onset of the conservative Reagan years, the American eye and marketplace for art shifted back to Europe after a postwar interim of nearly twenty-five years. Berlin's *Heftige Malerei* (violent painting) inundated the eastern shore of the United States. In an effort to create tidy international schools, some critics labeled Julian Schnabel's early paintings a Neo-expressionist venture. While Schnabel's appetite for approbation, brazen striving to reignite interest in painting and figurative imagery, aggressive paint handling, and heartbroken masochism reflected aspects of that brand of painting, his German mentor was Sigmar Polke, the pictorial chameleon, not K. H. Hödicke, the teacher of many of Berlin's exports. Schnabel's sense of the synthetic was more aligned with Dada and Marcel Duchamp than the purportedly unself-conscious outpourings of German Expressionism.

Yet Schnabel is intent on bringing the heroic back from the dead. He is not embarrassed to fill the air with Beethoven and huge lengths of velvet with the sensual, dramatic apparition of a diva such as Maria Callas. Sometimes the paintings reek of sentiment and the struggle to master the sublime. A less-confidant artist might not make public such crudely compelling, raw, and romantic pictures, but Schnabel is unafraid of faith in an era that mocks it, and he courts the archaic, willing to try to outfox nostalgia by mediating it. Still, when he is painting from life, his figures often are astonishingly clear and psychologically probing portraits: his wife, in *Jacqueline the Day after Her Wedding,* 1980, looking disheveled and resigned, her uncharacteristically large hands hanging heavily by her side and her body from mid-shoulder to mid-calf veiled with a light blue wash that matches figure to ground; or such literary legends as Malcolm Lowry, who wrote one great phantasmagoric novel before choking to death on alcohol-induced vomit, or Antonin Artaud, whose bad-boy antics and verbal assaults on society's norms took aesthetic form in his Theatre of Cruelty. Schnabel's phantom hero is hybrid, an illusion made of equal parts private yearning and opera-like artifice: the aristocratic, Fellini-like man with fleshy red lips posing in *La Spiaggia,* 1986, a New York dealer from Italy whose polka-dot, off-the-shoulder dress is outlined in white paint against the deepness of black velvet, or the prismatically painted and vulnerable Andy Warhol, who stands, wounded by a deranged woman, in a black field divided by a faint cross and dotted with an explosion of pale pink daubs. Or consider Jackson Pollock (so pained, perhaps, because he had to live with being the first postwar American painter to compete in stature with European modern masters), whose Jungian doodles and fertile, feverishly activated ground seem models. Like the protruding surface of his plate paintings, which defiantly derided in 1979 the Modernist's faith in the flatness of the picture plane, Schnabel's portraits of the 1980s can be ambiguous, abrasive, emotional, and sometimes violent. The images of people are broken, made up of pieces of mass-produced plates. Usually frontal, alone, and not fully rendered, the figures merge with a field of indeterminate detail. Schnabel tries desperately to pull his friends forward, as in a dream of dying when one is falling, falling down into a space that can not be articulated.

Little is sacred for Schnabel. Like a self-taught ethnographer, he studies and superimposes centuries (seventh B. C. to late twentieth A. D.), cultures (Aborigine, Japanese, Greek, Hollywood), and the content of others' art (Carravaggio, Goya, Courbet). He is searching for survivors, knowing he can do nothing with his knowledge but deconstruct the givens—frame them with his own needs and reading. If history is no longer perceived as an inevitable linear progression, then one can be progressive and still move backwards. Not content to refine a single signature style, Schnabel hungrily and impatiently makes paintings, drawings, and sculptures that encompass a near-manic variety of styles, from religious tracts and Mexican devotionalia to paintings by Francis Picabia. Schnabel mines all materials for multiple meanings, including antlers, great spills of oil and blood, and a Kabuki back-

Portrait of Andy Warhol, *1982. Oil on velvet; 108 x 120 (274.3 x 304.8). The Estate of Andy Warhol, New York.*

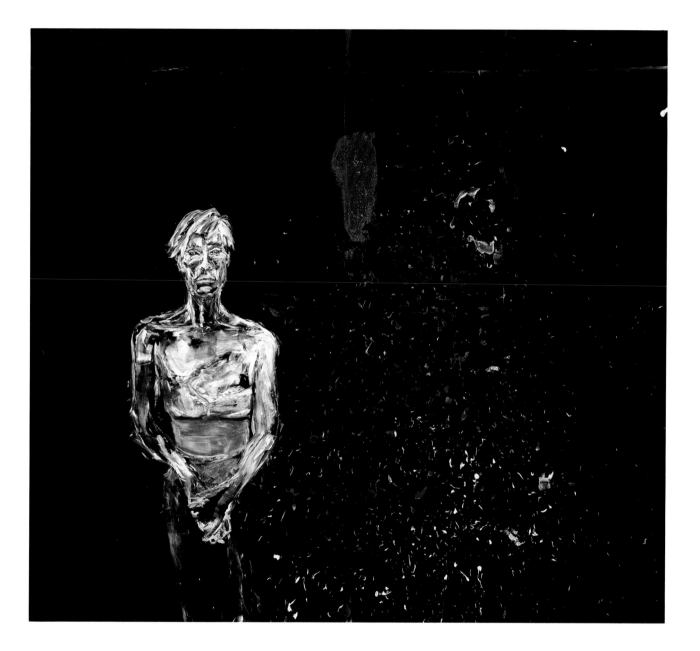

drop from the type of theater most popular in Japan. His methods range from accurate renderings to three-dimensional collage to abstract runs of opaque aluminum paint, from recording marks with stitches or tears to simulating the plaster cracks of fresco with paint on velvet. Among his sources are children's books and William Gaddis's *The Recognitions.* Schnabel ingests information and images from high and low sources and early and late periods as some do drugs, all the while suspicious of the substance and seduced by the surface thrill.

Painting himself out of the purity of the Modernist position, Schnabel has mixed drawn images and found objects with paint, creating the appearance of story-telling. When the tales can be decoded, the narrative, never linear, points to signs that, in their abundance and cacophony, bury the possibility of a single meaning or voice. Schnabel often talks figuratively out of both sides of his mouth. In a painting such as *Anh in a Spanish Landscape,* 1988, carnal and religious imagery mate upon a bombed-out earthy field of ocher-colored crockery shards. Only one plate from this domestic drama remains pure and unpainted—the one that covers the woman's heart.

In his bravado technique, seen at first as an ability to fill a painting full to overflowing but increasingly as a means of making structures as lean and elegant as a DNA spiral, Schnabel posits an almost coherent belief in the alchemical properties of paint, in the possibility of finding different versions of his search for meaning through the physicality of materials and sheer Sisyphean effort. His strategy revolves around neither an entirely theoretical approach nor a trance-like flinging of paint. While the scale of his ambition (who else but someone who can hold in his imagination both the hermetic scrawl of Cy Twombley and rousing lessons of Joseph Beuys would invite literary and social readings by introducing into the body and the title of paintings blocky letters spelling such words as "Virtue," "Charity," "Mercy," "L'Heroine," "Diaspora") and the size of his canvas are often monumental, he increasingly has found a place for and a faith in the intimate. Sometimes the suffering Schna-

bel registers in his handling of material and subject matter makes us squeamish. Can art today be called upon to speak of the unspeakable even when St. Sebastian—twice left for dead for trying to make converts to Christianity and routinely pictured with arrows piercing his youthful flesh—is invoked? In a number of works, including *Saint Sebastian—Born, 1951,* 1979, Schnabel, who was born in 1951, seems to want to bear witness to crisis and confusion by picturing figures such as this impassioned martyr, traditionally invoked against plagues. Light often springs from darkness, although the paint seems only to smudge or savage the canvas. His portraits, too, close to something shared to speak of archetypes, tell us he has found the heroic camping out on his own block.

Note

1. Julian Schnabel, quoted in "Expressionism Today: An Artists' Symposium," interview by Hayden Herrera, *Art in America* 70 (December 1982): 58-75, 139, 141.

Julian Schnabel.
Jacqueline the Day after
Her Wedding, *1980. Oil
on linen; 96 x 72 (243.8 x
182.9). Collection of the
artist.*

Julian Schnabel.
La Spiaggia, *1986. Oil and modeling paste on velvet; 96 x 72 (243.8 x 182.9). Susan and Lewis Manilow, Chicago.*

Julian Schnabel.
Self-Portrait in Andy's
Shadow, *1987. Oil, plates,
Bondo on wood; 103 x 72
(261.6 x 182.9). Eli and
Edythe L. Broad Collection,
Los Angeles.*

Julian Schnabel.
Portrait of Anh in a Mars
Violet Room, *1988. Oil,
plates, Bondo on wood; 72 x
60 (182.9 x 152.4). Private
collection, courtesy the Pace
Gallery, New York.*

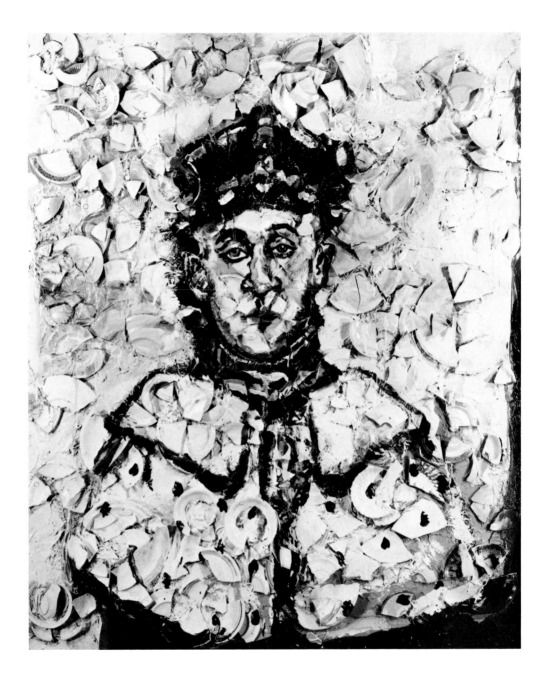

Julian Schnabel.
Portrait of David Yarritu,
*1988. Oil, plates, Bondo on
wood; 72 x 60 (182.9 x
152.4). Clodagh and Leslie
Waddington, London.*

Cindy Sherman

When I prepare each character I have to consider what I am working against; that people are going to look under the make-up and wigs for that common denominator, the recognizable. I'm trying to make other people recognize something of themselves rather than me.[1]
Cindy Sherman

Cindy Sherman replays all the roles women have played for generations in fairy tales, art history, film, television, advertising, soft porn, and real life—if everyday existence can be distinguished from fictive categories in this age of immersion by the mass media. Sherman is interested in the rhetoric of culture and how the visual language manufactured by the media creates a false but compelling picture of who we are, what we need, and what art can be about. While her feel for the nuances of this imagery is so precise we imagine we can pinpoint the exotic sources for her poses and pictures, she invents them all, combining found mannerisms and gender constructions to comment critically on the pernicious fictions thrown off by the media. Indeed, Sherman strips away the niceties of convention, exposing the patterns of female appearance and behavior that have been promulgated covertly by the media. Not content to imitate as much as analyze, Sherman's portraits of Everywoman depict a transitional rather than aggressive figure, defiantly human rather than heroic. Even the 1981 photographs, for example, *Untitled #93,* which were based on the visual syntax of pornography, represent distracted, solitary women who deflect, by a hyperreal expression of humanity, the desirous gaze that would subjugate them. These women and the photographs of them, unlike the originals we are reminded of, are not airbrushed screens on which male fantasies greedily are projected.

Influenced most by and involved with pictures from the popular culture that were made and transmitted with technology, Sherman fittingly performs for her camera. In bringing photography to center stage in the art world, she eschews the temptations of craft that have seduced photographers since Henry Fox Talbot, allowing technicians working in professional labs to pro-

duce the final photographs. Technical imperfections such as accidental shifts in focus inflect some of the work. These are obsessively conceived rather than finished works, which because of their enormous size, obdurate flatness, and matless format challenge the preciousness and documentary character of conventional prints. Like many women of her generation, Sherman has rejected the heroics of the brush, the "hisness" of history, and the reductive mechanics of Minimalism, finding in the stepchild medium of photography the perfect vehicle for telling morality tales and raising issues pertaining to women, second-class citizens. Choosing to mine the methods and meanings of representation in popular culture and move from hermetic to accessible source material, Sherman selected the photographic print, with its homogenous surface and reproductive capacity, which proved to be the perfect medium to examine the Postmodern world of multiple appearances, selves.

Sherman made her first color photographs in 1980. By 1981 the scale of her efforts had increased from 8 x 10 inches to 24 x 48 inches, furthering the blatantly fake and detached quality of her work. The large-scale C prints lack the immediacy of video and share the complicated, gorgeous artifice of film. She works in privacy and is in total control, shaping the often grotesque drama, designing the vaporous set in which the play of light often takes the place of specific detail, and formulating the character of her female survivors. Unlike the male artist, whose gaze objectifies his lover/model and separates him from her, Sherman is both artist and model, equally. No distinction is made between the creator and what is created. Woman is no longer simply muse, and artist is no longer a god-like figure. The viewer, sharing in Sherman's awareness, is never taken in entirely by the fiction she creates. We know we are not looking at Marilyn Monroe but at the type and the tragedy that springs from an individual succumbing to a particular style. By accentuating the stylized textures of her lighting, props, and costumes, Sherman reveals the layered intricacy of styles of representation. As we look, we peel the layers back until we see the horrible hollowness at the core. That hollowness more than anything else,

Untitled #168, 1987. Color photograph; 86⅛ x 61⅛ (218.4 x 155.2). The Corcoran Gallery of Art, Washington, D. C., gift of the Women's Committee of the Corcoran Gallery of Art.

may account for the fear that colors many of her portraits.

While she adopts the tragic, comic, beautiful, and ugly mannerisms of the stereotype and even adds fake body parts to her own, Sherman never turns herself into a shallow pastiche. Hers is not a skin-deep rendition. More like a method actor, she burrows in, exposing the pain, vulnerability, or innocence of her victims, vixen, and valorous women. Perhaps that is why her 1983 foray into the advertising world was abortive. For all her interest in appearances, she was unwilling to capitulate to the decorative norms of the advertising medium. The images she made were attractive to neither women nor men. In fact, some of the women pictured are among her most unglamorous, deranged, and extreme, for example, Jackie Kennedy after the assassination—soiled, introspective, and oblivious to the symbols she wore.

Sherman is not a narcissist. In fact, in an age in which some artists have become as familiar as rock stars, Sherman's visage is barely recognized. She has no public self just as she has no single-pictured self; she is a plastic material. Sherman even convincingly assumes the posture and clothing of a man or the devil or someone whose gender is undetermined, as in *Untitled #109*, 1982. She never makes fun of her characters or her viewers; there is no ironic wink. In the early work she avoided our gaze, never really confronting us before disappearing by decade's end into a grisly tangle of computer wires, flood of vomited meals, or landscape of festering boils. It is shocking to see how violent the seemingly everyday can be and how much tolerance we have for extreme emotional fluctuations. Sherman's work functions to disrupt the comfortable, seamless way the manufactured and real coexist. Paradoxically, her fictions help us see the drama and destruction of the front page better. Perhaps we are running from the quotidian, which so often is laced with danger, compromise.

Sherman is not afraid of sentimentality, seduction, or the supernatural and states her pictures are of emotions rather than herself. They are not documentary so much as representations, fic-

tional and felt tableaux of the most fantastic and patently theatrical type. Some photographs seem like outtakes, moments thrown away from some larger story that, like a dream, we sense rather than remember. The artifice moves us from melodrama to a presentation of everyday nightmare in which we participate as both voyeur and actor. Like a mirror, the photographs show us our trampy selves, shaped and conditioned by desires we have picked up from the mass media. While *tristesse* characterizes this fractured reflection, there is reward in gaining, even fleetingly, the self-awareness that permits us a bit more freedom in self-determination.

Cindy Sherman.
Untitled #74, *1980. Color photograph; 20 x 24 (50.8 x 61.0). Iris and Ben Feldman, New York.*

Cindy Sherman.
Untitled #93, *1981. Color photograph; 24 x 48 (61.0 x 121.9). Lise Spiegel, New York.*

Note

1. Cindy Sherman, quoted in *Documenta 7,* 2 vols., exhibition catalog (Kassel, West Germany: Paul Dierichs) 1: 411.

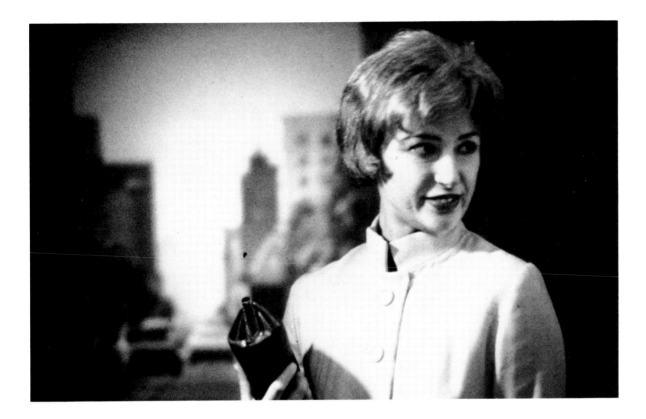

Cindy Sherman.
Untitled #109, *1982. Color*
photograph. 36 x 36 (91.4 x
91.4). Susan and Lewis
Manilow, Chicago.

Cindy Sherman.
Untitled #122, *1983. Color*
photograph; 34⅝ x 20⅝
(87.9 x 52.4). Pamela and
Arnold Lehman, Baltimore.

Jeff Wall

I think there's a basic fascination in technology which derives from the fact that there's always a hidden space—a control room, a projection booth, a source of light of some kind—from which the image comes. A painting on canvas, no matter how good it is, is to our eyes more or less flat. . . . One of the reasons for this is that the painting or the ordinary photograph is lit with the same light that falls in the room and onto the spectator him- or herself. But the luminescent image is fascinating because it's lit with another atmosphere. So two atmospheres intersect to make the image. . . . To me, this experience of two places, two worlds, in one moment is a central form of the experience of modernity. It's an experience of dissociation, of alienation. In it, space—the space inside and outside of the picture—is experienced as it really exists in capitalism: there is always a point of control, of projection, which is inaccessible.[1]
Jeff Wall

Jeff Wall's large cibachrome transparencies give lie to the advertising claim that, armed with a camera, everyone is an artist. There is nothing instant, natural, or unself-conscious about the spectacles he stages. His are manmade, not found or come-upon, images although he further confuses art and life by often basing his pictures on well-known paintings. A keen, almost Japanese knowledge of artificiality's dependence on craft informs his reconstructions and underscores his purpose: to analyze the reasons for picture making and the act of looking. Wall bends truth in order to mirror how sight is conditioned and mannered and how art best reflects the intersection of personal need and societal expectations, the real and the symbolic.

A hybrid, synthetic technology—combining attributes of photography, film, and painting—is used to comment on the history of representation. Wall's fascination with lighting, the material by which a photograph is organized and chemically realized, suggests both the fleeting nature of perception itself and the fact that illumination, or understanding, is at the core of his endeavor. His nearly life-size pictures of ordinary people in confrontational situations dissect the way formal, social, and sexual relationships have been represented in the history of art and through such mechanisms of popular culture as movies, commercial billboards, and advertising. With jewel-like sharpness and intensity, the transparencies, mounted in metal boxes and back-lit, crystalize the paradoxes surrounding photography and, by extension, society. The staged can be made to look spontaneous and the news simulated to give the television viewer a "better" picture of reality. The illusion is produced as an object, as both the transparency and desire are transformed through advertising into the hunger to consume something. And the poor or outcast are rendered with a richness of detail that lifts them out of the realm of stereotype into the world of archetypes, like the luminous commercial sign that turns everyday activity into something special.

The viewer is seduced and then liberated as the fiction unfolds and finally unravels. The image, which reports on contemporary life but is hardly a documentary picture in the traditional sense, does not sustain one's feelings of empathy, promoting instead an understanding that any image is a picture of its maker's ideology. The position of these luminous photographs in the gallery is calculated to control the viewer's role. The transparency, with its concealed source of light, often possesses the drama and immediacy of a moving picture, with the viewer sometimes a participant, sometimes a voyeur, and, finally, a judge. As one becomes more aware of the artifice, one becomes less secure in the traditionally passive role of viewer. Are we present as insiders or outsiders? Is seeing believing? Is faith blind? The questions are not neatly answered.

With an almost maniacal obsession for elaborating and ordering the telling detail or glint in an actor's eye, Wall arranges extremely elaborate tableaux that the camera constructs as if they were occurring in real time. By linking the concerns of the painter and film director, he exhibits exquisite control over the setting; lighting; costumes, props, and blocking of actors; composition of shapes and colors; and relationship of figure to ground. By collapsing the distinctions between painter and filmmaker, Wall points to the history of painting and the technical practices of the

Young Workers, *1978–83 (detail). Color transparency, fluorescent light, display case; 40 x 40 (101.6 x 101.6). Emanuel Hoffman-Stiftung, Museum für Gegenwartskunst, Basel.*

commercial world as two major sources for the interlocking of content and technique. The history of painting provides the visual matrix for his contemporary explorations. The techniques developed for the commercial world of film and advertising are the mechanisms for rendering those explorations in a manner appropriate to this time. As if producing a lavish advertisement for the disenfranchised and destitute, Wall uses the most sophisticated forms of lighting and retouching to create the reality of his pictures. Unlike the photographer for *Playboy* who airbrushes away pubic hair, however, Wall highlights that which is human in order to locate an ideal that may be achievable.

The models for *Young Workers,* 1978–83, represent and repeat a variety of physical and racial types. Each head, framed by an unblemished sky blue background, is cut off at the clavicle, leaving but a collar of prosaic clothing. While each is photographed in the luxurious and intimate detail usually lavished on movie stars, none are what conventionally would be called beautiful. The surface—the reality of appearances—is marred. Each character's face contains traces of real life. Physical imperfections give the disembodied and nameless a monumental dignity. We struggle to contradict our sense, constructed out of and corrupted by the formulaic images repeated in the movies and magazines, that the heroic does not appear in the guise of such fragile humanity and that the ideal is bigger than life. Yet we are touched by the fact that these eight are "allowed" to be, that a technically perfect art has made them so. Each looks upward, as the viewer must to see these 40 x 40 inch images hung high on the wall. In doing so, the viewer mimics the young workers and becomes identified with their mission. But the viewer, who does not see or know the high ideals that inspire their quiet, internalized devotion, steps back, unable to complete the revolutionary identification with the other. Suddenly, the viewer is subject to the strain of being human.

There also is discomfort in witnessing *Mimic,* 1982, a scene that relates racial violence, sexual inequality, proletarian anger, and ennui. Looking at this picture, one almost compulsively invents a parable about how the successful assimilation of Asians into the American economic system has prompted a sense of loss and fear from those less successful. With economic success comes respectability, allowing the recent immigrant to shed the label of "other." The formal attributes of this picture are finely tuned to the implications of the narrative. The perspectival retreat of the street forces the confrontation into the foreground just as the three characters are held in tight focus, bringing the details of their interaction closer to the viewer. While the violence is covert, occurring through a series of signs (idiomatic gesture, posture, clothing, ideograph, and spatial devices) rather than physical aggression, all communication is cast as negative. A poorly groomed Caucasian man, gripping his provocatively dressed but curiously detached girlfriend, signals his hatred of the neat Asian man with whom he shares the sidewalk by pulling one eye upward with his middle finger. Like the No Parking sign in the picture, which consists of an image surrounded by a red circle through which a diagonal runs, the gesture is a universal sign, conflating sexual and racial belligerence. While children make such gestures, a grown man mimicking his imagined rival appears particularly impotent and hostile. A similar heightening of tension is achieved with the realization that this episode has been staged. It is not street photography at its most lurid and fleeting but something carefully arranged to expose and to criticize. To imitate, after all, is to photograph— to make art is to try to make sense of what one feels, sees, and understands, which is what the viewer, like both the victim and aggressor in this picture, must do.

Note

1. Jeff Wall, quoted in Els Barents, "Typology, Luminescence, Freedom: Selections from a Conversation with Jeff Wall," *Jeff Wall Transparencies* (London: Institute of Contemporary Arts; Basel: Kunsthalle Basel, 1984), p. 95.

Jeff Wall.
Mimic, 1982. Color
transparency, fluorescent
light, display case; image,
77¹⁵/₁₆ x 90⅛ (198.0 x 229.0).
Frederick Roos, Malmö,
Sweden. Installation view at
David Bellman Gallery,
Toronto. (not in exhibition)

Jeff Wall.
Young Workers, *1978–83.*
Color transparencies,
fluorescent lights, display cases;
eight portraits, each 40 x 40
(101.6 x 101.6).
Emanuel Hoffman-Stiftung,
Museum für Gegenwartskunst,
Basel.

Checklist of the Exhibition

Laurie Anderson
O Superman, 1982
Videotape, 9 minutes

Slah Armajani
Sacco and Vanzetti Reading Room #4, 1989–90
Pressure treated wood, aluminum, steel, bricks,
books, newspapers
Dimensions variable
Courtesy Max Protetch Gallery, New York
Installation for Hirshhorn Museum and Sculpture
Garden

Francesco Clemente
Hunger, 1980
Tempera on paper mounted on cloth
93½ × 96½ (237.5 × 245.1)
Promised gift of Marion Stroud Swingle to the
Philadelphia Museum of Art

Francesco Clemente
Sun, 1980
Tempera on paper mounted on cloth
91 × 95 (231.1 × 241.3)
Philadelphia Museum of Art, Edward and Althea
Budd Fund, Katherine Levin Farrell Fund, and
funds contributed by Mrs. H. Gates Lloyd

Francesco Clemente
Perseverance, 1982
Oil on canvas
78 × 93 (198.1 × 236.2)
PaineWebber Group, Inc., New York

Francesco Clemente
Porta Coeli, 1983
Gouache on linen
103 × 93 (261.6 × 236.2)
Stefan T. Edlis Collection, Chicago

Francesco Clemente
Miele, Argento, Sangue (Honey, Silver, Blood), 1986
Fresco
Three panels; 118⅛ × 78¾ (300.0 × 200.0) each
Fundació Caixa de Pensions, Barcelona

James Coleman
So Different . . . and Yet, 1979–80
Video installation, 45 minutes
Narration performed by Olwen Fouere and Roger
Doyle, music composed and performed by Roger
Doyle
Collection of the artist, courtesy Marian Goodman
Gallery, New York

Tony Cragg
Mercedes, 1982
Bottles and stones
118⅛ (300.0) in diameter
Konrad Fischer, Düsseldorf

Tony Cragg
Real Plastic Love, 1984
Plastic fragments
73 × 33 (185.4 × 83.8)
Martin Sklar, New York

Tony Cragg
Mortar and Pestle, 1987
Cast aluminum
37¾ × 77 × 28 (95.9 × 195.6 × 71.2)
Private collection, California

Tony Cragg
Generations, 1988
Plaster of Paris
43⁵⁄₁₆ × 55⅛ × 70⅞ (110.0 × 140.0 × 180.0)
Courtesy Marian Goodman Gallery, New York

Katharina Fritsch
Anthurien (Anthurium), 1980
Plastic, wire, lacquer
13⅜ × 12⅝ × 14³⁄₁₆ (34.0 × 32.0 × 36.0)
Galerie Johnen & Schöttle and Jablonka Galerie,
Cologne

Katharina Fritsch
Wandvase (Wall Vase), 1980
Plastic, water
5⅞ × 3¹⁵⁄₁₆ × 11¹⁄₁₆ (15.0 × 10.0 × 28.0)
Galerie Johnen & Schöttle and Jablonka Galerie,
Cologne

Katharina Fritsch
Doppelseitiger Spiegel (Double-sided Mirror), 1981
Mirrored glass
7⅞ × 5⅞ × ³⁄₁₆ (20.0 × 15.0 × 0.4)
Galerie Johnen & Schöttle and Jablonka Galerie,
Cologne

Katharina Fritsch
Werbeblatt I (Flier), 1981
Paper
11¹³⁄₁₆ × 8¼ (30.0 × 21.0)
Galerie Johnen & Schöttle and Jablonka Galerie,
Cologne

Katharina Fritsch
Katze (Cat), 1981–89
Plastic
6¹¹⁄₁₆ × 6¹¹⁄₁₆ × 2³⁄₈ (17.0 × 17.0 × 6.0)
Galerie Johnen & Schöttle and Jablonka Galerie,
Cologne

Katharina Fritsch
Gehirn (Brain), 1981–89
Plastic
4¾ × 5⅛ × 5⅞ (12.0 × 13.0 × 15.0)
Galerie Johnen & Schöttle and Jablonka Galerie,
Cologne

Katharina Fritsch
Madonna, 1982
Painted plaster
11¹³⁄₁₆ × 3⅛ × 2³⁄₈ (30.0 × 8.0 × 6.0)
Galerie Johnen & Schöttle and Jablonka Galerie,
Cologne

Katharina Fritsch
Schafe (Sheep), 1982
Plaster
2⅛ (5.5) high
Galerie Johnen & Schöttle and Jablonka Galerie,
Cologne (not in exhibition)

Katharina Fritsch
Regen (Rain), 1987
Long-playing record
11¹³⁄₁₆ × 11¹³⁄₁₆ (30.0 × 30.0)
Galerie Johnen & Schöttle and Jablonka Galerie,
Cologne

Katharina Fritsch
Seidenschal (Silk Shawl), 1987–88
Printed silk
32½ × 31⅛ (82.5 × 79.0)
Galerie Johnen & Schöttle and Jablonka Galerie,
Cologne

Katharina Fritsch
Unken (Toad), 1988
Single record
7¹⁄₁₆ × 7¹⁄₁₆ (18.0 × 18.0)
Galerie Johnen & Schöttle and Jablonka Galerie,
Cologne

Katharina Fritsch
Vase mit Schiff, (Vase with Ship), 1987–88
Plastic
11¹³⁄₁₆ (30.0) high; 4¹⁵⁄₁₆ (12.5) in diameter
Galerie Johnen & Schöttle and Jablonka Galerie,
Cologne

Robert Gober and Sherrie Levine
Untitled Collaboration, 1989–90
Mixed media
32 × 33 × 12 feet (9.8 × 10.0 × 10.0 m),
approximate dimensions of site
Courtesy Mary Boone Gallery, New York, and
Paula Cooper Gallery, New York
Installation for Hirshhorn Museum and Sculpture
Garden

Robert Gober and Sherrie Levine
Checkerboard on Table, 1989–90
Enamel paint on wood (table), tempera on wood
(checkerboard)
Table, 30 × 36 × 30 (76.2 × 91.4 × 76.2);
checkerboard, 21 × 21 × 2 (53.3 × 53.3 × 5.1)
Courtesy Mary Boone Gallery, New York, and
Paula Cooper Gallery, New York

Robert Gober
Untitled Closet, 1989
Wood, plaster, enamel paint
84 × 52 × 28 (213.4 × 132.1 × 71.1)
Courtesy Paula Cooper Gallery, New York

Robert Gober
Hanging Man/Sleeping Man, 1989
Wallpaper, silkscreen on paper
Each roll 27 in. × 30 ft. (68.6 cm × 9.1 m)
Courtesy Paula Cooper Gallery, New York

Robert Gober
Cat Litter, 1989
Edition 1 of 7
Plaster, ink, latex paint
16½ × 7¾ × 4½ (41.9 × 19.7 × 11.4)
Courtesy Thomas Ammann, Zurich

Robert Gober
Cat Litter, 1989
Artist's proof
Plaster, ink, latex paint
16½ × 7¾ × 4½ (41.9 × 19.7 × 11.4)
Collection of the artist

Robert Gober
Cat Litter, 1989
Artist's proof
Plaster, ink, latex paint
16½ × 7¾ × 4½ (41.9 × 19.7 × 11.4)
Collection of the artist

Jenny Holzer
TRUISMS, 1977–79
Photostats produced in 1990
Six units; 96 × 40 (243.8 × 101.6) each
Collection of the artist and Barbara Gladstone
Gallery, New York

Jenny Holzer
Selections from TRUISMS ("ABUSE OF POWER COMES . . ."), 1987
Edition 2 of 3
Danby royal marble
17 × 54 × 25 (43.2 × 137.2 × 63.5)
Private collection, courtesy Thea Westreich Associates, New York

Jenny Holzer
Selections from TRUISMS ("ACTION CAUSES MORE TROUBLE . . ."), 1987
Edition 3 of 3
Danby royal marble
17 × 54 × 25 (43.2 × 137.2 × 63.5)
John and Mary Pappajohn, Des Moines

Jenny Holzer
Selections from TRUISMS ("ALL THINGS ARE DELICATELY INTERCONNECTED . . ."), 1987
Edition 2 of 3
Danby royal marble
17 × 54 × 25 (43.2 × 137.2 × 63.5)
Leonard and Jane Korman, Fort Washington, Pennsylvania

Jenny Holzer
Selections from TRUISMS ("A MAN CAN'T KNOW . . ."), 1987
Edition 1 of 3
Danby royal marble
17 × 54 × 25 (43.2 × 137.2 × 63.5)
Donald and Mera Rubell, New York

Jenny Holzer
Selections from TRUISMS ("A STRONG SENSE OF DUTY . . ."), 1987
Danby royal marble
17 × 54 × 25 (43.2 × 137.2 × 63.5)
Robert M. Kaye

Jeff Koons
New Shelton Wet/Dry 5-Gallon, New Hoover Convertible Doubledecker, 1981–87
Vacuum cleaners, plexi glass, fluorescent tubes
99 × 28 × 28 (251.5 × 71.1 × 71.1)
Elaine and Werner Dannheisser, New York

Jeff Koons
Two Balls 50/50 Tank, 1985
Edition of 2
Glass, iron, water, basketballs
62¾ × 36¾ × 13¼ (159.4 × 93.3 × 33.7)
Susan and Lewis Manilow, Chicago

Jeff Koons
Jim Beam J. B. Turner Train, 1986
Cast stainless steel
Edition 1 of 3
9¾ × 116 × 6¾ (24.8 × 294.6 × 17.1)
Saatchi Collection, London

Jeff Koons
Bear and Policeman, 1988
Polychromed wood
Edition of 3
85 × 43 × 36 (215.9 × 109.2 × 91.4)
Courtesy Sonnabend Gallery, New York

Sherrie Levine and Robert Gober
Untitled Collaboration, 1989–90
Mixed media
32 × 33 × 12 feet (9.8 × 10.0 × 10.0 m), approximate dimensions of site
Courtesy Mary Boone Gallery, New York, and Paula Cooper Gallery, New York
Installation for Hirshhorn Museum and Sculpture Garden

Sherrie Levine and Robert Gober
Checkerboard on Table, 1989–90
Tempera on wood (checkerboard); enamel paint on wood (table)
Checkerboard, 21 × 21 × 2 (53.3 × 53.3 × 5.1); table 30 × 36 × 30 (76.2 × 91.4 × 76.2)
Courtesy Mary Boone Gallery, New York, and Paula Cooper Gallery, New York

Sherrie Levine
"Untitled" (After Walker Evans: Negative) #3, 1989
Photograph
20 × 16 (50.9 × 40.6)
Courtesy Mary Boone Gallery, New York

Sherrie Levine
"Untitled" (After Walker Evans: Negative) #4, 1989
Photograph
20 × 16 (50.9 × 40.6)
Courtesy Mary Boone Gallery, New York

Sherrie Levine
"Untitled" (After Walker Evans: Negative) #5, 1989
Photograph
20 × 16 (50.9 × 40.6)
Courtesy Mary Boone Gallery, New York

Sherrie Levine
"Untitled" (Mr. Austridge: 1), 1989
Casein on wood
47½ × 27½ (120.6 × 69.8)
Eli and Edythe L. Broad Collection, Los Angeles

Sherrie Levine
"Untitled" (Mr. Austridge: 2), 1989
Casein on wood
47½ × 27½ (120.6 × 69.8)
Al Ordover, courtesy Mary Boone Gallery, New York

Sherrie Levine
"Untitled" (Mr. Austridge: 3), 1989
Casein on wood
47½ × 27½ (120.6 × 69.8)
Private collection, courtesy Mary Boone Gallery, New York

Sherrie Levine
"Untitled" (Mr. Austridge: 4), 1989
Casein on wood
47½ × 27½ (120.6 × 69.8)
Alain Clairet, New York, courtesy Mary Boone Gallery, New York

Sherrie Levine
"Untitled" (Mr. Austridge: 5), 1989
Casein on wood
47½ × 27½ (120.6 × 69.8)
Paul and Camille Oliver-Hoffmann, Chicago, courtesy Mary Boone Gallery, New York

Sherrie Levine
"Untitled" (Mr. Austridge: 6), 1989
Casein on wood
47½ × 27½ (120.6 × 69.8)
Collection of the artist, courtesy Mary Boone Gallery, New York

Yasumasa Morimura
Portrait (La Source 1), 1986–89
Type C print
94½ × 47¼ (240.0 × 120.0)
Tetsutada Fukunishi, Ehime, Japan

Yasumasa Morimura
Portrait (La Source 2), 1986–89
Type C print
94½ × 47¼ (240.0 × 120.0)
Tetsutada Fukunishi, Ehime, Japan

Yasumasa Morimura
Portrait (La Source 3), 1986–89
Type C print
94½ × 47¼ (240.0 × 120.0)
Tetsutada Fukunishi, Ehime, Japan

Yasumasa Morimura
Doublonnage (Marcel), 1988
Type C print
59¹⁄₁₆ × 47¼ (150.0 × 120.0)
Collection of the artist

Yasumasa Morimura
Doublonnage (Portrait C), 1988
Type C print
47¼ × 47¼ (120.0 × 120.0)
Collection of the artist

Yasumasa Morimura
Doublonnage (Portrait D), 1988
Type C print
47¼ × 47¼ (120.0 × 120.0)
Collection of the artist

Reinhard Mucha
Gruiten, 1985, reworked 1989
Wood, metal, glass
40¹⁵⁄₁₆ × 83⁷⁄₁₆ × 22⁷⁄₁₆ (104.0 × 212.0 × 57.0)
Sanders Collection, Amsterdam

Julian Schnabel
Jacqueline the Day after Her Wedding, 1980
Oil on linen
96 × 72 (243.8 × 182.9)
Collection of the artist

Julian Schnabel
Portrait of Andy Warhol, 1982
Oil on velvet
108 × 120 (274.3 × 304.8)
Courtesy the Estate of Andy Warhol, New York

Julian Schnabel
La Spiaggia, 1986
Oil and modeling paste on velvet
96 × 72 (243.8 × 182.9)
Susan and Lewis Manilow, Chicago

Julian Schnabel
Self-Portrait in Andy's Shadow, 1987
Oil, plates, Bondo on wood
103 × 72 (261.6 × 182.9)
Eli and Edythe L. Broad Collection, Los Angeles

Julian Schnabel
Anh in a Spanish Landscape, 1988
Oil, plates, Bondo on wood
114 × 125½ (289.6 × 318.8)
Winnie Fung, Hong Kong

Julian Schnabel
Portrait of Anh in a Mars Violet Room, 1988
Oil, plates, Bondo on wood
72 × 60 (182.9 × 152.4)
Private collection, courtesy the Pace Gallery, New York

Julian Schnabel
Portrait of David Yarritu, 1988
Oil, plates, Bondo on wood
72 × 60 (182.9 × 152.4)
Clodagh and Leslie Waddington, London

Cindy Sherman
Untitled #70, 1980
Color photograph
20 × 24 (50.8 × 61.0)
Whitney Museum of American Art, New York, gift of Barbara and Eugene Schwartz

Cindy Sherman
Untitled #74, 1980
Color photograph
20 × 24 (50.8 × 61.0)
Iris and Ben Feldman, New York

Cindy Sherman
Untitled #92, 1981
Color photograph
24 × 48 (61.0 × 121.9)
Eli and Edythe L. Broad Collection, Los Angeles

Cindy Sherman
Untitled #93, 1981
Color photograph
24 × 48 (61.0 × 121.9)
Lise Spiegel, New York

Cindy Sherman
Untitled #109, 1982
Color photograph
36 × 36 (91.4 × 91.4)
Susan and Lewis Manilow, Chicago

Cindy Sherman
Untitled #122, 1983
Color photograph
34⅝ × 20⅝ (87.9 × 52.4)
Pamela and Arnold Lehman, Baltimore

Cindy Sherman
Untitled #158, 1986
Color photograph
60 × 40 (152.4 × 101.6)
Silvio Sansone

Cindy Sherman
Untitled #162, 1986
Color photograph
32 × 31 (81.3 × 78.7)
Private collection

Cindy Sherman
Untitled #168, 1987
Color photograph
86⅛ × 61⅛ (218.4 × 155.2)
The Corcoran Gallery of Art, Washington, D.C., gift of the Women's Committee of the Corcoran Gallery of Art

Cindy Sherman
Untitled #177, 1987
Color photograph
49¼ × 73¼ (125.1 × 186.1)
Lunn Ltd., New York, and Galerie Baudoin Lebon, Paris

Jeff Wall
Young Workers, 1978–83
Color transparencies, fluorescent light, display cases
Eight panels; 40 × 40 (101.6 × 101.6) each
Emanuel Hoffman-Stiftung, Museum für Gegenwartskunst, Basel

Rasterops model 104, 24-bit video
display card.

The Prince and the Teenager

Maurice Culot

Turning your back on reality is no great accomplishment; but turning your back on your dreams is something else altogether. Because there is such scant realism inside man himself, it is heartbreaking for him to have to turn his back on his dreams.
René de Chateaubriand, 1844

To know where you stand with yourself, with other people, with society, even with the universe. After serving your apprenticeship and depending upon your personality, environment, age, social status, and cultural and educational background, you choose some prejudices that seem to fit with whatever stage you have reached in your life. The self-assurance that saves us from ourselves and sublimates our destructive and suicidal tendencies is something that, two decades ago, we might still have found in a certain group of symbolic juxtapositions: social and political activism, religious devotion, and the like. Alternatively, we might have found it in the life-enhancing experience that inspires us to make something of our lives. Artistic commitment might be one response to this all-too-human source of anxiety. Yet, with a lifetime's accomplishment behind him, an artist might still be moved to say, as did the painter Gustave Moreau, "My only claim to fame is that I have never made myself miserable; that I have been spared the affliction suffered by the dreamer without a dream, the enthusiast lacking in enthusiasm, the laborer toiling to no avail."[1]

The 1980s have seen the mass media seep into every aspect of daily life, and the media have left society wide open to egalitarian values and experiences. Needless to say, this explosion of jumbled information makes personal choice an increasingly sensitive matter. The unspoken consensus would seem to be that people should just live from one day to the next. In doing so we preserve (or fancy we preserve) our freedom of choice and the option to seize our chances and strike out in any direction that seems promising. In exchange, this newfound independence calls for extra vigilance, for human frailties and selfishness are being sorely tempted at the same time that a lack of fixed landmarks insistently requires viewing every gesture as communication. This media-dominated universe makes personal experience seem haphazard, and symbolic juxtapositions have become overpowering while sacrificing their power to persuade. They have become increasingly crude (addictive television, pornography, money, and vacations revered as paragons) or increasingly sophisticated (land art, body art, deconstructivism). As we approach the end of the twentieth century, the world view of the industrialized democracies has become a quintessentially personal matter in which everyone has an axe to grind. As Jean Clair, curator at Musée National d'Art Moderne in Paris, has pointed out, artists no longer "consider art for what it is; a bulwark against death and a means for surmounting the inevitability of death, at least in spirit."[2] The only thing that counts is an artist's urgent need to be catapulted into prominence by the media with a view to obtaining commissions and, if successful, to cling to the spotlight for as long as possible.

Collectors of art are themselves sucked into this media vortex. Increasingly, politicians and developers are hiring celebrity architects based on fame and rank in the international press. These clients disregard the problem that needs to be solved or do not consider whether the star's background and experience will allow him or her to come to grips with the historical milieu in question or analyze a specific issue in a city neighborhood.

In hastening the process by which ideas are converted into social behavior, media supremacy undermines the status quo and creates a tension that encourages each of us to resist being pigeonholed in established categories. And as we approach the end of the 1980s, morals and ideologies no longer hold much allure, nor do they produce great leaders of opposing factions or clashes between rival schools of thought. Opportunism has a way of blurring ideological differences. Experience per se is no longer a prerequisite, and young graduates fresh out of college may seek to challenge their older, more experienced counterparts simply because publication and exhibitions (rather than seniority) have become the key tests of architectural acumen. A novel division of labor has taken root within the architectural community. Architects who are hungry for business become more and more professional and more and more skilled while at the same time enhancing their ability to accommodate the new fashions and styles publicized by magazines, which are particularly fond of young graduates. Conversely, architects who aspire to become famous, published, or trend-setters will tend to regard themselves as unique artists and set their sights on the international star system. Corporate architects see their time taken up with the necessities of organization, finding the business and producing the designs. Artist architects, however, concentrate on being promoted by the media, and whenever they have occasion to build something, their thoughts are influenced by the knowledge that their work will eventually be exhibited, published, and talked about. This fact affects such architects' work so much so that they even stipulate the angle at which their creations are to be photographed. This attitude reaches its extreme when architects who are asked to design structures for historic sites think of them only as settings for contemporary masterpieces. Were it not for the Louvre, for example, I. M. Pei's pyramid would have little, if any, architectural significance. Furthermore, artist architects produce architectural drawings and designs for interiors independently of commissions for buildings, creating art for art's sake. Thus galleries and museums of architecture have emerged. Consider the success enjoyed by such fledgling establishments as the Deutsches Architekturmuseum in Frankfurt, the Institut Français d'Architecture in Paris, and the National Building Museum in Washington, D. C., not to mention the Canadian Centre for Architecture in Montreal, which opened its doors in 1989 and has no fewer than twelve thousand square meters given over to architecture. Most corporate architects admittedly remain unconcerned by such activities, yet all keep abreast of developments by following specialized publications and exhibits.

The 1980s have also seen the concept of urban renewal gather momentum. The traditional city, made up of streets and neighborhoods and classical and vernacular architecture, has become a focal point for international rallying efforts. Interest and support among architects have provided the incentive to undertake projects that have no hope of completion, create masterpieces that will never be built, enter competitions that may never be won, or perhaps just encourage articles for the cognoscenti. Yet this bridge with tradition will remain illusory as long as architecture judges itself only by its own standards. Human life stagnates if kept in isolation from the historical dimensions of society and the many kinds of intersections that go with them.

Artistic sensibility becomes finely honed in any society struggling to get its bearings, and photographers have been at the forefront in this respect. Being privileged to catch a preview of the world's sights and spectacles, photographers have shown even the

Port Grimaud, France, François Spoerry, planner and architect. Construction began on this village, which is on the Mediterranean Sea facing the famous resort city of Saint Tropez, in the 1960s. Port Grimaud was the first example in France of vernacular architecture. Reviled by architects of the time, today Spoerry is being quoted and his work illustrated by such historians of architecture as Charles Jencks and Kenneth Frampton. Since the development of Port Grimaud, Spoerry has opened an office in the United States where he is working on plans for Port Liberty, facing New York, and Port Louis, near New Orleans.

Roberto Behar, Monument for Little Haiti, Miami, 1986. Like Behar's other projects, this monument relates to the idea and image of the New World as a place of encounters. In Haiti, Creole became the voice of encounter with the French, Spanish, and African tongues. The project, which proposes unexpected marriages of the language of antiquity and the colors of the New World, could be interpreted as Haiti, land of mountains and magic, arriving in Miami.

Views of the new town of Seaside, Florida, Andres Duany and Elyzabeth Plater-Zyberk, planners. Tupedo Beach pavilion (left), designed by Ernesto Buch, and a house on Rosewalk (right). The plan of Seaside was laid down in 1979, and construction began in 1983. By 1989 one-third of the projected city had been completed.

unshowable.[3] As a result, photography has been appropriated by the mass media—it has left nothing to the imagination and the magic has gone. So, many photographers keep their distance from the media, the fashion community, advertising. Photographers are being driven by the urge to find a fresh, novel outlook on life—an outlook that is bringing many of them back to the origins of their art. According to the French photographer Dominique Delaunay, photographers are drawn to the era when their predecessors were astonished by their own pictures. This nostalgia is colored by the realization that an important aspect of photography has been lost for all time because the quality of the early prints is now impossible to achieve.

Until his death in 1927, Eugene Atget had never photographed a modern building. Taking his cue from the "primitives" (photographers who worked between 1840 and 1860), Atget photographed only chateaus, cathedrals, monuments, and ancient ruins—in short, building stones suffused with history. François Hers, who is curating a contemporary photographic expedition investigating "the State of France," refuses on principle to photograph modern architecture. He believes that photographing a building constructed after 1914 is as unseemly as photographing ice cream. As far as Hers and other photographers are concerned, the special images, precious prints, and incunabula of early photography evoke everything that is sadly lacking today and that haunts the world of their imagination: solitude, or the longing for an aristocratic age of photography practiced by a handful of enlightened amateurs, or the fact that their documents testify

Leon Krier, the Mall in Washington, D. C., and proposal for Jefferson Town.

Leon Krier. Fundamental Choices of Urban Development, *1987.*

Leon Krier, New Constitution Square. In his Completion of Washington, D. C., Bicentennial Master Plan for the Year 2000 *(1984), Krier has written: "In the historic districts of Charleston, of Savannah, and of reborn Williamsburg, the United States possesses tangible examples of how a "small-town America" wants ideally to live and what it wants to look like. The fervor with which these places are revered by their inhabitants and by countless visitors has made them not merely nostalgic national shrines of the past but desirable and attainable urban models of the future."*
"The eyes of the nation are turned towards Washington at all times. Beyond being the symbolic heart of Democracy and seat of government, I believe the Federal City is destined to become the touchstone and criterion for the rebirth of urban life and culture, of civilized social intercourse, of simple grandeur and elegant simplicity. What Venice is to us, Washington will be for our children, the ultimate urban paradigm, child of heart and intellect, of Art and Industry. America owes it to itself and to the world."

to permanence, emphasizing the monument not consumer goods. This sense of loss fills artists with a yearning to imitate, a yearning to rediscover a photography that bears witness to the measure of time, a quality sought for in vain in both contemporary photography and contemporary architecture.

As ideologies have vanished and cynicism and materialism emerged, the 1980s can also be credited with the current infatuation with museums in Europe. In France alone in 1989 more than 150 new museums are on the drawing board or in construction. This phenomenon seems to bear out André Malraux's adage that the twentieth century will be spiritual, or it will be nothing, especially if Jean Clair could see in the proliferation of museums not an accomplishment of culture but rather its spiritual decay, its reduction to a degenerate variety of communication. Yet Malraux's optimism and Clair's realism are already outdated. My teenage daughter and her classmates are undaunted by the destruction of the ozone layer in light of living in a unified Europe in 1992 and having to know at least three languages. For the younger generation the time for lamentation has long since past, even if they are moved to tears by Wim Wenders's "Wings of Desire" or Percy Adlon's "Bagdad Cafe," films whose antiheroes do not right wrongs but nonetheless touch fellow human beings to their very souls.

This new sensibility, which has emerged spontaneously without proclamation from a charismatic or divinely ordained leader, has a counterpart on the American continent in Roberto Behar. A Jewish architect living in Miami, he was born in Brazil, educated in New York, visits his grandparents in Paris. His Byzantine-mosaic background undoubtedly helps sharpen his perceptions. In his designs and writings Behar collects and puts on view the manifestations of America's new openness and accessibility. Citizen of the world, especially receptive diversity, Behar has argued eloquently in favor of an idea and image of the New World as a place of encounters where the translation and reunion of languages, spaces and times, migration and marriage, the familiar and the unexpected, freedom and imagination could be perceived as the material for a contemporary project that embraces people and place.[4]

The instrument of this change might then be European society's gaping wound—a wound that some have identified as the renunciation of all utopias. While this rejection undoubtedly entails a retreat from earlier critical thought on city planning (whatever happened to the sociologists of the 1970s?), it also reveals an inability to conceptualize systems for interpreting the world. In the aftermath of any upheaval, a period follows when people seek a reliable, safe haven. That fact could explain the incredible success enjoyed by the small town of Seaside, Florida, which was designed and built in the 1980s.[5] The almost mythical perception of Seaside—its "mediatization"—is out of context with a reality that would be disappointing were it not the very embodiment of a profound craving for the idea of a community (not for a city, yet, for we are in the United States) that coincides with an unprecedented ecological crisis already challenging the American way of life.

Did modern planners and architects in London ever use their eyes. . . . You have, Ladies and Gentlemen, to give this much to the Luftwaffe: When it knocked down our buildings, it didn't replace them with anything more offensive than rubble. We did that. Clausewitz called war the continuation of diplomacy by other means. Around St. Paul's, planning turned out to be the continuation of war by other means.

Those are not the words of the chairman of the neighborhood defense committee around the London cathedral but of the Prince of Wales. Which farsighted architectural historian could have predicted in 1980 that it would one day fall to a prince, in the computer age, to throw his hat in the ring and excoriate the architectural establishment and that his most persuasive arguments would be borrowed from theorist Leon Krier, an autodidact who claims to be an architect for the simple reason that he has never built anything?

Whether or not you agree with his comments, in pointing his royal finger at what is self-evident to everyone and by using his status as spokesman, the future king of England has turned a page in the history of architecture. Prince Charles has put into words something that most of us feel: namely, that it is impossible to improve on perfection where architecture and city planning are concerned. In so doing, as the end of the 1980s draws near, Prince Charles is raising the crucial question for the decades to come: Is nostalgic imitation the only means we have for getting back in touch with that thing we know as a "city," the summit achievement and pride of urban civilization? To reunite with life itself, the life bestowed upon us by the dead and departed in granting our wishes?

Notes

1. Gustave Moreau, *L'Assembleur de Réves: Ecrits complets de Gustave Moreau.* Fontfroide, France: Edition de la Bibliothèque Artistique et Littéraire, 1984.

2. Jean Clair, *Paradoxe sur le conservateur.* Caen, France: Editions de l'Echoppe, 1988.

3. At the begining of the 1970s, magazines all over the world published a picture by a great English war photographer, David MacCullin, depicting a death scene in Dacca: a soldier plunging his bayonet into the body of a bound prisoner. The astounding cold-bloodedness of the photographer, the quality of the image, and its worldwide diffusion would incite the French filmmaker Jean-Luc Godard to pose the question to MacCullin, "Why did you do that?" In doing so Godard brought to light the ethical problem of the legitimacy of the photograph that responds to the issue of a shocking image, wavering testimony, indifference to all cause, to all obligation if not to the fact that the event took place while it was being photographed.

4. See Roberto M. Behar, "The Marvel of the Real," *Black and White* (University of Miami School of Architecture), no. 1 (Fall 1988): 19-29.

5. Seaside was designed from 1979 to 1983 by the architects/planners Andres Duany and Elyzabeth Plater-Zyberk of Coral Gables, Florida. Construction, which began in 1983, continues today.

6. Speech given by His Royal Highness the Prince of Wales to the corporation of the London Planning and Communication Committee's annual dinner, Mansion House, December 1, 1987. Published in *APT Bulletin* 20, no. 3 (1988): 4.

Maurice Culot is Director of the Historian Archives of the Institut Français d'Architecture in Paris and President of the Fondation pour l'Architecture in Brussels.

Translated by Paul D. Mitchell and Company.

The Human Spirit in the Era of Genetic Engineering

Vijak Mahdavi and Bernardo Nadal-Ginard

Major changes in the perception and understanding of the physical world have usually been accompanied by significant changes in the perception of the nature of man that, in turn, have resulted in profound social dislocations. The second part of the twentieth century has witnessed an unprecedented revolution in the understanding of the physical world in general and the biological basis of human nature in particular. The advent of the genetic engineering revolution, brought about the discovery that deoxyribonucleic acid (DNA) is the genetic material, has opened living systems, humans among them, to a level of scrutiny, understanding, and possible manipulation that was unsuspected when Aldous Huxley published *Brave New World* in 1932. The recent discoveries in the biological sciences could be as paradigmatic as those of Nicolaus Copernicus, Sir Isaac Newton, and Albert Einstein in the physical sciences and the contributions of Martin Luther, Karl Marx, and Sigmund Freud in the social world. Probably before the end of the century we will have the complete DNA sequence of a human being. In essence, this sequence of approximately one billion bits of information represents the complete blueprint for a human. The body of knowledge already at hand and its possibilities for practical use has changed permanently our private world, the means of communication and interaction with one another and with the environment. Not surprisingly, there is significant confusion and controversy about the meaning and impact, both positive and negative, of the recent scientific discoveries and technical advancements. Society is becoming polarized between proponents of change and those committed to the status quo and preservation of the accepted social order. To the extent that there are many common features in the nature and social reactions to scientific discoveries, there might be something to be learned about the impact and dynamics of the current ones from a cursory analysis of how we have come to our present understanding about the living world and the place that humankind occupies in it.

The history of biology, of which humankind is an intrinsic and fundamental part, is the history of the struggle over the differences between the animate and the inanimate worlds, the material and the immaterial. Aristotle believed that living creatures could arise spontaneously from mud, and Ovid in his *Metamorphoses* describes the creation of man from clay by Prometheus. This perception of the natural world as a single interchangeable system, in which reversible transformations between living and nonliving things were entirely possible, was the basis of the ancient world and was widespread until the Renaissance.

Until the end of the Renaissance, the understanding of man had been based more on myth than on science. Both—myth and science—provide representations of the world and the laws that supposedly govern it. In absence of scientific explanations, myth has served to provide a coherent and unifying explanation of a bewildering set of phenomena that have impinged upon the fate of man since the beginning of recorded history, including the only explanation of the nature and origin of humankind.

Like myth, scientific developments have had a profound impact on the nature and content of artistic production. While explanations about the physical world and its representation began as the main domain of the arts, they have increasingly become the purview of science. Art, however, has continued to play a fundamental role in the analysis and definition of the essence of human nature, its meaning and its place in the universe.

The end of the Renaissance saw the birth of modern science when man changed his relation to the outside world. That change came through improved methods of

observation and increased exploration, together with the invention of instruments, such as the lens and the telescope, that expanded the range of his senses. As a result of this perceived changed in the outside world, both art and science attempted to describe a universe that would be in better agreement with the evidence coming through the improved senses. Copernicus's cosmology displaced an Earth-centered universe for a more realistic one. With the invention of perspective and foreshortening, the artist's role was transformed from a symbolic function to a representative one.

Despite the changes in the understanding of the physical world, knowledge of human nature was rudimentary. Anatomy, at the time the most advanced of human sciences, was an activity as much the province of the painter and sculptor as the physician, and its import was limited. Disease was not directly related to body function and, therefore, it had no anatomical basis. At the end of the Renaissance, however, knowledge of living organisms became based on the relation between structure and function, as demonstrated by the description of the circulation of the blood by William Harvey in the seventeenth century. But, even with this knowledge, the image of humankind remained static. Humans had originated from the hand of a creator in their present form and stood apart from the rest of the living creatures. Modeled on their creator, there was little room left for change. It was not until the second part of the nineteenth century when, with the development of thermodynamics, time became a central concern. In that new intellectual environment a novel theory of evolution and the first modern understanding of the origin and nature of humankind was formulated.

Charles Darwin realized that the distribution of forms and structures among different species, throughout distinct geographical spaces, actually reflected a distribution in time. Although this insight placed humans at the apex of the evolutionary pyramid, it also produced a profound realignment in their self-perception. In place of his direct and unmediated descendance from the gods, man had to accept a family relation with the other living creatures and a piecemeal evolution from the reptiles through the monkeys. The theory of evolution did more than challenge the creationist world. Although it took the living creatures away from the benevolent protection of the gods and threw them into the roulette of natural selection, it provided an optimistic counterpoint to that being developed by the physical sciences. According to the Second Law of Thermodynamics, as energy leaks out of the world, its entropy increases and the ability to maintain organized structures diminishes, giving rise to a more disorganized system with less internal diversity. Thus, the Second Law points toward an increasingly homogeneous world and, from a human perspective, a pessimistic future. Darwin's theory turned this problem on its head. The living world that emerged from Darwin proceeds from the lower to the higher forms of life, from the simple to the complex, from the undifferentiated to the highly specialized structure. The living world becomes more organized as it ages, advancing to higher forms as it moves on the arrow of time.

The intellectual climate of 1859 was ready to accept evolution. Yet it has taken more than a century to accept the basis of evolution—natural selection. Against the argument of a goal-oriented design by a creator, Darwin demonstrated that what appeared to be goal-oriented changes in the living world—the development of better legs for locomotion, better wings for flight—were in fact the result of random change, followed by natural selection. Chance and necessity became the two central tenets of the living world, with a meaning more concrete than the one given by the philosophers.

Chance is the random appearance of different characteristics in a living population, what we now know as mutations—the accidents of nature. In themselves, these new characters are neither good nor bad, but are the creative force of evolution. Necessity is natural selection. Among the multitude of random variants that are produced continuously, it selects those better suited to their environment. So, the same trait can be highly advantageous in one setting but detrimental in another. In this world, time and place have become essential determinants of success. Instead of a master plan for the living world, the inescapable conclusion of the Darwinian theory is a sobering one. The present living world and the position of our species in it, of which we are so proud, was not the result of a preordained plan but just one among many possible outcomes. The current distribution of living creatures is the result of innumerable chance events. It could have been quite different, or it could have not happened at all. It always comes as a surprise to realize that the number of species now living in the animal kingdom is estimated to be a few million, while the number of extinct ones has been evaluated at about 500 million. Thus, some 99 percent of all animal species that once lived on Earth have disappeared, making possible the world in which we live.

From the beginning, the Darwinian theory of evolution had a special significance because it provided an account of the history and present state of the living world and humankind's place in it. Such a powerful theory could not escape abuse and misuse. Enthusiastic Darwinists rapidly gave the theory a mythical status. Like all myths, it was interpreted not only to contain a universal explanation for the evolution of the biological world but also to give human life its meaning and ethical values. In the pre-Darwinian world, because all creatures were the direct product of God, the living universe was ruled by moral laws. After Darwin, attempts were made to reverse the situation and draw moral laws out of the knowledge of the natural world. From the time of its publication, natural selection was entangled in ideological disputes and used as scientific justification for the status quo. Colonialism and different totalitarian political systems, racism and male ascendancy were, and in many cases continue to be, justified on this basis. The tendency to explain moral behavior on biological considerations was further reinforced with the advent of genetics at the beginning of this century. The search for biological answers to moral and ethical questions, however, represents a perversion of science.

The task of biology is to explain how human beings have evolved the capacity to hold moral beliefs. Biology, however, cannot explain the content of those beliefs. Philosophies and moral codes are cultural products, not physiological processes. Even if temperamental and cognitive differences between sexes and races do exist, that does not mean they are biologically based and the result of natural selection. Even if that were the case, it would not justify placing people in different social roles based on their sex or racial identity. There is no more justification in seeking an evolutionary and genetic explanation for moral and social codes of conduct than there would be to seek such explanation for aesthetics. This reality, however, does not prove the opposite point of view, which attempts to deny the existence of genetic differences among individuals. We are not all endowed with similar physical and intellectual capacities. The "rights" and "wrongs" are determined by social context, not by biological determinism.

Despite the improved knowledge of human nature, the relative influence of genetic and sociocultural factors in the inheritance and development of acquired characters remains one of the most hotly debated issues in our society. Various forms of

biological determinism still subscribe, implicitly or explicitly, to the notion that shared behavioral patterns—cultural, economic, and sexual performance and preference among different human groups—is an accurate reflection of their biological worth. This misconception, which resulted from attributing to biological processes qualities that are characteristic of the human brain, arose and continues today because of a failure to distinguish between biological and cultural evolution. Biological or Darwinian evolution occurs very slowly. It takes millions of years to produce appreciable differences in a species. From the genetic and paleontological evidence available, it is clear that the biological endowment of humans has not changed in a measurable form during the last two million years. In fact, the human genome is still more than 90 percent identical to that of the chimpanzee from which it split six to eight million years ago. The cave man, the bush hunter, the crusader, and the Wall Street lawyer are not distinct stages in the biological evolution of mankind. The differences among them are cultural, and this attribute is what makes humans fundamentally different from other living beings. With the development of a large brain, humans acquired the capacity to store and transmit learned information from one generation to the next. That was the great breakthrough in evolution. Contrary to other mammals that find a tabula rasa at the beginning of their lives and take with them their learned experiences, human knowledge has become cumulative, which explains the accelerating nature of cultural evolution and discovery. Nurture—culture and knowledge—evolves very rapidly, while nature—the biological make-up—evolves very slowly according to the Darwinian dictum.

Theories of evolution and genetics have influenced legislation as well as dictated social mores and thus shaped in large measure the structure of our society. It is astounding that most of this impact occurred long before the true basis and the nature of the hereditary principle were understood. The discovery that DNA is the genetic material as well as the basis of life, the unlocking of its workings, and then learning how to manipulate it at will have occurred in the past half century, most during the past twenty years. The effects of these discoveries on the social fabric are just beginning to be felt. Because they have transformed our role, from spectators to active participants, in the manipulation of the material basis of life, it is likely that their consequences will be tremendous and lasting.

By the early 1950s, DNA had been accepted as being the genetic material. Yet, the manner by which this molecule, composed of monotonous repeats of only four building blocks in shapeless strings, stored information and transmitted it faithfully from generation to generation remained a mystery until James Waston and Francis Crick provided a model that, with unsuspected simplicity, fully explained both. The two chains of DNA are twisted around each other into a double helix in the shape of a spiral staircase. The stands are composed of building blocks of four different kinds called adenine, thymine, guanine, and cytosine, abbreviated A, T, G, and C. Watson and Crick's master discovery was to realize that the four building blocks formed the steps and not the balustrade of this staircase. The beauty of this arrangement is that each step is formed by two letters that are complementary to each other. An A is always paired with a T, and a G with a C. Therefore, knowing one half of the staircase is sufficient to predict the other. In this simple manner, each chain carries the information needed for its duplication. The astonishing aspect of this process is its universality—it is used by all living organisms, from the humble bacterium to the most arrogant human being. To

everyone's surprise, the process of heredity turned out to have an extremely elegant minimalist solution.

A tremendous amount of information can be stored in the DNA in a continuous string of A, T, C, and Gs, the letters of the genetic alphabet, because the string is decoded into three-letter words according to the so-called genetic code. Life, for its tremendous complexity, has a very simple vocabulary composed of a total of twenty words and a few punctuation marks. Each word codes for a different amino acid, the building blocks of proteins. Each and every one of the living organisms on Earth is a combination of the same twenty words (amino acids). The words are arranged into sentences, called genes, each coding for a different protein. The genetic sentences form paragraphs, so that many genes can be organized into structures of higher order to carry out complex functions. Since the same word and sentence (gene) can be used in many different contexts, the capacity to create different structures is practically unlimited. The simplicity of the system is what insures its accuracy and fidelity. Every second, many millions of cells in our bodies divide. It is one of the marvels of DNA that each time a cell divides, two strands of DNA each containing around one billion building blocks are copied faithfully, in a manner of minutes and with, on average, a single mistake. In an era when we are awed by the speed of computers and the fidelity of copying machines, it is sobering to realize that evolution, through slow but persistent tinkering, has produced a mechanism to store and reproduce information many ways superior to our best accomplishments.

When the complete human DNA sequence is available, we will have the whole set of blueprints needed to make one. This string of approximately one billion A, T, G, and Cs is the biological essence of mankind. Moreover, because this sequence of DNA is the product of several billion years of evolution and its mutation will dictate the changes that are possible for our species, both the past and the future of humans as a biological entity is imprinted in its DNA. Yet if we had expected that mastering the human DNA sequence would give us access to the genes encoding the human spirit we are in for a serious disappointment because those genes do not exist. An explanation of the anatomical and biochemical basis of our rationality is very far off. The main problem is not only that there is not a body of coherent knowledge about this process, but that we do not even know how to formulate well-framed questions that are relevant to the problem.

During the past decade, with the advent of the techniques of genetic engineering, we have learned to manipulate the DNA of humans and other species. It is now possible, and relatively simple, to isolate genes, grow them in tremendous quantities and reintroduce them into cells and embryos, which in turn, will pass them on to their progeny. It has become routine in the laboratory to create hybrid animals that contain genes from several species. Novel living organisms with unique combinations of characters are produced daily. A whole new industry has emerged to produce manmade genes in the laboratory starting from chemical reagents. These developments have occurred hand in hand with mastering the techniques for in vitro fertilization, artificial insemination, culture of embryos in the test tube, and the capacity to keep them frozen for extended periods of time. We have also learned to manipulate the immune system, so that the capacity to distinguish between self and nonself can be altered. That knowledge has opened the door to an increasing variety of organ transplants. In many ways, the

present technical capacities have surpassed the world imagined by Huxley in *Brave New World.*

For some people, the very notion of tampering with the DNA conjures up the most terrifying myths and produces the deepest kind of anxiety. It brings up the horror of Hieronymous Bosch's creatures, of beings mutilated or unnaturally joined together for eternities. Even more than organ transplants, it represents the ultimate form of appropriation, for while an organ is appropriated for a single life, DNA is taken forever, passed on from generation to generation. Therefore, that knowledge has the smell of the forbidden. In every culture, from the oldest myths on, humans that aspire to it have been harshly punished by the gods.

What is curious about this point of view is that it misses the point. Most of the issues raised by the biological revolution have been around for many centuries. What is different now is that the new technology can do more rapidly and efficiently what we were doing before inefficiently, by trial and error in the course of many generations. All domesticated species of plants and animals are the product of this tampering through breeding. The human genome has many pieces of DNA that come from viruses that are now part of our genetic make-up. It has been recently demonstrated that sperm is a perfect shuttle to bring foreign genetic material into the gene pool of a species. So, what is all the fuss about?

The course of evolution and the impact of natural selection have also been modified by and for the human species. Instead of letting nature eliminate the malformed, genetically defective, weak, and old, as is the case for all other species, we have allocated most of our medical resources for their survival. In 1989 we will have spent 12 percent of the gross national product in health care. Most of those resources will be used to fight natural selection and the effects of forces of nature and chance on humans. During the past twenty years, this tampering with natural selection and fight against forces of nature has initiated the most important demographic changes in our history. Those changes have been brought about not by genetic engineering but by the continued application of scientific advances to hygiene, nutrition, shelter, and health care. As a result, the twenty-first century will be a gerontocratic one. People in the seventh decade of their lives and older will be the most numerous, with all the economic and social consequences.

The increasing number of people who reach the end of the full biological life span makes it more clear that, what we care most about is not quantity but quality of life. What we want is the power to reduce the amount of physical and mental suffering. The DNA revolution is a means to that end. It will make important contributions through development of a new understanding of aging, production of new therapeutic drugs, and pre- and postnatal genetic screening to identify individuals at high risk for certain diseases. Approximately four thousand defective genes known to cause diseases in humans have been identified. It is already possible to screen for a few dozen, to ascertain that we are not passing them on to our children. Before the turn of the century it will be possible to screen for many hundred more. If we are so proud that smallpox and polio have been practically eradicated, do we not want to eliminate cystic fibrosis, Alzheimer's disease, and sickle cell anemia, among others? Should all parents not have the option to decide the legacy they want to pass on to their children? For many, the possibility conjures up the

nightmare of government-run eugenic programs that will impose birth control on certain groups of people—a valid indictment not of science but politics. In the midst of the thrill of debate about abortion, genetic screening, and AIDS testing, Galileo's plight comes to mind. He, and the world of rational sciences represented by him, were excommunicated because they threatened the status quo represented by the concept of an Earth-centered universe. The forces of conservatism had a temporary victory, but after all, the Earth continues to turn around the Sun. It is worrisome, however, that at a time when science has more promise to improve the quality of human life than ever before, a democracy that is misinformed and uncultivated about science might accede to the political blackmail and intimidation of bigoted groups that would like termination of pregnancy, genetic screening, and work on DNA to be banned altogether. It is a sad fact that societies have always embraced means of mass destruction with more alacrity than measures to improve their lot. Although the long-term outcome of the present debate is not in doubt, the short-term balance depends on our ability and commitment to elect an informed and socially responsible government that perceives the risks and rewards of science. We should come to understand that for progress to occur it is imperative to be willing to accept small risks in order to reap great benefits. A world without any risks is utopian. Absolute safety cannot be bought even at an infinite price.

When we analyze our behavior across centuries, it is clear that we as a species, including the most romantic lovers of the rational world and the most zealous believers in the sanctity of the genetic material, decided a long time ago that we wanted to be masters of our destiny, that we would leave to chance only the events that we could not control. It is in our nature to be tamperers and tinkerers. With some short-term setbacks, knowledge and mastery over the physical world is what has brought us to the end of the twentieth century. If we take the long view of our track record as tenants of the planet, it is better than that of any other species. We have come a long way in the past two thousand years and our rate of improvement has been accelerating rapidly. Is it not proper to start the new millennium with the highest optimism and faith on the best accomplishment of evolution, our brain? Its genetic imprinting and capacity for improved hardwiring are astounding. Let us have faith in its ability to accommodate an uninterrupted rate of cultural evolution.

Vijak Mahdavi and Bernardo Nadal-Ginard are Professors at Harvard Medical School.

The Money Game

Michael M. Thomas Art and cultural historians examining the 1980s would be well advised to follow the advice given the journalists investigating the Watergate scandal: Follow the money.

Had Ralph Nickleby, Nicholas's avaricious uncle and a true believer in the power of money, lived through the past decade, he would have thought he had died and gone to heaven. Never in the memory of most alive has money carried so much of culture before it as it has in the Reagan years and their immediate aftermath. To those not young enough, energetic enough, and sufficiently unfettered by tradition to have given themselves wholly to the kinetic, hypervisible, and to some eyes anarchic art scene of the 1980s, this has been a decade that, to use lyricist W. S. Gilbert's happy phrase, has "burst the bonds of art."

In a way Mr. Nickleby was merely expressing one of the theologies of capitalism dominant in Charles Dickens's time, namely the waning years of the Industrial Revolution, when the financier and rentier came to replace the inventor and industrial entrepreneur as the dominant figures perched on the summit of the capitalist pyramid. In this connection it should be recalled that just as cultural historians scramble to characterize the present age as "postmodern," so do economists and other students of socioeconomic change describe it as "postindustrial." In a sense we have come full circle.

Today's theology holds paper money and its proxies sacramental and sovereign. The electronic blip traversing the money wire and computer screen at lightning speed performs the transubstantiational—some would claim "alchemical"—function of the elevation of the Host, and the transaction is omnipotent. It would be surprising indeed if the making and trading of art did not powerfully reflect this new theology.

This writer regards much of the financial hyperactivity since 1982 as an unsound and, in the long run, unproductive sopping up of a monsoon-like liquidity that began to drench the world in the early 1980s, largely as the result of the increasing globalization of world commercial and financial markets. In the same spirit, almost without exception, I believe that the new art most actively promoted and successfully marketed in the last decade will come to be recognized as meretricious, cynical, calculated, and, above all, market-driven—"trendentious," one might say.

Some years ago, during my early art-historical training, in the course of trying to understand the nature of fifteenth-century patronage, I realized in a not altogether brilliant aperçu, that art follows prosperity as night the day. Carrying that thought a step further in the years that followed, I have come to believe that the way money is spent, on anything from personal furnishings to works of art, has everything to do with how it is made and by whom. Those who have acquired money too easily tend to be careless with it, hence the oft-noted failure of inheritors. Those who have worked hard for it tend to hoard it. Those who have gained it by cleverness or chicanery tend to disburse it to purchase the appearance and accoutrements of solid respectability. And those who just seem to attract it, as have innumerable people on Wall Street since the great stock market breakout of 1982, have little or no idea what to do with it and tend to flail about with their fistfuls of dollars seeking less in the way of validation of their respectability than confirmation of their market shrewdness. One of the principal beneficiaries of this tendency has been the art-dealing *banlieues de mode* in New York and other artistic centers.

Like the many other forces subject to Parkinson's Law and variations, art seems to expand in quantity to absorb the money available for its consumption. A corollary is that expenditure is inhibited in inverse degree to the "reality" of the money to hand.

Those to whom money comes hard, either physically or—as in the case of the Presbyterian Maecenases of the turn the century, Henry Clay Frick and Andrew Carnegie, among others—spiritually, spend it scrupulously and insist on value, namely, certification by the endorsement of a respected avant-garde.

In the present age money has ceased to be money in the conventional sense, which has greatly affected the way it is felt, in a visceral sense, and the way it is handled. A million dollars today is, in fact, an infinitesimal blip, one of several trillion particles making up a whirling electronic universe it would take the mind of a scientist like Stephen Hawking to encompass. A billion dollars is simply another blip. Some years ago, watching the price spikes in the auction market, a witty observer declared: "It's not that the art isn't worth the money, it's that the money isn't worth the money." Additional pressure for disembodiment comes from abroad, from foreigners whose view of American fiscal policy ranges from the derisory to the disbelieving.

People in America seldom touch money any more, even in small amounts. Only the poor pay cash. When money is not an item on a computer screen or printout, it tends to be represented by one or more small embossed plastic rectangles. In such an environment it then becomes unreal, protoplasmic, cut loose from the ancient materialities that added in some way up to "meaning." In addition, the inevitable by-product of a liquidity surge is a credit expansion. Since 1982, credit transactions on every scale from multibillion-dollar leveraged buyouts of entire corporations to fifty-dollar credit card purchases have been executed in a burgeoning, ebullient, blindly self-confident buyers' market. We have before us the consequences of that process in the savings and loan disaster. Who is to say that the same "value carnage" may not be experienced when historical judgment comes to render its verdict on the art of the present and very recent past.

For at least two centuries, *a billion* was a term of almost supernatural resonance in capitalist discourse. Real money, serious money. Today, it is a commonplace, tripping as casually off the lips of unseasoned Wall Street types as the day's weather or baseball score. For many people over forty that fact has been difficult to grasp—arithmetically, emotionally, and in some cases politically. To them, it seems totally unconnected with everything they were taught to expect at the cash nexus and thus fraught with the short, sharp shock of the revolutionary.

This has been an age of financial revolution, make no mistake about it. *Revolutionary* is the word used more than any other by the apologists and analysts of the age to characterize the innovative finance of the years of Michael Milken, Ivan Boesky, Kohlberg Kravis, and the leveraged buy-out, the globally integrated world financial system, the enormous world and individual build-up of debts and deficits. In that connection it is only to historians after the fact, and the disenfranchised, of course, that a revolution is ever less than a wholly constructive alteration in the scheme of things.

In finance, "change" has become "overthrow," an equally resonant revolutionary connotation. The principal outcome has been a shift on Wall Street from the dominance of nurtured, long-term, multiconstituent (investor, employee, business customer) relationships to a state of affairs in which the transaction is granted omnipotence and only the interests of investors and their agents are considered to matter. The philosophical or moral basis of the transaction, its aesthetic if you will, ceased to be its productivity or its social or commercial utility. That it could be, and was, executed served as justification and beauty enough.

This reorientation brought in its wake an almost savage termination of earlier ways of doing business, an opportunistic displacement of traditional values and loyalties and at times a scornful abandonment of venerable practice and principle and anything with roots in the unprofitable past. In its early stages this new mode ran well ahead of the ability of its apologists to come up with a coherent ideology. Soon, however, two approaches developed: a public, professorial "analysis" that could be easily interpreted as propaganda or objective, disinterested fact-finding; and a private, gloating and often bloodthirsty rhetoric of vindicated personal alienation that would do credit to such revolutionaries as Kropotkin or Robespierre.

In such conditions time itself breaks up into discrete parts. An enterprise that may have sunk its roots in commerce and community over a century can be disassembled by a takeover artist in a matter of weeks. Continuum means nothing. Relationships mean nothing. The modern financier lives and dies by the transaction. Each day is wholly new, the wheel subject to endless reinvention. There is no need for coherence because there is no advantage to coherence. Action is all, and the philosopher kings and theologians of action are the promoters and agents, in finance the investment bankers and their apologists, in art the dealers and their creatures in the media. Critical judgment is neutered by celebrity, censure collapses in the face of success.

In sum, finance is now in the grip of a promotional mentality defined by new products, that is, new ways to draw investors into the game. The individual trade—whether of one hundred shares or an entire corporation seems to make little difference—is the focus of attention and effort. Time is defined essentially in terms of the present. The past is encumbering and the future ambiguous, the long-looking idea of a career too hedged with uncertainty. Get it now. Go for it.

Without going into tiresome detail, this attitude represents a momentous shift, a breakaway into a new orbit, in the *modus pensendi* of a financial system that, American dominated, took all of five decades to cast aside the stigmatizing memories of the 1929 crash.

Finally, one has to take into account what seems the most discouraging, and potentially self-destructive, characteristic of the current financial system: a pervasive cynicism about the system itself within the system itself, a conviction that success boils down to what one can get away with, accompanied by a corollary belief that gives teeth to the premise that these days —at least until recent months—anything goes. The publicized felony indictments on Wall Street have, as of this writing, done little to abate this attitude.

Money is everywhere, seeping through the slightest chink and crevice, undermining even the most well-sited embankment, dominating the discourse, shouting out other voices in the room. Wherever it goes, it brings along its own habits and ways of seeing and doing, its particular sense of itself, if you will.

How long this may continue is anyone's guess. By 1990, when this essay sees print, the carmagnole may have ended or it may be louder and more frenzied than ever. I leave it to my readers to draw their own conclusions as to whether, and how, any of the troubling and troublesome characteristics of the money game may have transferred to the art world and what that might mean in the long run, when, as economist John Maynard Keynes observed, all of us will be dead. And only art shall have escaped to tell our story.

Michael M. Thomas, a novelist, is a contributing editor at The Nation *and columnist for the* New York Observer.

Minds and Screens: Mirrors for the Postmodern

Sherry Turkle

Emerson said that "dreams and beasts are two keys by which we find out the secrets of our own nature. They are test objects." Like us and not like us, they were the mirrors for modernism, the test objects of Freud and Darwin. The computer is our new mirror, the mirror for the postmodern.

Like dreams and beasts, the computer stands on the margins. It is mind that is not yet mind. It is inanimate yet interactive. It does not think, but neither is it external to thought. It stands poised between the thought and the thought-of. On the boundaries between matter, life, and mind, it causes us to rethink the way we have drawn the lines.

Computers are psychological machines, not only because of their as-yet very primitive psychologies but because they encourage us to reflect upon our own. They are evocative objects, not only because of their existence but because of their availability. Current reconsiderations of mind and machine, refracted in the language of art, are sparked by people's relationships with an object that they can touch, use, bring into their homes. As computers became ubiquitous in the 1980s, they carried with them a new culture of the self. And they carried with them a new technological aesthetic.

Computers provide new forms of representation—the inscription of reality in program. They provide a new kind of object—the computational object: frozen on the screen, belonging to the world of the physical and the mathematical, the concrete and the psychological. They provide a new set of ideas for thinking about process—among them, powerful ways of thinking about recursion, self-reference, simulation, and the interaction of inner objects to create emergent phenomena. Together these ideas shape an aesthetic that depends not on the real but on its representation and appropriation, not on tangible objects but on the reflection of mirrors in mirrors—the play of signifiers torn from what they signify.

Postmodern art communicates the sense of a world lived through substitutes, registering a sense of reality as if perceived in exposure, through the eye of a lens. The computer presence heightens this sensibility and moves us toward a sense of reality as if perceived on a video screen.

This electronic reality provides new and compelling forms of interaction. One can become lost in the idea of mind building mind and in the sense of merging with a universal system. The computer offers a promise of perfection. The world on the screen has the purity of thought unsullied by the messiness and complexity of the real. And instead of a quest for an idealized person now there is the computer as a second self.

The experience of programming is of the appropriation and externalization of thought. Like Narcissus and his reflection, people can fall in love with the artificial worlds they have created or that have been built for them by others. The experience is heady. For some it is reassuring. Insecure in our understanding of ourselves, decentered by psychoanalysis and structuralist and deconstructivist philosophies, we search for mirrors not only to admire our reflection but to see who we are, indeed if we are. When mind is embodied in program there is the fantasy both of projection of self and of achieving a meeting of the minds with a machine.

Mind meeting or merging with machine is a powerful theme for the contemporary sensibility, touching a point of painful vulnerability. Our characteristic malaise is not dominated by sexual repression but by the fragility of self and thus the impossibility of connection. In hysteria, the neurosis of Freud's time, a sexual thought found its expression in a physical symptom: a paralyzed limb spoke for an unacceptable

wish. Today, cases of hysteria have virtually disappeared. Indeed, clinicians report that patients rarely suffer from a clear symptom at all. Early experiences of love rejected are transformed into rage against the other who frustrates and terror before the other to whom one is so vulnerable. There is lack of feeling, fear of relationship, a sense of emptiness and not being. These symptoms translate into a paradox: a terror of intimacy and a terror of being alone.

Machines come into this picture in several ways. One can find oneself in the machine. One can see oneself as the machine, and one can turn to the world of machines for what is too frightening to ask of other people: one can turn to the machine for relationship. With the computer, each possibility is enhanced. Programming is a new projective screen and confirmation for the self. As a "mind machine," the computer offers increasingly sophisticated models with which to identify. And finally, to the terror of intimacy and the terror of being alone, the computer offers a schizoid compromise. Interactive and reactive, the computer offers the illusion of companionship without the demands of friendship. You can be a loner yet never alone.

The mirroring of mind in the machine and as the machine are compelling but not always reassuring. In many ways what we see there is an affront. If mind is machine, who is the actor? Where is responsibility, spirit, soul?

Copernicus and Darwin took away our special role as the centerpiece of creation, but we could still think of ourselves as the center of ourselves. Freud's notion of the unconscious subverted the idea of the centered self—our personal drama is played out on another stage with other and unknown actors. But the Freudian unconscious had a certain abstract quality. It allowed people to slide between "I am my unconscious" and the more acceptable "I am influenced by my unconscious."

The theorists who followed Freud reasserted the power of an active and autonomous ego, making it easier for psychoanalysis to enter the general culture as a triumph of reason over the uncivilized within each of us. Psychoanalytic ego psychology offered a version of the unconscious acceptable to the conscious. The computer's threat to the "I" is far more relentless. The computer culture takes up where psychoanalysis left off. It takes the idea of a decentered self and makes it more concrete by modeling mind as program or as multiprocessing machine. The "I" is a collection of rules or inner programs, whose connections, negotiations, and competitions create their own illusions.

Psychoanalysis has taught us that resistance to a theory is part of its cultural impact. Resistance to the idea of the unconscious and the irrational leads to a view of people as essentially logical beings. Resistance to a computational model of mind leads to the view that what is essential in the human is what is uncapturable by any language or formalism. When we use computational models to explain more and more of our behavior, we seem compelled to define as our essence something we can think of as beyond information or computation.

Images of mind as program, mechanism, and information processing have provoked their own reactions. Although many feared that computers would lead to increasingly mechanistic views about people, the reality has been far more complex. People seem willing to allow almost unlimited rationality to computers while maintaining a sharp line between computers and people by taking the essence of human nature to be what computers cannot do.

But defining people in relation to what computers cannot do in terms of

performance leaves one in a highly vulnerable position, vulnerable to what clever engineers might come up with next. There is a more subtle response. People begin by admitting that human minds are some kind of computer and then go on to find ways to think of people as something more as well. When they do so, their thoughts often turn to their feelings. The human is the emotional. Or, the human is the unprogrammable.

As a self-conscious response to Englightenment rationalism, what Romanticism longed for was clear: feelings, the "law of the heart." At that time, in reaction to the view that what was most human was reason, sensibility was declared more important than logic, the heart more human than the mind. Now, with the language of programming, the computer provides us a new discourse for describing the divided self. On one side is placed that which is simulable; on the other that which cannot be simulated. People who say they are comfortable with the idea of mind as machine assent to the premise that simulated thinking is thinking but cannot bring themselves to propose further that simulated feeling is feeling. Simulated love is never love.

In the notion of simulation lies a complexity and contradiction in what the computer contributes to the postmodern sensibility. Simulation is taken up as a way of defining people in opposition to the computer even as it is used to model the human mind. And simulation becomes central to the way we deal with the world beyond our minds. We appropriate that world by bringing it within the confines of the machine. We use computers to create artificial worlds whether to simulate the behavior of economies, political systems, or imaginary subatomic particles. And once created we work within them.

Video games and adventure games, business spreadsheets, educational microworlds that teach the principles of physics, all have become everyday objects. In some, there is the effort to model a physical reality that can be experienced directly. In others, there is the effort to model an invisible but theoretically confirmed reality—a program simulates what it looks like to travel down a road at nearly the speed of light; shapes are distorted, they twist and writhe; objects change color and intensity.

But it is the very nature of programming to make no such demands for confirmation either physical or theoretical. When you program you can build straight from the mind. The rules of the program need not respect the physical laws that constrain the real world. You can build a world that never existed and that could never exist. A virtuoso programmer describes how as a child he took clocks apart and tried "to put them together in new ways, to make new kinds of clocks." But while there were limits to how far he could make the materials of a clock into something new, programming presents him with none. His associations are to liberation and creation, and they fly from programming to parenting. "Why do you think people call ideas brainchildren?" he asks. "They are something you create that is entirely your own. A chip off the old block." The program provides generativity without sexuality; the computer culture brings us "mind children" freed from the constraints of biology. And unlike other mind children that were embodied in artifacts—books, paintings, sculptures, photographs—the program may interact with you, respond to you, surprise you.

Nature can be captured (enhanced or devalued) in an artifact or appropriated in a photograph. In a program, nature can be simulated or left aside altogether in favor of a constructed world limited only by one's powers of abstraction. The physical object disappears; the computational object remains. It is an ambivalent object. You can play

with it as you would a dab of paint, a Newtonian particle, or Euclidean point. Belonging to the world of the physical and the abstract, it transcends the limitations of each and blurs the line between them.

Philosopher Jean Baudrillard has described a world of such objects—a universe characterized by simulation rather than representation, a world without origins where the various signs for reality have come to substitute for reality. It is a world of formal systems, artifice, and manipulation. It is reflected in an art whose problems are epistemological, expressed through an appropriation and radical displacement of both object and image. What is it that we see before us? It is not a rabbit but an inflatable toy. It is not an inflatable toy but a mirror. Is it about biology or replication? Is it about the art or what the art is not? Artists confront us with the epistemology of absence rather than presence; programming validates their aesthetic of combination, recombination, and code.

The 1980s have been a turning point. The idea of program, of artificial intelligence and simulation, became interpretive myth for the culture as a whole. The new myth separates feeling from thought, subject from object, reality from representation. "Purified" thought, objects, and representations circulate but not freely. They take the form of images on a screen. Engaging with them requires that we companion a new transformative technology. Intimacy with a camera allowed the appropriation of signifiers with no necessary external referent. You court an object that produces an ephemeral, electronic trace. The photons dance; there is no one and nothing to touch. The movement from photograph to screen image is the most recent step in the historical devaluation of the artifact. Beyond mirroring, photographing, and rephotographing the real we move on to pure simulation: the appropriation of the hyperreal.

Sherry Turkle is the author of Psychoanalytic Politics: Freud's French Revolution *(New York: Basic Books, 1978; reprint, Cambridge: MIT Press, 1981) and* The Second Self: Computers and the Human Spirit *(New York: Simon and Schuster, 1984; reprint, New York: Touchstone, 1985). She is Associate Professor of Sociology in the Program in Science, Technology, and Society at Massachusettes Institute of Technology.*

Representation and Sexual Identity

Simon Watney
To speak of sexuality and the body, and not also speak of AIDS, would be, well, obscene.
B. Ruby Rich, "Only Human: Sex, Gender, and Other Misrepresentations"

We must step back from the problem a moment to ask what on earth the category of the body is. Because in some sense it is obvious, perhaps it is also misleading.
Parveen Adams, "Versions of the Body"

On Friday, April 13, 1821, eighteen-year-old John Horwood was executed in Bristol, England, for the murder of one Eliza Balsum. The judge had ordered that his body should be "anatomized"—that is, dissected. The anatomist was an eminent local surgeon, Dr. Richard Smith, who was also something of a phrenologist. The chart that was made from the bumps on the dead boy's head apparently demonstrated that Horwood was "really quite a friendly sort of chap." Nothing was overlooked. Even Horwood's skin was saved for tanning and eventually used to bind Smith's detailed account of the entire grisly business. The book is now in the Bristol Records Office, one of only a dozen or so such survivals, complete with its transcript of the trial. The case against Horwood was extremely weak, and there would have been no case against him by today's legal standards. The treatment of the boy's corpse spoke eloquently of then-held beliefs and values—in phrenology, the law, passionate crime, retributive justice, and the emergent disciplines of modern pathology and clinical medicine. We may find the conjuncture of medicine and punishment especially disturbing, yet it remains a powerful relation in the twentieth century. The distinguished American historian Robert Jay Lifton has described in great detail the central role played by medical science at every stage in the planning and implementation of the Nazi death camps.[1] Moreover, medicine is also centrally involved in the public definition and regulation of sexuality and the biomedical administration of human bodies.

In an important essay, the British feminist critic Parveen Adams has drawn attention to the exact status of the category of "the body" as an object of knowledge, arguing that:

We must step back from the problem a moment to ask what on earth the category of the body is. Because in some sense it is obvious, perhaps it is also misleading. Perhaps because psychoanalysis is taken to be a theory of psychical mechanisms, it is all too easy to imagine that the body is what is external to it, some irreducible given system. This is made even more plausible when one considers that the body is also the object of clinical medicine, an organic domain subject to the laws of anatomy and physiology.[2]

Yet, as she pointed out:

The development of the body is not merely the maturation of the body and our passive perception of it. For psychoanalysis does not perceive of perception as an unmediated registration of a pre-given body. Rather, it has a libidinal theory of perception.[3]

One leading artist whose photographic work engages feminist analysis in a psychoanalytic context is Victor Burgin, who has observed:

Freud made it clear enough, in various parts of his work (see his discussions of voyeurism, fetishism, and psychogenic disturbances of vision) . . . that unconscious desire operates in our looking and being looked at.[4]

Throughout the 1980s much important art has been produced in relation to such concerns with sight and its relation to sexual identity, not least by Burgin himself.[5] Writing of the work of Burgin and Barbara Kruger, the feminist critic and theorist Laura Mulvey has described a "poetics of psychoanalysis" that draws attention to the workings of unconscious fantasy in all acts of looking and representation.[6] Such artwork has generally been concerned primarily with questions of gender, but it frequently also involves aspects of sexuality and sexual identity. For example, our attempts to determine the gender of Cindy Sherman's later self-portraits demonstrate the anxious work of the unconscious, struggling to stabilize and confirm our sense of sexual identity as viewers in relation to threateningly ambiguous figures. A "mistake" in the register of gender may have profound consequences in the register of sexuality, for as we constantly scan people in relation to their apparent gender, it is our sexual identity that is either confirmed or called into question. At its best, such art draws attention to just this process of visual scanning and the complex power of sexuality to demarcate licit (heterosexual) from illicit (homosexual) desire. The flip-side of such radically subversive art may be found in the hysterical tableaux of Ralph Lauren's catalogs and advertisements and their myriad avatars: images that defiantly embody the most conservative cultural and psychic defenses of the 1980s. In that world, maximized gender identities convert the actual, complex, and evidently terrifying world of social and sexual diversity into a densely overdetermined pastorale of pure, uncontaminated WASP heterosexuality. The authenticity of this elaborate fantasy-world is guaranteed and secured even in its proudly misogynistic exclusions of women or their ruthless reduction to the status of elegantly bonsaied baubles. Future readings of the role of sexual imagery in the art of the 1980s will have to address the question of the decade's increasingly violent polarization between the widespread cultural and political legitimation of bigotry and antigay prejudice and the forms of sexual radicalism that emerged in response. This turn of events has been most significantly posed by escalating attacks on the independence of the National Endowment for the Arts and the insistence by feminists such as Lisa Duggan that "the time has come to argue forcefully for the complete deregulation of consensual sexuality and its representations."[7]

Michel Foucault, Jeffrey Weeks, and many others have charted the history and significance of the emergence of the modern categories of sexuality and the topography of what Sigmund Freud defined as "object-choice": hetero-, homo-, and bisexualities.[8] Particular attention has been paid to the category of homosexuality, constructed at the interstices of medicine, psychiatry, sexology, law, sociology, and so on. For more than a century the pathological figure of "the homosexual" has been constructed in the likeness of supposed gender confusion, predatory perversion, and what is still frequently deemed "unnatural" sex. It is hardly surprising that a cultural politics of considerable sophistication has emerged to challenge the authority of this deeply ideological iconography and the punitive legislation and social reality that it protects. Yet we should also recognize that the category of "the homosexual" has another primary function, which is to sustain and protect its reciprocal twin—the category of "the heterosexual." Indeed, there is nothing more tellingly characteristic of the modern period than its nervous sense of an intimate, revealing, and possibly threatening link between the gender of the body in representation and the sexuality of the artist. Our uneasy awareness of the visceral maleness of Paul Cézanne's bathers, within a convention that since J. A. D. Ingres had

Bound manuscript, John Horwood, *by Richard Smith, surgeon.*

154

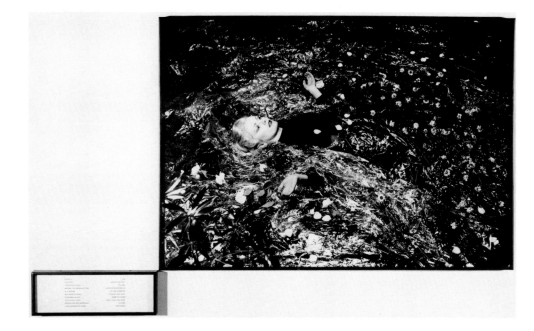

Victor Burgin, The Bridge—Venus Perdica, *1984. Black-and-white photograph, two panels, 35 x 60 (88.9 x 152.4) overall. Courtesy John Weber Gallery, New York.*

Cindy Sherman, Untitled, *1980–87. Black-and-white photograph, two panels, 7½ x 5½ (19.1 x 14.0) each. Courtesy Metro Pictures, New York.*

Paul Cézanne, The Small Bathers, *1896-97. Lithograph on paper, 14 x 17⅞ (35.6 x 45.3). National Gallery of Canada.*

Back page of The New York Crimes, *AIDS activism publication created and distributed by Gran Fury in coordination with ACT UP's 1989 demonstration.*

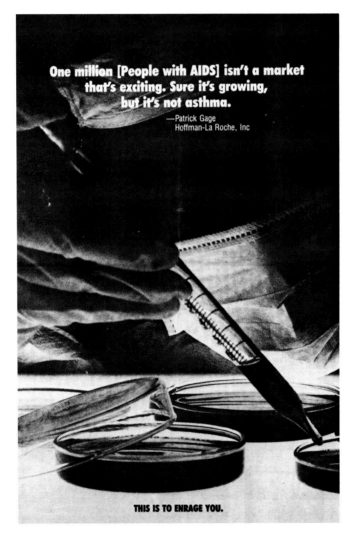

been overwhelmingly organized around the cultural spectacle of women's naked bodies, is a dimension of meaning to which we are now likely to be more sensitive. The re-evaluation of the homoerotic iconography of Giorgio De Chirico's late work is also typical of the sensibility of the 1980s. Some of the most significant art of the decade has charted this perilous domain, if often obliquely and intuitively. From Andy Warhol to Sandro Chia and Francesco Clemente, via Gilbert and George, Bruce Weber, and Mary Kelly, we are warned that our cherished and seemingly indispensable sexual identities are at best convenient fictions and at worst a dangerous delusion.

Nothing reveals this more clearly than the representation of AIDS in the mass media and far beyond.[9] It should go without saying that nobody chooses to get sick. It should also go without saying that a completely unknown and initially asymptomatic virus would be widely transmitted before its characteristics and modes of transmission were established. Yet as things stand, AIDS continues to be used to shore up the fragile categories of sexuality throughout the West, in the illusory belief that a plain gold ring is an effective prophylactic against a retrovirus that has an average of ten years' dormancy before symptoms become apparent. The epidemic has evidently been hijacked to the political purposes of many Western governments and lobbies, especially from the New Right. Effective health education has all too frequently come a poor second to the tactical potential of recruiting AIDS to frankly ideological purposes. The cultural struggles that are currently being bitterly waged around the meaning of AIDS hinge upon the rivalry of two fundamentally incompatible pictures of human sexuality, invested in the body. One argues that when push comes to shove, all forms of consensual human sexual desire and behavior are much of a muchness and that sexuality cannot be adequately explained in simple naturalistic terms. The other commands in the loudest tones of moral outrage that we can and must all continue to try to make sense of our sexual desires and behavior on the basis of a crude Manichaean distinction between supposedly licit and illicit sexual acts. From the latter perspective, AIDS is endlessly read as a moral verdict on individuals, thus restoring the connection between medicine and punishment that in the past dominated lay perceptions of the meaning of disease and its corporeal manifestations.

Throughout the 1980s the bodies of people living with AIDS have been systematically employed to legitimate the "knowledge" and purportedly immutable "truths" of sexuality, in ways that are often strictly comparable to the worst excesses of Victorian symbolic anatomy.[10] Thus the entire spectrum of HIV disease is collapsed together into the starkest images of extreme physical debilitation and disfigurement, in such a way that the body of the person living with AIDS is reduced to the status of an admonitory sign, warning against "forbidden pleasures," "unnatural sex," "promiscuity," "permissiveness," and so on. Such bodies are forced to speak of limitless depravity, garrulous even in their disposable zip-up plastic sacks. Such images ultimately tell us far more about the ever-potent sexual anxieties of puritan culture, and the psychic mechanisms of displacement and projection, than they do about AIDS. Furthermore, some of the most important cultural work of the late 1980s has been specifically concerned with contesting the meaning of such images, as in the incisive imagery produced by groups such as the New York-based collectives Gran Fury and Testing the Limits. Yet with the notable exception of work by artists such as Don Moffat and Ross Bleckner, such art has rarely been produced for exhibition in white-space galleries. As critic Douglas Crimp pointed out:

I think that there are very specific dangers in art shows about AIDS. The really important work being done now is out in the culture, dealing with larger issues, dealing with larger audiences: it's not on gallery walls.[11]

Nonetheless, it is clear that the scale of the AIDS crisis has forced a new awareness of the need for a full-fledged assault on the systematic double standards and cruelty of the categories of Western sexuality and the extreme limitations of formalist aesthetics in a period of intense social transition. One aspect of the emergence of what Crimp has termed "the AIDS activist aesthetic" will involve a thorough critique of the cultural identity of "the heterosexual" that is as ethically, intellectually, and aesthetically bracing as the earlier critique of "the homosexual," considered as a category of persons. In all the above we can only concur with Freud that we know far too little of sexuality "to construct from our fragmentary information a theory adequate to the understanding alike of normal and pathological conditions."[12] We may, however, hope that the art of the 1990s might be actively engaged with ensuring that future generations are spared the terrible consequences of reading off the "normal" and the "pathological" across the innocent divisions of sexual object-choice.

Notes

1. See Robert Jay Lifton, *The Nazi Doctors: Medical Killing and the Psychology of Genocide* (New York: Basic Books, 1986).

2. Parveen Adams, "Versions of the Body," *m/f* (London), nos. 11/12 (1986): 27.

3. Ibid., p. 29.

4. Victor Burgin, "Re-reading *Camera Lucida*," in *The End of Art Theory: Criticism and Postmodernity* (London: Macmillan, 1986; Atlantic Highlands, N.J.: Humanities Press International, 1986), p. 83. Essay first published in *Creative Camera* (London) 215 (November 1982).

5. See Burgin, *Between* (Oxford: Basil Blackwell, in association with the Institute of Contemporary Arts, London, 1986).

6. Laura Mulvey, "Kruger and Burgin," *Creative Camera* (London) 233 (May 1984): 1382.

7. Lisa Duggan, "Sex Panics," *Artforum* 28 (October 1989): 27.

8. See Michel Foucault, *The History of Sexuality, Volume 1: An Introduction* (New York: Random House, 1978); and Jeffery Weeks, *Sexuality* (London: Tavistock Publications, 1986).

9. See Douglas Crimp, "How to Have Promiscuity in an Epidemic," *October* 43 (Winter 1987): 237-70; see also Jan Zita Grover, "Visible Lesions: Images of People with AIDS," *Afterimage* 17 (Summer 1989): 10-17.

10. See Simon Watney, "The Specticle of AIDS," *October* 43 (Winter 1987): 71-86.

11. Douglas Crimp, "Art and Activism: A Conversation between Douglas Crimp and Greg Bordowitz," in *AIDS: The Artists' Response,* ed. Jan Zita Grover, exhibition catalog (Columbus: Ohio State University Press, 1989), p. 8.

12. Sigmund Freud, "Three Essays of Sexuality," in *The Pelican Freud Library: Volume 7, On Sexuality* (Harmondsworth, England: Pelican, 1977), p. 169.

Simon Watney, a London-based art historian and AIDS activist, was a member of the editorial board of Screen *from 1983 until 1989. He is the author of* Policing Desire: Pornography, AIDS, and the Media *(Minneapolis: University of Minnesota Press, 1987, 1989). His most recent book,* Taking Liberties: AIDS and Cultural Politics *(London: Serpent's Tail Press, 1989), was co-edited with Erica Carter.*

1,000 yen note.

Exhibitions and Bibliographies

Anna Brooke

Laurie Anderson

Born Laurie Anderson, June 5, 1947, in Chicago. Education: Mills College, Oakland, Calif., 1965-66; Barnard College, New York, 1966-69, B. A., magna cum laude, 1969, Phi Beta Kappa; Columbia University, 1971-72, M. F. A. 1972. Awards include: New York State Council on the Arts CAPS Grants, 1974, 1977; National Endowment for the Arts, Visual Artists Fellowships 1974, 1977, 1980; Guggenheim Fellowship, 1982; Honorary Doctorate, San Francisco Art Institute, 1980. Lives and works in New York.

Selected Solo Exhibitions

1973
Harold Rivkin Gallery, Washington, D. C., *Laurie Anderson at Harold Rivkin*, October 1-31.

1977
Holly Solomon Gallery, New York, *Laurie Anderson*, January 12-February 1.
Hopkins Center, Dartmouth College, Hanover, N. H., *Laurie Anderson: Discopictures*, April 15-May 15.

1978
and/or Gallery, Seattle, *Laurie Anderson*, June 6-14.
Holly Solomon Gallery, New York, *An Audio Installation by Laurie Anderson*, September 9-30.
The Museum of Modern Art, New York, *Projects: Laurie Anderson*, September 15-October 29.
Wadsworth Atheneum, Hartford, *Laurie Anderson: Matrix Forty-Six*, December 19-January 21, 1979.

1980
Holly Solomon Gallery, New York, *Laurie Anderson: Dark Dogs, American Dreams*, April 12-May 3.

1981
Holly Solomon Gallery, New York, *Laurie Anderson*, September 11-October 3.

1983
Institute of Contemporary Art, University of Pennsylvania, Philadelphia, *Laurie Anderson: Works from 1969 to 1983*, October 15-December 4, and tour to Frederick S. Wight Gallery, University of California, Los Angeles, January 31-March 4, 1984; Contemporary Arts Museum, Houston, April 21-June 3; The Queens Museum, Flushing, N. Y., July 1-September 9.

1984
Mr. Heartbreak performance tour.
United States Live record set released.

1986
Natural History world tour.

1987
Swimming to Cambodia film soundtrack.
Hosted Public Broadcasting Service's "Alive from Off Center" television series.

1989
Spoleto Festival, Charleston, S. C., *Laurie Anderson: "Empty Places,"* June 8, 10, 11, and tour.

Selected Group Exhibitions

1973
Pace University, New York, *Thought: Structures*, January 24-February 14.
John Gibson Gallery, New York, *Story*, April 7-May 3.
California Institute of the Arts, Valencia, *c. 7500*, May 1973, and tour to nine other institutions.

1974
Artists Space, New York, *Systems*, January 5-26.
112 Greene Street, New York, *Anarchitecture Show*, March 9-20.

1975
Museum of Contemporary Art, Chicago, *Bodyworks*, March 8-April 27.
Sarah Lawrence College, Bronxville, N. Y., *Word Image Number*, September 23-October 19.

1976
Fine Arts Gallery, California State University at Los Angeles, *New Work/New York*, October 4-28.

1977
Museum of Contemporary Art, Chicago, *Words at Liberty*, May 7-July 3.
Palais de Tokyo, Musée d'Art Moderne de la Ville de Paris, *10e Biennale de Paris*, September 17-November 1.

1978
Institute of Contemporary Art, Boston, *Narration*, April 18-June 18.
Contemporary Art Museum, Houston, *American Narrative/Story Art: 1967-1977*, December 17-February 25, 1979, and tour to Contemporary Arts Center, New Orleans, March 25-May 21; Winnipeg Art Gallery, June 15-August 13; University Art Museum, Berkeley, Calif., September 16-November 10; University Art Museum, Santa Barbara, Calif., December 15-February 12, 1979.

1979
Museum Bochum, West Germany, *Words*, January

27-March 11, and tour to Palazzo Ducale, Genoa, March 28-May 4.

Neuberger Museum, State University of New York at Purchase, *Ten Artists/Artists Space,* September 9-October 15.

1980

Neue Galerie-Sammlung Ludwig, Aachen, West Germany, *Les Nouveaux Fauves, Die Neuen Wilden,* January 19-March 21.

Thirty-Ninth Venice Biennale, *Drawings: The Pluralist Decade,* June 1-September 30, and tour to Institute of Contemporary Art, University of Pennsylvania, Philadelphia, October 4-November 9.

1981

Musée National d'Art Moderne, Centre Georges Pompidou, Paris, *Autoportraits Photographiques 1898-1981,* July 8-September 14.

Neuberger Museum, State University of New York at Purchase, *Soundings,* September 20-December 23.

1982

Art Gallery of New South Wales, Sydney, *The Fourth Biennale of Sydney: Vision in Disbelief,* April 7-May 23.

Stedelijk Museum, Amsterdam, *Sixty/Eighty: Attitudes/Concepts/Images,* May 9-July 11.

1983

Museum of Contemporary Art, Chicago, *Dogs,* June 4-July 29.

Brooklyn Museum, New York, *American Artist As Printmaker,* October 28-January 22, 1984.

1984

Contemporary Arts Center, Cincinnati, *Disarming Images: Art for Nuclear Disarmament,* September 14-October 27, and Art Museum Association of America tour to nine other institutions.

Hirshhorn Museum and Sculpture Garden, Smithsonian Institution, Washington, D. C., *Content: A Contemporary Focus, 1974-1984,* October 4-January 6, 1985.

1985

Musée d'Art Contemporain, Montreal, *Ecrans politiques,* November 17-January 12, 1986.

Art Gallery, Queensborough Community College, Bayside, N. Y., *The Parodic Power of Popular Imagery,* March 10-29.

1986

Weatherspoon Art Gallery, Greensboro, N. C., *Art on Paper 1986,* November 16-December 14.

1987

Los Angeles County Museum of Art, *Avant-Garde in the Eighties,* April 23-July 12.

Stedelijk Museum, Amsterdam, *The Arts for Television,* September 4-October 18, and tour to twelve other museums.

1988

Olympic Arts Festival, Immeuble Nova Building, Calgary, *On Track: An Exhibition of Art in Technology,* January 26-February 28.

Greenville (S. C.) County Museum of Art, *Just Like a Woman,* March 15-May 15.

1989

Bass Museum of Art, Miami Beach, Fla., *The Future Now,* March 10-April 30.

Selected Bibliography

Allen, Jennifer. "The Anderson Tapes." *New York* (February 14, 1983): 18, 20.

Amirkhanian, Charles. "Interview with Laurie Anderson." In *The Guests Go in to Supper,* edited by Melody Sumner, et al., 217-28. Oakland: Burning Books, 1986.

Anderson, Laurie. "About 405 East 13th Street Number One." *Artforum* 12 (September 1973): 88-90. Reprinted in *Collective Consciousness,* edited by Jean Dupuy, 100-103. New York: Performing Arts Journal Publications, 1980.

_____. "Autobiography: The Self in Art." *LAICA Journal/Art-Rite* 19 (June-July 1978): 34-35.

_____. "From 'Americans on the Move.'" *October* 8 (Spring 1979): 45-57.

_____. "From 'For Instants.'" In *Post-Movement Art in America,* edited by Alan Sondheim, 68-83. New York: E. P. Dutton, 1977.

_____. In "Projects." *Artforum* 18 (February 1980): 68-69.

_____. "Laurie Anderson: Confessions of a Street Talker. . . ." *Avalanche* 11 (Summer 1975): 22-23.

_____. "Notes from 'Like a Stream.'" In *Performance by Artists,* edited by A. A. Bronson and Peggy Gale, 41-48. Toronto: Art Metropole, 1979.

_____. Statements in *Collective Consciousness,* edited by Jean Dupuy, 154-56. New York: Performing Arts Journal Publications, 1980.

_____. Statements in "Unskirting the Issue. . . ." *Art-Rite* 5 (Spring 1974): 6.

_____. "Stereo Decoy (A Canadian/American Duet)." In *Artpark 1977,* edited by Sharon Edelman, 6-8. Lewiston, N. Y.: Artpark, 1977.

_____. "Take Two." *Art-Rite* 6 (Summer 1974): 5.

_____. "United States: Part II." In *Performance Text(e)s + Documents*, edited by Chantal Pontbriand, 158-63. Montreal: Parachute, 1981. Reprinted in *United States.* New York: Harper and Row, 1984.

_____. "Words in Reverse." *Top Stories* 2 (1979): entire issue. Reprinted in *Blasted Allegories,* edited by Brian Wallis, 68-71. New York: New Museum of Contemporary Art; Cambridge: MIT Press, 1987.

Baer, Joshua. "Laurie Anderson: The Peripheral Visions of a Rock Raconteuse." *Musician* 66 (April 1984): 55-65. Interview.

Berger, Maurice. "The Mythology of Ritual: Reflections on Laurie Anderson." *Arts Magazine* 57 (June 1983): 120-21.

de Groot, Els. "Laurie Anderson." *Modern Denken* 3 (1981): 4-9. Interview.

Dery, Mark. "Laurie Anderson Goes for the Throat." *High Performance* 7 (1984): 8-9, 80, 86. Interview.

Foote, Nancy. "Situation Esthetics: Impermanent Art and the Seventies Audience." *Artforum* 18 (January 1980): 22-29. Interview by mail.

Glueck, Grace. "Art: Laurie Anderson Now Starring at Museum." *New York Times,* July 27, 1984, sec. C, p. 21.

Goldberg, Roselee. "Public Performance: Private Memory." *Studio International* 192 (July-August 1976): 19-23. (Includes Laurie Anderson, "For Instants—Part 3"; "Notes from Interview.")

Goodyer, Tim. "Brave New Science." *Music Technology* (July 1987): 75-78. Interview.

Harrington, Richard. "Laurie Anderson's Offstage Reflection: After Her Film Foray, Seeking a New Transition." *Washington Post,* July 12, 1986, Sec. D, pp. 1, 5.

Heynen, Pieter. "Tussen Gregoriaans en de Velvet Underground." *Museumjournaal* (the Netherlands) 25 (August 1980): 185-88. Interview.

Howell, John. "A Few Things We Know about Her." *Art-Rite* 10 (Fall 1975) (unpaginated). Includes statements.

_____. "Laurie Anderson Interview." *New York Beat* 1 (February-March 1984): 6-7.

_____. "Laurie Anderson United States: A Talk with John Howell." *Live* 5 (1981): 2-9.

Kardon, Janet. *Laurie Anderson: Works from 1969 to 1983.* Exhibition catalog. Philadelphia: Institute of Contemporary Art, University of Pennsylvania, 1983.

Kroll, Jack. "An Electronic Cassandra." *Newsweek,* February 23, 1983, p. 77.

La Frenais, Rob. "An Interview with Laurie Anderson." In *The Art of Performance,* edited by Gregory Battcock and Robert Nickas, 255-69. New York: E. P. Dutton, 1984.

Larson, Kay. "Something Future Something Past." *New York* (July 23, 1984): 48-49.

"Laurie Anderson." In *Sixteen Projects/Four Artists: A Cooperative Workshop/Exhibitions Program,* 6-25. Exhibition catalog. Dayton: Wright State University, 1978.

Levin, Kim. "O Superwoman." *Village Voice,* July 24, 1984, p. 87. Reprinted in *Beyond Modernism: Essays on Art from the '70s and '80s,* 187-89. New York: Harper and Row, 1988.

Lifson, Ben. "Laurie Anderson: Dark Dogs, American Dreams." *Aperture* 85 (1981): 44-49.

Loder, Kurt. "Laurie Anderson Could Change the Way That We Look at Music—Literally." *Rolling Stone,* July 8, 1982, p. 23.

McKenna, Kristine. "Laurie Anderson." *Wet* (September-October 1981): 24-30. Interview.

Owens, Craig. "Amplifications: Laurie Anderson." *Art in America* 69 (March 1981): 120-23.

Pincus-Witten, Robert. "Notes." *Art-Rite* 6 (Summer 1974): 21-22.

Rockwell, John. "Laurie Anderson Returns." *New York Times,* July 23, 1988, p. 14.

Sayre, Henry M. *The Object of Performance,* 145-55. Chicago: University of Chicago Press, 1989.

Scarpetta, Guy. "Laurie Anderson: Entretien. . . ." *Art Press* 38 (June 1980): 24-26. Interview.

Shewey, Don. "The Performing Artistry of Laurie Anderson." *New York Times Magazine* (February 6, 1983): 26-27, 47, 55, 59.

Smith, Philip. "A Laurie Anderson Story." *Arts*

Magazine 57 (January 1983): 60-61. Interview.

Sondheim, Alan. "Laurie Anderson: Procedure and Text." *Parachute* 14 (Spring 1979): 9-12.

Sparkman, David. "Laurie Anderson." *Washington Review* 7 (October-November 1981): 25-26.

Stewart, Patricia. "Laurie Anderson: With a Song in My Art." *Art in America* 67 (March-April 1979): 110-13.

Taylor-States, Sarah. "Laurie Anderson." *Real Life Magazine* 9 (Winter 1982-83): 24-27.

Testa, Bart. "The Epic of Concatenation: On 'Amerika' and 'United States.'" *C Magazine* 10 (Summer 1986): 46-55.

White, Robin. "Laurie Anderson." *View* 2 (January 1980). Reprinted in *Artwords 2*, edited by Jeanne Siegel, 25-35. Ann Arbor, Mich.: UMI Research Press, 1988; *American Artists on Art from 1940 to 1980*, edited by Ellen H. Johnson, 240-44. New York: Harper and Row, 1982.

Siah Armajani

Born Siah Armajani, July 10, 1939, in Tehran. Education: Macalester College, St. Paul, 1958-63, B. A. 1963. Awards include: National Endowment for the Arts, Visual Artists Fellowship, 1978; Laura Slobe Memorial Prize, *Seventy-Fourth American Exhibition,* the Art Institute of Chicago, 1982. Lives and works in St. Paul.

Selected Solo Exhibitions

1978
Philadelphia College of Art, Philadelphia, *Siah Armajani: Projects for PCA 3, Red School House for Thomas Paine,* March 4-25.

1979
Max Protetch Gallery, New York, *Siah Armajani: First Reading Room—Installation, Models and Drawings,* March 6-April 7.

1980
Joslyn Art Museum, Omaha, *Siah Armajani: Reading Garden Number Two,* June 14-September 7. Contemporary Arts Center, Cincinnati, *Constructions I: Siah Armajani,* November 21-January 4, 1981.

1981
Max Protetch Gallery, New York, *Siah Armajani: Doors, Windows, Notations, and Models,* March 12-April 4.

The Hudson River Museum, Yonkers, N. Y., *Siah Armajani: Office for Four,* April 11-July 5.

1982
Baxter Art Gallery, California Institute of Technology, Pasadena, *Siah Armajani: A Poetry Lounge,* March 3-April 25.
Grand Rapids (Mich.) Art Museum, *Siah Armajani: Picnic Garden,* June 5-July 4.

1984
Max Protetch Gallery, New York, *Siah Armajani: Dictionary for Building III,* April 5-28.

1985
Institute for Contemporary Art, University of Pennsylvania, Philadelphia, *Siah Armajani: Bridges, Houses, Communal Spaces, Dictionary for Building,* October 11-December 1.
Max Protetch Gallery, New York, *Siah Armajani: Dictionary for Building IV,* November 1-30.

1987
Kunsthalle Basel, *Siah Armajani,* March 22-April 26, and tour to Stedelijk Museum, Amsterdam, May 16-June 28.
Galerie Rudolf Zwirner, Cologne, *Siah Armajani: Skulpturen,* May 19-June 15.
Ghislaine Hussenot, Paris, *Siah Armajani,* September 12-October 22.
Max Protetch Gallery, New York, *Siah Armajani: Elements,* October 31-December 5.
Westfälisches Landesmuseum für Kunst und Kulturgeschichte, Münster, *Siah Armajani: Reading Room, Sacco and Vanzetti,* December 16-January 31, 1988, and tour to Portikus Frankfurt am Main, February 17-March 20.

1988
List Visual Arts Center, Massachusetts Institute of Technology, Cambridge, *Siah Armajani,* February 27-April 10.
Max Protetch Gallery, New York, *Siah Armajani: Dictionary for Architecture II,* March 8-April 2.

1989
Max Protetch Gallery, New York, *Siah Armajani: Elements,* March 25-April 29.

Selected Group Exhibitions

1969
Indianapolis Museum of Art, *Painting and Sculpture Today,* May 4-June 1.
Museum of Contemporary Art, Chicago, *Art by Telephone,* November 1-December 14.

1970
The Museum of Modern Art, New York, *Information*, July 2-September 20.

1971
Walker Art Center, Minneapolis, *Works for New Spaces*, May 18-July 25.

1977
Walker Art Center, Minneapolis, *Scale, and Environment: Ten Sculptors*, October 2-November 27.

1978
Solomon R. Guggenheim Museum, New York, *Young American Artists, 1978 Exxon National Exhibition*, May 5-June 16.
Institute of Contemporary Art, University of Pennsylvania, Philadelphia, *Dwellings*, October 20-November 25.

1980
Thirty-Ninth Venice Biennale, *Drawings: The Pluralist Decade*, June 1-September 30, and tour to Institute of Contemporary Art, University of Pennsylvania, Philadelphia, October 4-November 9.

1981
Whitney Museum of American Art, New York, *1981 Biennial Exhibition*, January 2-April 12.
Hirshhorn Museum and Sculpture Garden, Smithsonian Institution, Washington, D. C., *Metaphor: New Projects by Contemporary Sculptors*, December 17-February 28, 1982.

1982
The Art Institute of Chicago, *Seventy-Fourth American Exhibition*, June 12-August 1.
Museum Fridericianum, Kassel, West Germany, *Documenta 7*, June 19-September 26.
The Aldrich Museum of Contemporary Art, Ridgefield, Conn., *Postminimalism*, September 19-December 19.

1983
Hirshhorn Museum and Sculpture Garden, Smithsonian Institution, Washington, D. C., *Directions 1983*, March 10-May 15.
Tate Gallery, London, *New Art at the Tate Gallery 1983*, September 14-October 23.

1984
The Museum of Modern Art, New York, *An International Survey of Recent Painting and Sculpture*, May 17-August 19.
Hirshhorn Museum and Sculpture Garden, Smithsonian Institution, Washington, D. C., *Content: A Contemporary Focus, 1974-1984*, October 4-January 6, 1985.

1985
Los Angeles County Museum of Art, *The Artist As Social Designer: Aspects of Public Urban Art Today*, February 7-March 17.

1986
Arnhem, the Netherlands, *Sonsbeek 86*, June 18-September 14.

1987
Los Angeles County Museum of Art, *Avant-Garde in the Eighties*, April 23-July 12.
Museum Fridericianum, Kassel, West Germany, *Documenta 8*, June 12-September 20.
Westfälisches Landesmuseum für Kunst und Kulturgeschichte, Münster, *Skulptur Projekte in Münster 1987*, June 14-October 4.

1988
The Carnegie Museum of Art, Pittsburgh, *Carnegie International*, November 5-January 22, 1989.
Solomon R. Guggenheim Museum, New York, *Viewpoints: Postwar Painting and Sculpture*, December 9-January 22, 1989.

Selected Bibliography

Ashbery, John. "Armajani: East Meets Midwest." *Newsweek*, April 4, 1983, p. 72.

Berlind, Robert. "Armajani's Open-Ended Structures." *Art in America* 67 (October 1979): 82-85.

Brenson, Michael. "Siah Armajani." *New York Times*, November 15, 1985, sec. C, p. 24.

Day, Peter. "Interview with Siah Armajani." *Impulse* 13 (Winter 1987): 10-12.

Decter, Joshua. "Siah Armajani." *Arts Magazine* 60 (January 1986): 140-41.

Glueck, Grace. "Siah Armajani." *New York Times*, March 25, 1983, p. 18.

Kardon, Janet. *Projects for PCA: Red School House for Thomas Paine.* Exhibition catalog. Philadelphia: Philadelphia College of Art, 1978.

_____. *Siah Armajani: Bridges, Houses, Communal Spaces, Dictionary for Building.* Exhibition catalog. Philadelphia: Institute for Contemporary Art, University of Pennsylvania, 1985.

Merkel, Jayne. "Siah Armajani." *Artforum* 19 (March 1981): 89-90.

Miro, Marsha. "An Interview with Siah Armajani." In *Sculpture at Cranbrook 1978-1980* (unpaginated).

Bloomfield Hills, Mich.: Cranbrook Academy of Art, 1979.

Nadelman, Cynthia. "Siah Armajani." *Artnews* 78 (Summer 1979): 175.

Phillips, Patricia C. "Siah Armajani." *Artforum* 26 (February 1988): 142-43.

_____. "Siah Armajani's Constitution." *Artforum* 24 (December 1985): 70-75.

Pincus-Witten, Robert. "Siah Armajani: Populist Mechanics." *Arts Magazine* 53 (October 1978): 126-28.

Princenthal, Nancy. "Master Builder." *Art in America* 74 (March 1986): 126-33.

Reck, Hans Ulrich. "Nicht Stil: Konstruktion—Siah Armajanis Aneignung der Moderne." *Kunstforum International* 99 (March-April 1989): 180-99.

Shearer, Linda. "Siah Armajani." In *Young American Artists: 1978 Exxon National Exhibition,* 14-18. Exhibition catalog. New York: Solomon R. Guggenheim Museum, 1978. Interview.

Shermeta, Margo. "An American Dictionary in the Vernacular: Utilitarian Ideas and Structures in the Sculpture of Siah Armajani." *Arts Magazine* 61 (January 1987): 38-41.

Siah Armajani. Exhibition catalog. Basel: Kunsthalle Basel; Amsterdam: Stedelijk Museum, 1987. Introduction by Jean-Christophe Ammann.

Siah Armajani. Exhibition catalog. Yonkers, N. Y.: Hudson River Museum, 1981. Essay by Julie Brown.

Siah Armajani: A Poetry Lounge. Exhibition catalog. Pasadena, Calif.: Baxter Art Gallery, California Institute of Technology, 1982. Poems by David Antin.

Siah Armajani: Reading Garden Number Two. Exhibition brochure. Omaha: Joslyn Art Museum, 1980. Essay by Holliday T. Day.

Siah Armajani: Reading Room, Sacco and Vanzetti. Exhibition catalog. Münster: Westfälisches Landesmuseum für Kunst und Kulturgeschichte, 1987. Essay by Ulrich Wilmes.

Wortz, Melinda. "Siah Armajani: Baxter Art Gallery." *Artnews* 81 (December 1982): 131.

Francesco Clemente

Born Francesco Clemente, March 23, 1952, in Naples, Italy. Education: Studied architecture at the University of Rome, 1970. Lives and works in New York and Madras.

Selected Solo Exhibitions

1974
Galleria Area, Florence, *Francesco Clemente,* December 28-January 1975.

1978
Centre d'Art Contemporain, Geneva, *Francesco Clemente,* February 20-March 20.

1979
Lisson Gallery, London, *Francesco Clemente,* November 20-December 21.
Gian Enzo Sperone, Turin, *Francesco Clemente: Non Scopa,* December.

1980
Padiglione d'Arte Contemporanea, Milan, *Francesco Clemente,* December 4-February 1, 1981.
Sperone Westwater Fischer, New York, *Francesco Clemente,* April 2-19.

1981
Sperone Westwater Fischer, New York*, Francesco Clemente,* May 2-30.
Anthony d'Offay, London, *Francesco Clemente: Pinxit,* September 2-October 10.
Museum van Hedendaagse Kunst, Ghent, *Francesco Clemente,* June 6-July 4.
University Art Museum, University of California, Berkeley, *Francesco Clemente: Matrix/Berkeley Forty-Six,* August-mid October, and tour to Art Museum and Art Galleries, California State University, Long Beach, October 26-December 13; Wadsworth Atheneum, Hartford, February 20-April 18, 1982.

1982
Daniel Templon, Paris, *Francesco Clemente,* June 5-July 16.
Paul Maenz, Cologne, *Francesco Clemente: "Il Viaggiatore Napoletano,"* November 26-December 23.
Galerie Bischofberger, Zurich, *Francesco Clemente Aquarelle,* December 5-January 22, 1983.

1983
Whitechapel Art Gallery, London, *Francesco Clemente: The Fourteen Stations,* January 7-February 20, and tour to Groninger Museum, Groningen, the Netherlands, April 1-May 8; Badischer Kunstverein, Karlsruhe, May 24-July 3; Galerie

d'Art Contemporain, Nice, July 14-August 31;
Moderna Museet, Stockholm, September 17-
October 30.
Mary Boone and Sperone Westwater, New York,
Francesco Clemente, April 2-30.
Akira Ikeda Gallery, Nagoya, *Francesco Clemente:
Paintings,* September 5-30.

1984
Nationalgalerie, Staatliche Museen Preussischer
Kulturbesitz, Berlin, *Francesco Clemente: Pastelle
1973-1983,* March 16-May 13, and tour to
Museum Folkwang, Essen, West Germany, June
15-August 19; Stedelijk Museum, Amsterdam,
September 27-November 18; Fruitmarket Gallery,
Edinburgh, November 28-December 29; Kunsthalle
Tübingen, West Germany, January 12-February 24,
1985.
Akira Ikeda Gallery, Tokyo, *Francesco Clemente:
New Paintings,* July 23-August 25.
Arts Council of Northern Ireland, Belfast, *Francesco
Clemente in Belfast,* November 1-December 1.
Kestner-Gesellschaft, Hannover, *Francesco Clemente:
Bilder und Skulpturen,* December 7-January 20,
1985.

1985
Metropolitan Museum of Art, New York, *An
Exhibition and Sale of Francesco Clemente Prints
1981-1985,* May 14-June 9.
John and Mable Ringling Museum of Art, Sarasota,
Fla., *Francesco Clemente,* October 9-December 8,
and tour to Walker Art Center, Minneapolis,
January 12-March 2, 1986; Dallas Museum
of Art, March 30-May 18; University Art Museum,
University of California, Berkeley, July 9-September
21; Albright-Knox Art Gallery, Buffalo, November
14-January 4, 1987; The Museum of Contemporary
Art, Los Angeles, February 8-March 29.

1986
Anthony d'Offay, London, *Francesco Clemente:
Recent Paintings,* September 4-30.
Sperone Westwater, New York, *Francesco Clemente,*
November 22-December 20.

1987
Fundación Caja de Pensiones, Madrid, *Francesco
Clemente: Affreschi, pinturas al fresco,* April 6-May 17.
Museum für Gegenwartskunst, Basel, *Francesco
Clemente: Zeichnungen und Aquarelle 1971-1986,*
May 2-July 5, and tour to Groninger Museum,
Groningen, the Netherlands, September 9-October
10; Ulmer Museum, Ulm, West Germany,
November 8-December 6; Musée de la Ville, Nice,
January-February, 1988; Museum Ludwig,

Cologne, March 15-April 24; Frankfurter
Kunstverein, June 22-July 24; Musée Cantonal des
Beaux-Arts, Lausanne, Switzerland, September 1-
October 16.
Galerie im Taxispalais, Innsbruck, Austria, *Francesco
Clemente,* December-January 10, 1988.

1988
Mario Diacono, Boston, *Francesco Clemente,* April
15-May 14.
Museum of Contemporary Art, Chicago, *Francesco
Clemente: Fourteen Stations of the Cross,* April 23-
June 19.
Fundació Joan Miró, Barcelona, *Francesco Clemente:
La Partença de l'Argonauta,* June 16-August 28.
Dia Art Foundation, New York, *Francesco Clemente:
Funerary Paintings,* October 7-June 18, 1989.
Paul Maenz, Cologne, *Francesco Clemente: Major
New Work,* November 11-December 23.

1989
Yvon Lambert, Paris, *Francesco Clemente Pastels,*
May 20-June 30.
Anthony d'Offay Gallery, London, *Francesco
Clemente: Story of My Country,* May 23-June 21.

Selected Group Exhibitions
1973
Museum of the Philadelphia Civic Center, *Italy Two
Art around '70,* November 2-December 16.

1977
Palais de Tokyo, Musée d'Art Moderne de la Ville
de Paris, *10e Biennale de Paris,* September 17-
November 1.

1979
Castello Colonna, Genzano, Italy, *Le Stanze,*
November 30-February 29, 1980.

1980
Thirty-Ninth Venice Biennale, *Aperto 80,* June 1-
September 30.
Museum Folkwang, Essen, West Germany, *7 Junge
Künstler aus Italien,* October 17-November 30.

1981
Rheinhallen der Kölner Messe, Cologne, *Westkunst:
Zeitgenössiche Kunst seit 1939,* May 30-August 16.
Organized by Museen der Stadt Köln.

1982
Art Gallery of New South Wales, Sydney, *The
Fourth Biennale of Sydney: Vision in Disbelief,* April
7-May 23.
Museum Fridericanum, Kassel, West Germany,
Documenta 7, June 19-September 26.

Martin-Gropius-Bau, Berlin, *Zeitgeist,* October 15-January 16, 1983.

1983
Kunsthalle Bielefeld, *Sandro Chia, Francesco Clemente, Enzo Cucchi,* February 13-April 17.

1985
La Grande Halle du Parc de la Villette, Paris, *Nouvelle Biennale de Paris 1985,* March 21-May 21.
Museum of Art, Carnegie Institute, Pittsburgh, *1985 Carnegie International,* November 9-January 5, 1986.

1986
The Museum of Contemporary Art, Los Angeles, *Individuals: A Selected History of Contemporary Art 1945-1986,* December 10-January 10, 1988.

1987
Musée National d'Art Moderne, Centre Georges Pompidou, Paris, *L'Epoque, la mode, la morale, la passion,* May 21-August 17.
Los Angeles County Museum of Art, *Avant-Garde in the Eighties,* April 23-July 12.

1988
Forty-Third Venice Biennale, *Padiglione Italia,* June 26-September 25.
Museum van Hedendaagse Kunst, Antwerp, *De Verzameling, La Collection,* March 12-June 5.
The Carnegie Museum of Art, Pittsburgh, *Carnegie International,* November 5-January 22, 1989.

1989
Vrej Baghoomian, New York, *Land-Scope,* January 7-February 4.
Royal Academy of Arts, London, *Italian Art in the Twentieth Century,* January 14-April 9.
Freedman Gallery, Albright College, Reading, Penn., *The European Avant-Garde,* May 16-June 25.
Musée National d'Art Moderne, Centre Georges Pompidou, Paris, *Magicians of the Earth,* May 18-August 29.

Selected Bibliography

Albertazzi, Liliana. "Francesco Clemente." *Artefactum* 4 (November 1987-January 1988): 6-9.

Ashbery, John. "Under the Volcano—Francesco Clemente." *Interview* 18 (March 1988): 62-70.

Auping, Michael. *Francesco Clemente.* Exhibition catalog. New York: Harry N. Abrams; Sarasota, Fla.: John and Mable Ringling Museum of Art, 1985. Essay by Francesco Pellizi.

Bastian, Heiner, interviews, and Wolfgang Max

Faust, introduction. *Sandro Chia, Francesco Clemente, Enzo Cucchi.* Exhibition catalog. Bielefeld: Kunsthalle Bielefeld, 1983.

Berger, Danny. "Francesco Clemente at the Metropolitan: An Interview." *Print Collector's Newsletter* 13 (March-April 1982): 12. Reprinted in *An Exhibition and Sale of Francesco Clemente Prints 1981-1985.* New York: Metropolitan Museum of Art, 1985.

Bienek, Horst. "Francesco Clemente: Wenn er Träumt verändert er die Welt." *Art: Das Kunstmagazin* 10 (October 1988): 30-46.

Chua, Lawrence. "Francesco Clemente." *Flash Art* 144 (January-February 1989): 111.

Clemente. New York: Vintage Books, 1987. Interview by Rainer Crone and Georgia Marsh.

Clemente, Francesco. *The Departure of the Argonaut.* London: Petersburg Press, 1986.

_____. *Francesco Clemente: India.* Pasadena, Calif.: Twelvetrees Press, 1987.

_____. *Purification of the Twelve.* London: Anthony d'Offay, 1987.

_____. *Undae Clemente Flamina Pulsae.* Amsterdam: Art + Project, 1980.

_____. *'Vetta.'* Modena, Italy: Emilio Mattoli, 1979. Essay by Achille Bonito Oliva.

Crone, Rainer. "Francesco Clemente." *Flash Art* 134 (Summer 1986): 30.

_____. *Francesco Clemente: Pastelle 1973-1983.* Exhibition catalog. Munich: Prestel-Verlag, 1984. Essays by Rainer Crone, Zdenek Felix, Lucius Grisebach, and Joseph Leo Koerner.

Davvetas, Demosthène. "La Paradoxe de Clemente." *Artstudio* 7 (Winter 1987-88): 56-63.

de Ak, Edit. "A Chameleon in a State of Grace." *Artforum* 19 (February 1981): 36-41.

_____. "Francesco Clemente." *Interview* 12 (April 1982): 68-70.

An Exhibition and Sale of Francesco Clemente Prints 1981-1985. Exhibition catalog. New York: Metropolitan Museum of Art, 1985. Excerpt of essay by Henry Geldzahler, interview by Danny Berger.

Francesco Clemente. Exhibition brochure. Boston: Mario Diacono, 1988. Essay by Mario Diacono.

Francesco Clemente: Affreschi, pinturas al fresco. Exhibition catalog. Madrid: Fundación Caja de Pensiones, 1987. Essays by Henry Geldzahler, Rainer Crone, and Diego Cortez.

Francesco Clemente: "Il Viaggiatore Napoletano." Cologne: Verlag Gerd de Vriez, 1982. Essay by Ranier Crone.

Francesco Clemente in Belfast. Exhibition catalog. Belfast: Arts Council of Northern Ireland, 1984. Essay by Kent Dur Russell, interview by Giancarlo Politi.

Francesco Clemente: New Paintings. Exhibition catalog. Tokyo: Akira Ikeda Gallery, 1984.

Francesco Clemente: Paintings. Exhibition catalog. Nagoya: Akira Ikeda Gallery, 1983. Foreword by Maki Kuwayama.

Francesco Clemente: Pastels 1980. London: Anthony d'Offay, 1986. (The Pondicherry Pastels)

Francesco Clemente: Sixty-Four Pastels. Zurich: Bruno Bischofberger, 1989. Poems by Robert Creeley.

Francesco Clemente: The Fourteen Stations. Exhibition catalog. London: Whitechapel Art Gallery, 1983. Essays by Mark Francis, Nicholas Serota, and Henry Geldzahler. Also French edition.

Francesco Clemente: Two Garlands. New York: Sperone Westwater, 1986.

Francesco Clemente Women and Men. Tokyo: Akira Ikeda Gallery, 1986.

Haenlein, Carl. *Francesco Clemente: Bilder und Skulpturen.* Exhibition catalog. Hannover: Kestner-Gesellschaft, 1984.

Hughes, Robert. "Symbolist with Roller Skates." *Time* 125 (April 22, 1985): 68.

Jones, Alan. "Francesco Clemente." *Flash Art* 133 (April 1987): 81.

Kent, Sarah. "Matter of Time." *20/20* (June 1989): 146-49.

_____. "Turtles All the Way: Francesco Clemente Interviewed by Sarah Kent." *Artscribe* 77 (September-October 1989): 54-59.

Koepplin, Dieter. *Francesco Clemente CVIII: Watercolours Adayar 1985.* Exhibition catalog. Zurich: Schweizer Verlagshaus, 1987.

Kuspit, Donald. "Clemente Explores Clemente." *Contemporanea* 2 (October 1989): 36-43. Interview.

_____. "Francesco Clemente." *Artforum* 25 (April 1987): 125-26.

_____. "Francesco Clemente." *Artforum* 26 (November 1987): 149-50.

Maenz, Paul. *Francesco Clemente: "Il Viaggiatore Napoletano."* Cologne: Verlag Gerd de Vries, 1982. Edited by Paul Maenz.

Marsh, Georgia. "Francesco Clemente: faire quelque chose à partir de rien." *Art Press* 113 (April 1987): 4-10. Interview.

Morera, Daniela. "Francesco Clemente." *Vogue* (Italy) 455 (February 1988): 232-37, 256-59. Interview.

Pellizzi, Francesco. "Charon's Boat." *Artforum* 27 (November 1988): 112-17.

Politi, Giancarlo, and Helena Kontova. "Francesco Clemente." *Flash Art* 117 (April-May 1984): 12-21. Interview. Reprinted in *Artwords 2*, edited by Jeanne Siegel, 120-38. Ann Arbor, Mich.: UMI Research Press, 1988; *Francesco Clemente in Belfast.* Belfast: Arts Council of Northern Ireland, 1984.

Ricard, Rene. *Francesco Clemente: Sixteen Pastels.* Exhibition catalog. London: Anthony d'Offay Gallery, 1989. Poems by Rene Ricard.

Smith, Roberta. "Francesco Clemente." *New York Times,* December 5, 1986, sec. C, p. 30.

Storr, Robert. "Realm of the Senses." *Art in America* 75 (November 1987): 132-45, 199.

Tuchman, Phyllis. "Clemente: Shuttling Back and Forth in Time and Space." *The Journal of Art* 1 (January 1989): 70-73.

White, Robin. "Francesco Clemente." *View* 3 (November 1981): 1-28. Entire issue. Interview.

James Coleman

Born James Coleman, July 6, 1941, in Roscommon, Ireland. Education: Ecole des Beaux-Arts, Paris, 1960-61; Central School of Arts and Crafts, London, 1961-63; National College of Art and Design, Dublin, 1963-66; Accademia di Belle Arti, Milan, 1966-71. Awards include: Purser Griffith Travelling Scholarship in the History of European Painting, 1964; Arts Council of Ireland Grants, 1968, 1970; Irish-American Cultural Institute Award for the Arts, 1977; Irish Arts Council Award, 1979; Pollock-Krasner Foundation Grant, 1989. Lives and works in Dublin.

Selected Solo Exhibitions

1970
Studio Marconi, Milan, *James Coleman,* October.

1972
Galleria Toselli, Milan, *James Coleman,* April.
The Douglas Hyde Gallery, Trinity College, Dublin, *James Coleman,* April 20-May 22.

1973
Studio Marconi, Milan, *James Coleman,* April 5-early May.

1974
Ulster Museum, Belfast, *James Coleman,* January 18-February 28.
Studio Lia Rumma, Naples, *James Coleman,* March 5-April 4.
Cork (Ireland) Arts Society Gallery, *James Coleman,* July 15-27.

1975
Studio Marconi, Milan, *James Coleman,* April 16-May 15.

1980
Nigel Greenwood, London, *A Video Installation by James Coleman,* June 10-21.

1981
Project Gallery, Project Arts Centre, Dublin, May 28-June 6. Installation.
Franklin Furnace, New York, June 25. Installation.

1982
The Douglas Hyde Gallery, Trinity College, Dublin, *James Coleman,* April 20-May 22, and tour to the Arts Council of Northern Ireland Gallery, Belfast, June 10-July 3.

1984
The Douglas Hyde Gallery, Trinity College, Dublin, *James Coleman,* June 6.
David Bellman Gallery with Art Metropole, Toronto, *James Coleman,* November 6-9.

1985
The Renaissance Society at the University of Chicago, *James Coleman: Selected Works,* October 6-November 17, and tour to the Institute of Contemporary Arts, London, December 13-January 26, 1986.

1987
Rüdiger Schöttle, Munich, *James Coleman,* June 10-July 25, and tour to Galerie Johnen & Schöttle, Cologne, October 27-December 5.

1988
Galerie des Beaux-Arts, Brussels, *James Coleman,* March 15-April 16.

1989
ARC-Musée d'Art Moderne de la Ville de Paris, *James Coleman,* March 22-May 21.
List Visual Arts Center, Massachusetts Institute of Technology, Cambridge, *James Coleman,* June 2-July 2.
Stedelijk Van Abbemuseum, Eindhoven, *James Coleman,* September 17-June 24. Five different installations.

Selected Group Exhibitions

1973
Musée d'Art Moderne de la Ville de Paris, *8e Biennale de Paris: Italia,* September 14-October 21.
Parcheggio di Villa Borghese, Rome, *Contemporanea,* November 1-February 28, 1974.

1976
National Gallery of Ireland, Dublin, *Irish Exhibition of Living Art,* September 3-30.

1977
Hugh Lane Municipal Gallery of Modern Art and the National Museum of Ireland, Dublin, *ROSC '77,* August 21-October 30.

1978
Thirty-Eighth Venice Biennale, *From Nature to Art, from Art to Nature: Art and Cinema,* July 2-October 15.

1980
Institute of Contemporary Arts, London, *Without the Walls,* February 16-March 16.
Palazzo Reale, Milan, *Camera Incantate: Espansione dell'Immagine,* May 15-June 15.
The Douglas Hyde Gallery, Trinity College, Dublin, *Hibernian Inscape,* December 2-January 4, 1981, and tour in Ireland to Wexford Arts Centre, January-February; Crawford Gallery, Cork, March-April; Orchard Gallery, Derry, July-August; Arts Council of Northern Ireland Gallery, Belfast, September-October.

1982
Art Gallery of New South Wales, Sydney, *The Fourth Biennale of Sydney: Vision in Disbelief,* April 7-May 23.
Nigel Greenwood, London, *James Coleman and Rita Donagh,* July 1-August 12.
Tate Gallery, London, *Audio, Tape-Slide, Drawings, and Performance,* August 23-September 19.

The Museum of Modern Art, New York, *Reading Video,* October 28-December 7.

1986
Fruitmarket Gallery, Edinburgh, *The Mirror and the Lamp,* July 19-August 31, and tour to Institute of Contemporary Arts, London, September 10-October 12.
Palais des Beaux Arts, Brussels, *Au Coeur du Maelström,* September 19-October 19.

1987
Independent Curators, Inc., New York, *The Analytical Theatre: New Art from Britain,* tour to Akron (Ohio) Art Museum, February 6-March 29; Alberta College of Art Gallery, Calgary, November 26-December 19; University Art Museum, California State University, Long Beach, January 26-March 6, 1988; Institute of Contemporary Art, University of Pennsylvania, Philadelphia, October 12-November 27.
Stedelijk Museum, Amsterdam, *Uit het Oude Europa,* October 17-December 6.
Mercer Union and YYZ Gallery, Toronto, *Dark/Light,* November 11-December 13.

1988
Artists Space, New York, *Michael Asher/James Coleman,* June 2-July 2.
Guiness Hop Store, Royal Hospital, Kilmainham, Dublin, *ROSC '88,* August 15-October 15.

1989
P.S. 1, Institute for Art and Urban Resources, Long Island City, N. Y., *Theatergarden Bestiarium,* January 15-March 12, and tour to Lope de Vega Theater, Seville, June 22-July 30; Confort Moderne, Poitiers, France, September 29-November 29.
Marian Goodman Gallery, New York, *A Photo Show: A Selection,* May 16-June 10.

Selected Bibliography

Fisher, Jean. *The Enigma of the Hero in the Work of James Coleman.* Londonderry: Orchard Gallery, 1983.

_____. *James Coleman.* Exhibition catalog. Dublin: Douglas Hyde Gallery, Trinity College, 1982.

_____. "The Place of the Spectator in the Work of James Coleman." *Open Letter* 5 (Summer-Fall 1983): 51-64.

Fowler, Joan. "'So Different . . . and Yet,' Language and the Theater in the Work of James Coleman." *Circa* (Belfast) 17 (July-August 1984): 18-24.

James Coleman. Exhibition catalog. Eindhoven: Stedelijk Van Abbemuseum, 1989. Essays by Frank Lubbers.

"James Coleman." In *The Analytical Theatre: New Art from Britain,* by Milena Kalinovska and Michael Newman, 34-37. Exhibition catalog. New York: Independent Curators, 1987.

James Coleman: Selected Works. Exhibition catalog. Chicago: Renaissance Society at the University of Chicago; London: Institute of Contemporary Arts, 1985. Essays by Michael Newman and Anne Rorimer.

Kearney, Richard. "Conversation with James Coleman." *Aspects* (1982): 1-3.

Leigh, Christian. "James Coleman." *Artforum* 27 (November 1988): 142-43.

Newman, Michael. "James Coleman, Guaire." *Artforum* 24 (November 1985): 119.

Rorimer, Anne. "Michael Asher and James Coleman at Artists Space." In *Michael Asher/James Coleman,* 6-13. Exhibition catalog. New York: Artists Space, 1988.

Tuer, Dot. "Feminine Pleasure in the Politics of Seduction." *C Magazine* 4 (Winter 1985): 22-23.

Walker, Dorothy. "Installations and Performance in Ireland." *Flash Art* 92/93 (October-November 1979): 39-41.

Tony Cragg
Born Tony Cragg, April 9, 1949, in Liverpool. Education: Gloucestershire College of Art and Design, 1969-70; Wimbledon School of Art, 1970-73; Royal College of Art, 1973-77, M. A. 1977. Awards include: Turner Prize, 1988. Lives and works in Wuppertal.

Selected Solo Exhibitions

1979
Lisson Gallery, London, *Nicholas and Fiona Logsdail Present New Works by Tony Cragg,* February 28-March 16.
Kunstlerhaus, Hamburg, *Tony Cragg,* November.

1980
Lisson Gallery, London, *Tony Cragg: Sculpture,* July 16-August 9.

1981
Musée d'Art et d'Industrie, Saint-Etienne, *Tony Cragg,* January 23-March 8.

Whitechapel Art Gallery, London, *Tony Cragg: Sculpture,* February 27-March 22.
Von der Heydt-Museum, Wuppertal, *Tony Cragg,* October 20-November 22.

1982
Badischer Kunstverein, Karlsruhe, *Tony Cragg,* January 12-February 28.
Kanransha Gallery, Tokyo, *Tony Cragg,* January 18-February 20.
Marian Goodman Gallery, New York, *Tony Cragg,* May 11-June 5.
Galerie Schellmann & Klüser, Munich, *Tony Cragg,* October 7-November 24.
Lisson Gallery, London, *Tony Cragg: Sculpture,* December 2-24.

1983
Marian Goodman Gallery, New York, *Tony Cragg,* April 5-30.
Kunsthalle Bern, *Tony Cragg,* April 30-June 5.

1984
Marian Goodman Gallery, New York, *Tony Cragg,* March 13-April 14.
Kanransha Gallery, Tokyo, *Tony Cragg,* March 26-April 28.
Kölner Kunstverein, Cologne, *Tony Cragg,* September 16-October 28.

1985
Staatsgalerie Moderner Kunst, Munich, *Tony Cragg,* February 6-April 8.
Palais des Beaux-Arts, Brussels, *Tony Cragg,* June 20-July 28, and tour to ARC-Musée d'Art Moderne de la Ville de Paris, October 8-December 1.
Kestner-Gesellschaft, Hannover, *Tony Cragg: Skulpturen,* December 20-February 9, 1986.

1986
University Art Museum, University of California, Berkeley, *Tony Cragg/Matrix Berkeley Ninety-Three,* March-May, and tour to La Jolla (Calif.) Museum of Contemporary Art, August 15-September 21.
Marian Goodman Gallery, New York, *Tony Cragg,* March 13-April 5.

1987
Hayward Gallery, London, *Tony Cragg,* March 5-June 7, and tour to Cornerhouse Gallery, Manchester, July 1-September 30.
Marian Goodman Gallery, New York, *Tony Cragg,* November 6-December 5.
Kanransha Gallery, Tokyo, *Tony Cragg,* December 1-26.

1988
Galerie Bernd Klüser, Munich, *Tony Cragg: Neue*

Arbeiten, October 4-November 5.
Lisson Gallery, London, *Tony Cragg,* December 2-January 28, 1989.

1989
Crown Point Press, San Francisco and New York, *Tony Cragg: Thirty-Five Etchings,* January 19-March 4.
Kanransha Gallery, Tokyo, *Tony Cragg,* March 13-April 8.
Galerie de Expeditie, Amsterdam, *Tony Cragg: Niewe Esten,* April 5-May 13.
Galerie Pierre Huber, Geneva, *Tony Cragg: Traveaux de 1980-1984,* April 7-May 6.
Tate Gallery, London, *Tony Cragg,* April 26-June 25.
Stedelijk Van Abbemuseum, Eindhoven, *Tony Cragg: Beelden/Sculptures,* May 14-July 2.

Selected Group Exhibitions

1977
Battersea Park, London, *A Silver Jubilee Exhibition of Contemporary British Sculpture 1977,* June 2-September 4.

1980
Thirty-Ninth Venice Biennale, *Aperto 80,* June 1-September 30.

1981
Whitechapel Art Gallery, London, *British Sculpture in the Twentieth Century,* Part Two, November 27-January 24, 1982.

1982
Metropolitan Museum of Art, Tokyo, *Aspects of British Art Today,* February 27-April 11, and British Council tour in Japan to Tochigi Prefectural Museum of Fine Art, Utsunomiya, April 24-May 30; The National Museum of Art, Osaka, June 15-July 25; Fukuoka Art Museum, August 7-29; Hokkaido Museum of Modern Art, Sapporo, September 9-October 9.
Kunsthalle Bern, *Leçons de Choses/Sachkunde,* June 9-July 25, and tour to Musée Savoisien, Chambéry, France, August 6-September 27.
Kunstmuseum Lucerne, *Englische Plastik Heute/ British Sculpture Now,* July 11-September 12.
Fifth Triennial India, New Delhi, March 15-April 7.
Museum Fridericianum, Kassel, West Germany, *Documenta 7,* June 19-September 26.

1983
Tate Gallery, London, *New Art at the Tate Gallery 1983,* September 14-October 23.
Parque Ibirapuera, São Paulo, *17a Bienal de São Paulo,* October 14-December 18.

1984

Louisiana Museum of Modern Art, Humlebaek, Denmark, *Borofsky, Cragg, Sherman,* January 21-April 4.

Art Gallery of New South Wales, Sydney, *The Fifth Biennale of Sydney: Private Symbol—Social Metaphor,* April 11-June 17.

Indianapolis Museum of Art, *Painting and Sculpture Today 1984,* May 1-June 10.

The Museum of Modern Art, New York, *An International Survey of Recent Painting and Sculpture,* May 17-August 19.

1985

Hayward Gallery, London, *The Hayward Annual 1985,* May 15-July 5.

Kunsthistorische Musea, Antwerp, and Openluchtmuseum voor Beeldhouwkunst, Middleheim, Belgium, *Biennale 18,* June 16-October 6.

1986

Arnhem, the Netherlands, *Sonsbeek 86,* June 18-September 14.

1987

Museum of Contemporary Art, Chicago, *A Quiet Revolution: British Sculpture Since 1965,* January 23-April 5, and tour to San Francisco Museum of Modern Art, June 4-July 26; Newport Harbor Art Museum, Newport Beach, Calif., August 14-October 4; Hirshhorn Museum and Sculpture Garden, Smithsonian Institution, Washington, D. C., November 10-January 10, 1988; Albright-Knox Art Gallery, Buffalo, February 12-April 10.

Musée National d'Art Moderne, Centre Georges Pompidou, Paris, *L'Epoque, la mode, la morale, la passion,* May 21-August 17.

Museum Fridericianum, Kassel, West Germany, *Documenta 8,* June 12-September 20.

1988

Museum van Hedendaagse Kunst, Antwerp, *De Verzameling/La Collection,* March 12-June 5.

Museo d'Arte Contemporanea, Prato, Italy, *Europa Oggi/Europe Now,* June 25-October 20.

Forty-Third Venice Biennale, *Tony Cragg XLIII Biennale di Venezia,* June 26-September 25.

Musée des Beaux-Arts 'André Malraux,' Le Havre, France, *Britannica. Trente Ans de Sculpture,* October 15-December 12, and British Council tour to Museum van Hedendaagse Kunst, Antwerp, January 21-March 5, 1989; Centre d'Art Contemporain Midi-Pyrénées, Toulouse, France, March 25-May 8.

1989

Marisa del Re, New York, *Influences,* March 8-April 1.

Selected Bibliography

Baker, Kenneth. "Tony Cragg at Marian Goodman." *Art in America* 72 (September 1984): 206.

Celant, Germano. "Tony Cragg and Industrial Platonism." *Artforum* 20 (November 1981): 40-46.

Cooke, Lynne. "Tony Cragg at the Whitechapel." *Artscribe* 28 (March 1981): 54-55.

_____. "Tony Cragg: Darkling Light." *Parkett* 18 (1988): 96-102.

Cragg, Tony. "Project for Artforum." *Artforum* 26 (March 1988): 120-22.

Graham-Dixon, Andrew. "Cragg's Way." *Artnews* 88 (March 1989): 132-37.

Haenlein, Carl, Tony Cragg, and Demosthène Davvetas. *Tony Cragg: Skulpturen.* Exhibition catalog. Hannover: Kestner-Gesellschaft, 1985.

Januszcak, Waldemar. "Tony Cragg and Richard Deacon." *Modern Painters* 1 (Autumn 1988): 67-69.

Leçons de Choses/Sachkunde. Exhibition catalog. Bern: Kunsthalle Bern, 1982. Interview by Hubert Martin.

Lemaître, Isabelle. "Interview with Tony Cragg." *Artefactum* 2 (November-December-January 1985-86): 7-11.

Linker, Kate. "Tony Cragg: Marian Goodman Gallery." *Artforum* 26 (February 1988): 146-47.

McEwen, John. "Tony Cragg at the Hayward." *Art in America* 75 (July 1987): 36-37.

Newman, Michael. "New Sculpture in Britain." *Art in America* 70 (September 1982): 107-9.

Tony Cragg. Exhibition brochure. Tokyo: Kanransha Gallery, 1982. Essay by Nobuo Nakamura.

Tony Cragg. Exhibition brochure. Tokyo: Kanransha Gallery, 1984. Essay by Reiji Kawaguchi.

Tony Cragg. Exhibition catalog. Bern: Kunsthalle Bern, 1983. Reprint of statements and essay by Germano Celant.

Tony Cragg. Exhibition catalog. Brussels: Palais des Beaux-Arts, 1985. Essay by Annelie Pohlen. Interview by Demosthène Davvetas.

Tony Cragg. Exhibition catalog. Karlsruhe: Badischer Kunstverein, 1982. Essay by Michael Newman.

Tony Cragg. Exhibition catalog. London: Arts Council of Great Britain, 1987. Interview and essay by Lynne Cooke.

Tony Cragg. Exhibition catalog. Saint-Etienne: Musée d'Art et d'Industrie, 1981. Foreword by Bernard Ceysson.

Tony Cragg: XLIII Biennale di Venezia. Exhibition catalog. London: British Council, 1988. Essay by Demosthène Davvetas.

Tony Cragg: Vier Arbeiten, 1984. Exhibition brochure. Cologne: Kölner Kunstverein, 1984.

Tony Cragg: Winner of the 1988 Turner Prize. Exhibition catalog. London: Tate Gallery and Patrons of New Art, 1989. Writings by Tony Cragg.

Tony Cragg's 'Axehead.' London: Tate Gallery, 1984. Interview with Pat Turner.

Weskott, H. "Tony Cragg: Abfallskulptur des Plastik zeit alters." *Kunstforum International* (January 1981): 165-66.

Winter, P. "Tony Cragg Puzzlespiel und Superzeichen." *Kunstforum International* (June 1983): 56-65.

Katharina Fritsch

Born Katharina Fritsch, February 14, 1956, in Essen, West Germany. Education: Kunstakademie Düsseldorf, 1979-86; nominated "Meister-schülerin," winter semester 1980. Lives and works in Düsseldorf.

Selected Solo Exhibitions

1984
Rüdiger Schöttle, Munich, *Katharina Fritsch,* April 28-May 31.

1985
Galerie Johnen & Schöttle, Cologne, *Katharina Fritsch,* September 6-October 19.
Galerie Schneider, Constance, West Germany, *Katharina Fritsch,* November 8-December 21.

1987
Kaiser Wilhelm Museum, Krefeld, West Germany, *Katharina Fritsch: Elefant,* February 8-July 26.

1988
Kunsthalle Basel, *Katharina Fritsch,* June 12-August 7, and tour to Institute of Contemporary Arts, London, October 8- November 27.

1989
Westfälischer Kunstverein, Münster, *Katharina Fritsch,* June 11-July 30.

Selected Group Exhibitions

1982
Museum für Kunst und Gewerbe, Hamburg, *Möbel perdu—Schöneres Wohnen,* October 21-January 16, 1983.

1984
Messegelände, Halle 13, Düsseldorf, *Von hier aus,* September 29-December 2. Organized by Gesellschaft für Aktuelle Kunst.

1986
Kunstverein Hamburg, *Von Raum zu Raum,* May 17-June 22.
Arnhem, the Netherlands, *Sonsbeek 86,* June 18-September 14.
Museum Ludwig, Cologne, *Europa/Amerika,* September 6-November 30.
New Museum of Contemporary Art, New York, *A Distanced View,* September 26-November 30.
Galerie Schipka, Sofia, Bulgaria, *Junge Rheinische Kunst,* November 24-December 12.

1987
Museum Haus Lange, Krefeld, West Germany, *Anderer Leute Kunst,* May 24-July 26.
Westfälisches Landesmuseum für Kunst und Kulturgeschichte, Münster, *Skulptur Projekte in Münster 1987,* June 14-October 4.
Rüdiger Schöttle, Munich, *Theatergarten Bestiarium,* October 23-November 22.

1988
Deste Foundation for Contemporary Art, Athens, Greece, *Cultural Geometry,* January 18-April 17.
Musée d'Art Contemporain, Bordeaux, *Collections Pour une Région,* March 4-April 24.
Galerie Johnen & Schöttle, Cologne, *Katharina Fritsch, Michael Van Ofen, Jeff Wall: Krieg-Liebe-Geld,* April 29-May 28.
Art Gallery of New South Wales, Sydney, *1988 Australian Biennale: From the Southern Cross—A View of World Art c. 1940-88,* May 18-July 3, and tour to National Gallery of Victoria, Melbourne, August 4-September 18.
The Carnegie Museum of Art, Pittsburgh, *Carnegie International,* November 5-January 22, 1989.

1989
De Appel, Amsterdam, *Katharina Fritsch, Martin Honert, Thomas Ruff,* February 25-March 25.

Selected Bibliography

Blase, Christoph. "On Katharina Fritsch." *Artscribe* 68 (March-April 1988): 52-55.

Cameron, Dan. "The Critic's Way." *Artforum* 26 (September 1987): 119.

Christov-Bakargiev, Carolyn. "Something Nowhere." *Flash Art* 140 (May-June 1988): 80-85.

Hermes, Manfred. "Katharina Fritsch." *Flash Art* 137 (November-December 1987): 112-13.

Heynen, Julian. "Katharina Fritsch." *Kunstwerk* 41 (January 1989): 129-30.

Katharina Fritsch. Exhibition catalog. Basel: Kunsthalle Basel; London: Institute of Contemporary Arts, 1988. Essay by Jean-Christophe Ammann.

Katharina Fritsch: Elefant. Exhibition catalog. Krefeld, West Germany: Krefelder Kunstmuseen, 1987. Essay by Julian Heynen.

Koether, Jutta. "Katharina Fritsch." *Artscribe* 63 (May 1987): 84.

————. "Katharina Fritsch Elephant." *Parkett* 13 (1987): 90-92.

Kraft, Monika Maria. "Katharina Fritsch." In *Von hier aus,* 280-83. Exhibition catalog. Cologne: DuMont, 1984.

Locker, Ludwig. "Architektonische Aspekte in der Düsseldorfer Gegenwartskunst (2)." *Artefactum* 2 (February-March 1986): 2-9.

Magnani, Gregorio. "This Is Not Conceptual." *Flash Art* 145 (March-April 1989): 84-87.

Messler, Norbert. "Raum-und Bildwelt." In *Von Raum zu Raum,* 23-24. Exhibition catalog. Hamburg: Kunstverein Hamburg, 1986.

Puvogel, Renate. "Katharina Fritsch: Elefant." *Kunstforum International* 89 (May-June 1987): 338-40.

Reust, Hans Rudolf. "Rosemarie Trockel, Katharina Fritsch." *Artscribe* 73 (January-February 1989): 88-89.

Salvioni, Daniela. "Trockel and Fritsch." *Flash Art* 142 (October 1988): 110.

"Situation." *Kunstforum International* 91 (October-November 1987): 160-213.

Syring, Marie Luise, and Christiane Vielhaber. "Katharina Fritsch." In the *BiNationale: German Art of the Late 80's,* 116-21. Exhibition catalog. Cologne: DuMont, 1988. Interviews by Jürgen Harten and David A. Ross. Fritsch withdrew from the exhibition.

Wilmes, Ulrich. "Madonna." In *Skulptur Projekte in Münster 1987,* 89-92. Exhibition catalog. Münster: Westfälisches Landesmuseum für Kunst und Kulturgeschichte, 1987.

Wulffen, Thomas. "Katharina Fritsch." *Kunstforum International* 91 (October-November 1987): 168-73.

Robert Gober

Born Robert Gober, September 12, 1954, in Wallingford, Conn. Education: Tyler School of Art, Temple University, Philadelphia, Fall 1974; Middlebury College, Middlebury, Vt., 1972-76, B. A. 1976. Lives and works in New York.

Selected Solo Exhibitions

1984
Paula Cooper Gallery, New York, *Robert Gober: Slides of a Changing Painting,* May 1-5.

1985
Daniel Weinberg Gallery, Los Angeles, *Robert Gober: Recent Sculpture,* February 20-March 16.
Paula Cooper Gallery, New York, *Robert Gober: Recent Sculptures,* September 14-October 9.

1986
Daniel Weinberg Gallery, Los Angeles, *Robert Gober: Recent Work,* June 14-July 12.

1987
Galerie Jean Bernier, Athens, Greece, *Robert Gober,* February 26-March 21.
Paula Cooper Gallery, New York, *Robert Gober,* October 3-28.

1988
Tyler School of Art, Temple University, Phildelphia, *Robert Gober,* February 25-March 21.
The Art Institute of Chicago, *Robert Gober,* April 26-June 26.
Galerie Max Hetzler, Cologne, *Robert Gober,* October 7-November 2.
Galerie Gisela Capitain, Cologne, *Robert Gober,* October 8-November 5.

Selected Group Exhibitions

1979
112 Greene Street, New York, *Amore Store,* December.

1981

Ian Birksted Gallery, New York, *Domestic Situations: Three Look into American Home Life,* May 9-June 10.

1982

Paula Cooper Gallery, New York, *Changing Group Exhibition,* January 24-February 20.
Paula Cooper Gallery, New York, *Changing Group Exhibition,* September 11-October 23.

1983

Studio 10, Chur, Switzerland, *New York New Work,* May 28-June 18.

1985

University Art Museum, University of California, Santa Barbara, *Scapes,* October 30-December 15, and tour to the University of Hawaii Art Gallery, Honolulu, January 26-February 28, 1986.

1986

Daniel Weinberg Gallery, Los Angeles, *Objects from the Modern World: Richard Artschwager, R. M. Fischer, Robert Gober, Jeff Koons,* February 18-March 8.
Nature Morte, New York, *Robert Gober and Kevin Larmon: An Installation,* March 1-28.
The Renaissance Society at the University of Chicago, *New Sculpture: Robert Gober, Jeff Koons, Haim Steinbach,* May 7-June 21.
Cable Gallery, New York, *Robert Gober, Nancy Shaver, Alan Turner, Meg Webster,* September 18-October 11.
Galerie Max Hetzler, Cologne, *Günther Förg, Robert Gober, Axel Hütte, Jon Kessler, Hubert Kiecol, Jeff Koons, Meuser, Heimo Zobernig,* November.
Wellesley (Mass.) College Museum, *1976-1986: Ten Years of Collecting Contemporary American Art,* November 13-January 18, 1987.
Centre Cultural de la Fundació Caixa de Pensions, Barcelona, *Art and Its Double: A New York Perspective,* November 27-January 11, 1987.

1987

Los Angeles County Museum of Art, *Avant-Garde in the Eighties,* April 23-July 12.
Studio Lia Rumma, Naples, *Extreme Order,* May.

1988

Deste Foundation for Contemporary Art, Athens, Greece, *Cultural Geometry,* January 18-April 17.
Institute of Contemporary Art, Boston, *Utopia Post Utopia: Configurations of Nature and Culture in Recent Sculpture and Photography,* January 29-March 27.
Walker Art Center, Minneapolis, *Sculpture Inside Outside,* May 21-September 11, and tour to the Museum of Fine Arts, Houston, December 10-March 5, 1989.
Forty-Third Venice Biennale, *Aperto 88,* June 26-September 25.
Rooseum, Malmö, Sweden, *Art at the End of the Social,* July 29-October 2.
The Aldrich Museum of Contemporary Art, Ridgefield, Conn., *Innovations in Sculpture 1985-1988,* September 24-December 31.
Institute of Contemporary Art and Museum of Fine Arts, Boston, *The BiNationale: American Art of the Late 80's,* September 24-November 27, and tour to Städtische Kunsthalle, Kunstsammlung Nordrhein-Westfalen, Kunstverein für die Rheinlande und Westfalen, Düsseldorf, December 10-January 29, 1989.
Museum of Contemporary Art, Chicago, *Three Decades: The Oliver-Hoffmann Collection,* December 17-February 5, 1989.

1989

Stedelijk Museum, Amsterdam, *Horn of Plenty: Sixteen Artists from New York City,* January 14-February 19.
Paula Cooper Gallery, New York, *Richard Artschwager, John Baldessari, Jonathan Borofsky, Robert Gober, Peter Halley, Nancy Shaver,* January 28-February 25.
Stux Gallery, New York, *Pre-Pop, Post-Appropriation,* February 3-March 4.

Selected Bibliography

Beyer, Lucie. "Förg, Kiecol, Meuser, A. Hütte, Zobernig, Koons, Kessler, Gober, Max Hetzler, Cologne." *Flash Art* 132 (February-March 1987): 111.

Boswell, Peter W. "Robert Gober." In *Sculpture Inside Outside,* 97-104. Exhibition catalog. Minneapolis: Walker Art Center, 1988.

Cameron, Dan. "Signs of Empire." In *New York Art Now: The Saatchi Collection,* 13-56. London: The Saatchi Collection, 1988.

Collins, Tricia, and Richard Milazzo. "Post-Appropriation and the Romantic Fallacy. Gober, Etkin, Shaver, and Carroll." *Tema Celeste* 21 (July-September 1989): 36-43.

_____. "Robert Gober: The Subliminal Function of Sinks." *Kunstforum International* 84 (June-August 1986): 320-22.

Cone, Michèle. "Ready-Mades on the Couch." *Artscribe* 58 (June-July 1986): 30-33.

Decter, Joshua. "Robert Gober." *Arts Magazine* 60 (December 1985): 124.

Gober, Robert. "Cumulus from America." *Parkett* 19 (March 1989): 169-71.

Heartney, Eleanor. "Homeward Unbound." *Sculpture* 8 (September-October 1989): 20-23.

Indiana, Gary. "A Torture Garden." *Village Voice,* October 27, 1987, p. 105.

Joselit, David. "Investigating the Ordinary." *Art in America* 76 (May 1988): 148-55.

Kaplan, Steven. "Head, Heart, and Hands." *Artfinder* (Spring 1987): 96-102.

Koether, Jutta. "Group Show, Hetzler." *Artscribe* 62 (March-April 1987): 91-92.

_____. "Robert Gober." *Artforum* 27 (February 1989): 145.

Leigh, Christian. "Home Is Where the Heart Is." *Flash Art* 145 (March-April 1989): 79-83.

Lichtenstein, Therese. "Group Show." *Arts Magazine* 59 (November 1984): 37.

Mahoney, Robert. "Real Inventions/Invented Functions." *Arts Magazine* 62 (May 1988): 102.

Marincola, Paula. "Robert Gober." *Artforum* 26 (May 1988): 153.

Princenthal, Nancy. "Robert Gober at Paula Cooper." *Art in America* 75 (December 1987): 153-54.

Puvogel, Renate. "Robert Gober." *Artscribe* 75 (May 1989): 88-89.

Rian, Jeffrey. "Past Sense, Present Sense." *Artscribe* 73 (January-February 1989): 60-65.

Rinder, Larry. "Kevin Larmon and Robert Gober." *Flash Art* 128 (May-June 1986): 56-57.

Robert Gober. Exhibition brochure. Chicago: Art Institute of Chicago, 1988. Essay by Neal Benezra.

Robert Gober. Exhibition brochure. Phildelphia: Tyler School of Art, Temple University, 1988. Essay by Paolo Colombo.

Rubinstein, Meyer Raphael, and Daniel Weiner. "Robert Gober." *Flash Art* 138 (January-February 1988): 119.

Russell, John. "Robert Gober." *New York Times,* October 4, 1985, sec. C, p. 24.

Sherlock, Maureen P. "Arcadian Elegy: The Art of

Robert Gober." *Arts Magazine* 64 (September 1989): 44-49.

Vitale, Robert. "Review." *New Art Examiner* 15 (January 1988): 60-61.

Jenny Holzer

Born Jenny Holzer, July 29, 1950, in Gallipolis, Ohio. Education: Duke University, Durham, N. C., 1968-70; University of Chicago, 1970-71; Ohio University, Athens, 1970-72, B. F. A., with honors, 1972; Rhode Island School of Design, Providence, 1975-77, M. F. A. 1977; Whitney Museum Independent Study Fellow, 1977. Awards include: Watson F. Blair Prize, *Seventy-Fourth American Exhibition,* the Art Institute of Chicago, 1982. Lives and works in New York.

Selected Solo Exhibitions

1978
P.S. 1, Institute for Art and Urban Resources, Long Island City, N. Y., *Special Project,* January 15-February 18.

1980
Rüdiger Schöttle, Munich, *Living,* December 10-January 20, 1981.

1982
Times Square, New York, *Untitled,* March 1-31. Sponsored by Public Art Fund.
Barbara Gladstone Gallery, New York, *Plaques For Buildings Thirty Texts From the Living Series, Cast in Bronze, by Jenny Holzer and Peter Nadin,* April 28-May 22.

1983
Institute of Contemporary Art, University of Pennsylvania, Philadelphia, *Investigations Three: Jenny Holzer,* June 11-July 31.

1984
Kunsthalle Basel, *Jenny Holzer,* May 13-June 24, and tour to Le Nouveau Musée, Villeurbanne, France, September 28-December 16.
Dallas Museum of Art, *Jenny Holzer,* October 28-January 1, 1985.

1986
Barbara Gladstone Gallery, New York, *Jenny Holzer: "Under a Rock,"* October 7-November 1.
Des Moines Art Center, *Jenny Holzer: Signs,* December 6-February 1, 1987, and tour to the Aspen (Colo.) Art Museum, February 19-April 12; Artspace, San Francisco, May 5-June 27; Museum of Contemporary Art, Chicago, July 31-September

27; List Visual Arts Center, Massachusetts Institute of Technology, Cambridge, October 9-November 29.

1987

Rhona Hoffman Gallery, Chicago, *Jenny Holzer: "Under a Rock,"* February 13-March 21.

1988

The Brooklyn Museum, *Jenny Holzer: Signs and Benches,* May 5-July 18.
Interim Art, London, *Jenny Holzer: Plaques,* November 27-December 21.
Institute of Contemporary Arts, London, *Jenny Holzer,* December 7-February 12, 1989.

1989

Doris C. Freedman Plaza, New York, *Jenny Holzer,* July-December.
Solomon R. Guggenheim Museum, New York, *Jenny Holzer,* December 12-February 11, 1990.

Selected Group Exhibitions

1978

Los Angeles Institute of Contemporary Arts, *Artwords and Bookworks,* February 28-March 30, and tour to Artists Space, New York, June 10-30; Herron School of Art, Indianapolis, September 15-29; New Orleans Contemporary Art Center, October 14-30.

1981

Rheinhallen der Kölner Messe, Cologne, *Westkunst: Zeitgenössiche Kunst seit 1939,* May 30-August 16. Organized by Museen der Stadt Köln.

1982

Artists Space, New York, *Jenny Holzer/Peter Nadin: Eating Friends,* January 9-February 13.
The Art Institute of Chicago, *Seventy-Fourth American Exhibition,* June 12-August 1.
Museum Fridericianum, Kassel, West Germany, *Documenta 7,* June 19-September 26.

1983

Whitney Museum of American Art, New York, *1983 Biennial Exhibition,* March 15-May 22.
Allen Memorial Art Museum, Oberlin (Ohio) College, *Art and Social Change, U. S. A.,* April 19-May 30.

1984

Art Gallery of New South Wales, Sydney, *The Fifth Biennale of Sydney: Private Symbol—Social Metaphor,* April 11-June 17.
Indianapolis Museum of Art, *Painting and Sculpture Today 1984,* May 1-June 10.

Städtische Kunsthalle Düsseldorf, *A Different Climate: Aspects of Beauty in Contemporary Art,* August 25-October 6.
Hirshhorn Museum and Sculpture Garden, Smithsonian Institution, Washington, D. C., *Content: A Contemporary Focus, 1974-1984,* October 4-January 6, 1985.

1985

Whitney Museum of American Art, New York, *1985 Biennial Exhibition,* March 13-June 9.
La Grande Halle du Parc de la Villette, Paris, *Nouvelle Biennale de Paris 1985,* March 21-May 21.
Museum of Art, Carnegie Institute, Pittsburgh, *1985 Carnegie International,* November 9-January 5, 1986.

1986

Contemporary Arts Center, Cincinnati, *Jenny Holzer/Cindy Sherman: Personae,* February 7-March 15.
Institute of Contemporary Art, Boston, *Dissent: The Issue of Modern Art in Boston—As Found,* April 29-June 22.
Museum Ludwig, Cologne, *Europa/Amerika,* September 6-November 30.

1987

Los Angeles County Museum of Art, *Avant-Garde in the Eighties,* April 23-July 12.
Museum Fridericianum, Kassel, West Germany *Documenta 8,* June 12-September 20.
Westfälisches Landesmuseum für Kunst und Kulturgeschichte, Münster, *Skulptur Projekte in Münster 1987,* June 14-October 4.

1988

The Museum of Modern Art, New York, *Committed to Print,* January 31-April 19.
Art Gallery of New South Wales, Sydney, *1988 Australian Biennale: From the Southern Cross—A View of World Art c. 1940-88,* May 18-July 3, and tour to National Gallery of Victoria, Melbourne, August 4-September 18.
Museum of Contemporary Art, Chicago, *Three Decades: The Oliver- Hoffmann Collection,* December 17-February 5, 1989.

1989

Tony Shafrazi Gallery, New York, *Words,* January 21-February 18.
Bass Museum of Art, Miami Beach, Fla., *The Future Now,* March 10-April 30.
The Museum of Contemporary Art, Los Angeles, *A Forest of Signs: Art in the Crisis of Representation,* May 7-August 13.

Selected Bibliography

Bordaz, Jean-Pierre. "Jenny Holzer and the Spectacle of Communication." *Parkett* 13 (1987): 22-33.

Brenson, Michael. "Jenny Holzer: The Message Is the Message." *New York Times,* August 7, 1988, pp. 29, 31.

Cameron, Dan. "Jenny Holzer." *Tema Celeste* 10 (March 1987): 61-62.

Esman, Abigail R. "Jenny Holzer." *New Art International* 2 (February-March 1988): 50-53. Interview.

Evans, Steven. "Not All about Death: Jenny Holzer Interviewed by Steven Evans." *Artscribe* 76 (Summer 1989): 57-59.

Ferguson, Bruce. "Wordsmith: An Interview with Jenny Holzer." *Art in America* 74 (December 1986): 108-15, 153.

Foster, Hal. "Subversive Signs." *Art in America* 70 (November 1982): 88-92.

Graham, Dan. "Signs." *Artforum* 19 (April 1981): 38-43.

Holzer, Jenny. *Essay Packs.* New York: n. p., 1988.

_____. "Truisms." In *Blasted Allegories,* edited by Brian Wallis, 103-11. New York: New Museum of Contemporary Art; Cambridge: MIT Press, 1987.

_____. *Truisms and Essays.* Halifax: Nova Scotia College of Art and Design, 1983.

Howell, John. "Jenny Holzer: The Message Is the Medium." *Artnews* 87 (Summer 1988): 122-27.

Jenny Holzer. Exhibition brochure. Dallas: Dallas Museum of Art, 1984. Essay by Sue Graze.

Jenny Holzer. Exhibition catalog. Basel: Kunsthalle Basel; Villeurbanne, France: Le Nouveau Musée, 1984. Introduction by Jean-Christophe Ammann.

"Jenny Holzer." In *Cave Canem,* 13-25. New York: Cave Canem Books, 1982.

Jenny Holzer/Cindy Sherman: Personae. Exhibition catalog. Cincinnati: Contemporary Arts Center, 1986. Essay by Sarah Rogers-Lafferty.

Jenny Holzer: Signs. Exhibition catalog. Des Moines: Des Moines Art Center, 1986. Interview by Bruce Ferguson, essay by Joan Simon. Rev. ed. London: Institute of Contemporary Art, 1988. Interview reprinted and abridged in *Art in America* 74 (December 1986): 108-15, 153.

Jones, Ronald. "Jenny Holzer's 'Under a Rock.'" *Arts Magazine* 61 (January 1987): 42-43.

Larson, Kay. "In the Beginning Was the Word." *New York* (April 3, 1989): 71-72.

_____. "Signs of the Times: Jenny Holzer's Art Words Catch On." *New York* 21 (September 5, 1988): 48-53.

MacPherson, Rory. "Jenny Holzer." *Splash* 1 (Summer 1988) (unpaginated). Interview.

Nemiroff, Diana. "Personae and Politics: Jenny Holzer." *Vanguard* 12 (November 1983): 26-27. Interview.

Ratcliff, Carter. "Jenny Holzer." *The Print Collector's Newsletter* 13 (November-December 1982): 149-52.

Reason, Rex. "Democratism or I Went to See 'Chelsea Girls' and Ended Up Thinking about Jenny Holzer." *Real Life* 8 (Spring-Summer 1982): 5-13. Interview.

Siegel, Jeanne. "Jenny Holzer's Language Games." *Arts Magazine* 60 (December 1985): 64-68. Reprinted in *Artwords 2,* 284-97. Ann Arbor, Mich.: UMI Research Press, 1988.

Smith, Roberta. "Flashing Aphorisms by Jenny Holzer at Dia." *New York Times,* March 10, 1989, sec. C, p. 28.

Smolik, Noemi. "Jenny Holzer: Ein Interview." *Wolkenkratzer Art Journal* 5 (1986): 102-3.

Staniszewski, Mary Anne. "Jenny Holzer: Language Communicates." *Flash Art* 143 (November-December 1988): 112. Interview.

Watson, Gray. "Jenny Holzer: ICA and Elsewhere, London." *Flash Art* 145 (March-April 1989): 120-21.

Jeff Koons

Born Jeff Koons, January 21, 1955, in York, Penn. Education: The Maryland Institute, College of Art, Baltimore, 1972-76, B. F. A., cum laude, 1976; The School of the Art Institute of Chicago, 1975-76. Lives and works in New York.

Selected Solo Exhibitions

1980

New Museum of Contemporary Art, New York, *The New,* May 29-June 26.

1985

International with Monument Gallery, New York,

Jeff Koons, May 4-June 2.
Feature Gallery, Chicago, *Jeff Koons,* September 12-
October 12.

1986
Daniel Weinberg Gallery, Los Angeles, *Jeff Koons,*
July 19-August 16.
International with Monument Gallery, New York,
Jeff Koons: New Work, September 12-October 12.

1987
Daniel Weinberg Gallery, Los Angeles, *Jeff Koons:
Encased Works,* December 5-January 9, 1988.

1988
Museum of Contemporary Art, Chicago, *Jeff Koons,*
July 1-August 28.
Galerie Max Hetzler, Cologne, *Jeff Koons,* November
13-30.
Sonnabend Gallery, New York, *Jeff Koons,* November
19-December 23.
Donald Young Gallery, Chicago, *Jeff Koons,*
December 3-January 7, 1989.

1989
Galerie 't Venster, Rotterdam, *Jeff Koons—Nieuw
Werk,* January 13-February 8.

Selected Group Exhibitions

1981
P.S. 1, Institute for Art and Urban Resources, Long
Island City, N. Y., *Lighting,* February 15-April 5.

1982
Espace Lyonnais d'Art Contemporain, Lyons, France,
Energie New-York, January 15-March 15.
The Renaissance Society at the University of Chicago,
A Fatal Attraction: Art and the Media, May 2-June 12.

1983
Artists Space, New York, *The Los Angeles New York
Exchange,* May 21-July, and tour to Los Angeles
Contemporary Exhibitions, June 8-July 16.

1985
Whitney Museum of American Art, Stamford,
Conn., *Affiliations: Recent Sculpture and Its
Antecedents,* June 28-August 24.

1986
Daniel Weinberg Gallery, Los Angeles, *Objects from
the Modern World: Richard Artschwager, R. M. Fischer,
Robert Gober, Jeff Koons,* February 18-March 8.
The Renaissance Society at the University of Chicago,
*New Sculpture: Robert Gober, Jeff Koons, Haim
Steinbach,* May 7-June 21.
New Museum of Contemporary Art, New York,
Damaged Goods, Desire and the Economy of the Object,

June 21-August 10.
Institute of Contemporary Art, Boston, *Endgame:
Reference and Simulation in Recent Painting and
Sculpture,* September 25-November 30.
Galerie Max Hetzler, Cologne, *Günther Förg, Robert
Gober, Axel Hütte, Jon Kessler, Hubert Kiecol, Jeff
Koons, Meuser, Heimo Zobernig,* November.
Centre Cultural de la Fundació Caixa de Pensions,
Barcelona, *Art and Its Double: A New York
Perspective,* November 27-January 11, 1987.

1987
Whitney Museum of American Art, New York,
1987 Biennial Exhibition, April 10-July 5.
Los Angeles County Museum of Art, *Avant-Garde
in the Eighties,* April 23-July 12.
The Aldrich Museum of Contemporary Art,
Ridgefield, Conn., *Post-Abstract Abstraction,* May
31-September 6.
Westfälisches Landesmuseum für Kunst und
Kulturgeschichte, Münster, *Skulptur Projekte in
Münster 1987,* June 14-October 4.

1988
Deste Foundation for Contemporary Art, Athens,
Greece, *Cultural Geometry,* January 18-April 17.
Kunstverein, Munich, *New York in View,* February
26-April 3.
Institute of Contemporary Art and Museum of Fine
Arts, Boston, *The BiNationale: American Art of the
Late 80's,* September 23-November 27, and tour to
Städtische Kunsthalle, Kunstsammlung Nordrhein-
Westfalen, Kunstverein für die Rheinlande und
Westfalen, Düsseldorf, December 10-January
29, 1989.
The Carnegie Museum of Art, Pittsburgh, *Carnegie
International,* November 5-January 22, 1989.
Museum of Contemporary Art, Chicago, *Three
Decades: The Oliver-Hoffmann Collection,* December
17-February 5, 1989.

1989
Museum van Hedendaagse Kunst, Antwerp, *Het
Postmoderne: Aan Kinderen Verklaard,* March 18-
April 23.
Whitney Museum of American Art, New York,
1989 Biennial Exhibition, April 27-July 9.
The Museum of Contemporary Art, Los Angeles, *A
Forest of Signs: Art in the Crisis of Representation,*
May 7-August 13.
Galerie Thaddaeus Ropac, Salzburg, Austria, *The
Silent Baroque,* June-August.

Selected Bibliography

Brenson, Michael. "Greed Plus Glitz, with a Dollop

of Innocence." *New York Times,* December 18, 1988, pp. 41, 44.

Cox, Meg. "Feeling Victimized? Then Strike Back: Become an Artist." *Wall Street Journal,* February 13, 1989, sec. A, pp. 1, 8.

Craw, Isabelle. "Atlantic Alliance: Interview with Georg Herold and Jeff Koons." *Wolkenkratzer Art Journal* (January-February 1988): 105-7.

Danoff, I. Michael. *Jeff Koons.* Exhibition catalog. Chicago: Museum of Contemporary Art, 1988.

Dreher, Thomas. "Jeff Koons: Objekt-Bilder." *Artefactum* 6 (January-February 1989): 6-11. English translation, 66-68.

Halley, Peter. "The Crisis in Geometry." *Arts Magazine* 58 (Summer 1984): 111-15.

Indiana, Gary. "Jeff Koons at International with Monument." *Art in America* 73 (November 1985): 163-64.

Januszczak, Waldemar. "Diary: The Critic As Jeff Koons Fan." *Modern Painters* 1 (Summer 1988): 56-59.

Joselit, David. "Investigating the Ordinary." *Art in America* 76 (May 1988): 149-54.

Koons, Jeff. "A Project for Artforum by Jeff Koons: Baptism." *Artforum* 26 (November 1987): 101-7.

_____. "A Text by Jeff Koons." *Spazio Umano* 4 (October-December 1986): 104-9.

Kramer, Hilton. "Koons Show in the City Succeeds in Carrying Things to a New Low." *New York Observer,* December 19, 1988, pp. 1, 11.

Lacayo, Richard. "Artist Jeff Koons Makes, and Earns, Giant Figures." *People Weekly* 31 (May 8, 1989): 127-32.

Morgan, Stuart, et al. "Big Fun: Four Reactions to the New Jeff Koons." *Artscribe* 74 (March-April 1989): 46-49.

Nagy, Peter. "Flash Art Panel: From Criticism to Complicity." *Flash Art* 129 (Summer 1986): 46-49. Panel includes Koons.

O'Brien, Glenn. "Koons ad nauseum." *Parkett* 19 (March 1989): 65-69.

Ottmann, Klaus. "Jeff Koons." *Journal of Contemporary Art* 1 (Spring 1988): 18-23. Interview.

Palmer, Laurie. "Jeff Koons." *Artforum* 27 (October 1988): 153.

Pincus-Witten, Robert. "Entries: Concentrated Juice and Kitschy Kitschy Koons." *Arts Magazine* 63 (February 1989): 34-39.

Plagens, Peter. "The Emperor's New Cherokee Limited Four by Four." *Art in America* 76 (June 1988): 23-24.

Politi, Giancarlo. "Luxury and Desire: An Interview with Jeff Koons." *Flash Art* 132 (February-March 1987): 71-76.

Saltz, Jerry. "The Dark Side of the Rabbit: Notes on a Sculpture by Jeff Koons." *Arts Magazine* 62 (February 1988): 26-27.

Salvioni, Daniela. "Interview with McCollum and Koons." *Flash Art* 131 (December 1986-January 1987): 66-68.

Schwartzman, Allan. "The Yippie-Yuppie Artist." *Manhattan Inc.* 4 (December 1987): 137-38.

Siegel, Jeanne. "Jeff Koons: Unachievable States of Being." *Arts Magazine* 61 (October 1986): 66-71.

Smith, Roberta. "Rituals of Consumption." *Art in America* 76 (May 1988): 164-71.

Tillim, Sidney. "Ideology and Difference, Reflections on Olitski and Koons." *Arts Magazine* 63 (March 1989): 49-51.

Wallach, Amei. "The Art and Power of Jeff Koons." *Newsday* (N. Y.) December 1, 1988, Part Two, pp. 4-5.

Sherrie Levine

Born Sherrie Levine, April 17, 1947, in Hazleton, Penn. Education: University of Wisconsin, Madison, 1965-73, B. S. 1969, M. F. A. 1973. Awards include: New York Foundation for the Arts Fellowship in Painting, 1987. Lives and works in New York.

Selected Solo Exhibitions

1974
De Saisset Art Gallery, University of Santa Clara (Calif.), *Sherrie M. Levine: Betrayal,* June 5-28.

1978
Hallwalls, Buffalo, *Dogs and Triangles,* February 3-28.

1981
Metro Pictures, New York, *Sherrie Levine: Photographs,* May 14-June 3.

1983
Richard Kuhlenschmidt Gallery, Los Angeles, *Sherrie Levine Photographs,* February 12-March 19.

Baskerville & Watson, New York, *Sherrie Levine:
New Watercolors and Photographs,* November 22-
December 22.

1984
A & M Artworks, New York, *Self-Portraits by
Sherrie Levine after Egon Schiele,* March 11-April 28.
Galerie Optica, Montreal, *Sherrie Levine:
Photographies,* May 1-23.
ACE Exhibits, Washington, D. C., *Sherrie Levine,*
May 24-June 14.
Nature Morte, New York, *Sherrie Levine: 1917,*
October 2-31.

1985
Richard Kuhlenschmidt Gallery, Los Angeles,
Sherrie Levine Watercolors, February 21-March 30.
Baskerville & Watson, New York, *Sherrie Levine,*
November 19-December 21.

1986
Daniel Weinberg Gallery, Los Angeles, *Sherrie
Levine: Recent Paintings,* October 4-November 1.

1987
Donald Young Gallery, Chicago, *Sherrie Levine,*
February 5-28.
Wadsworth Atheneum, Hartford, *Sherrie Levine/
Matrix Ninety-Four,* May 16-June 22.
Mary Boone Gallery, New York, *Sherrie Levine,*
September 12-October 10.

1988
Hirshhorn Museum and Sculpture Garden,
Smithsonian Institution, Washington D. C.,
Directions—Sherrie Levine, March 9-May 30, and
tour to High Museum of Art, Atlanta, *Art at the
Edge: Sherrie Levine,* June 11-September 11.
Galerie nächst St. Stephan, Rosemarie
Schwarzwälder, Vienna, *Sherrie Levine,* April 27-
June 4.
Mario Diacono Gallery, Boston, *Sherrie Levine,*
November 18-December 23.

1989
Donald Young Gallery, Chicago, *Sherrie Levine,*
February 13-March 4.
Mary Boone Gallery, New York, *Sherrie Levine,*
September 9-October 14.

Selected Group Exhibitions

1977
Artists Space, New York, *Pictures,* September 25-
October 29, and tour to Allen Memorial Art
Museum, Oberlin (Ohio) College, February 28-
March 25, 1978; Los Angeles Institute of

Contemporary Art, May 27-June 30; University of
Colorado, Boulder, September 8-October 6.

1979
Joseloff Art Gallery, University of Hartford,
Hartford Art School, West Hartford, Conn.,
Imitation of Life, November 6-28.

1980
Padiglione d'Arte Contemporanea, Milan, *Horror
Pleni: Pitture d'oggi à New York,* April-May.

1981
Metro Pictures, New York, *Photo,* September 12-
October 3.
Nigel Greenwood, London, *Real Life Presents,*
September 29-November 9.

1982
Museum Fridericianum, Kassel, West Germany,
Documenta 7, June 19-September 26.
Vancouver (British Columbia) Art Gallery,
Mannerism: A Theory of Culture, March 27-April 25.
The Art Institute of Chicago, *Seventy-Fourth
American Exhibition,* June 12-August 1.

1983
Allen Memorial Art Museum, Oberlin (Ohio)
College, *Art and Social Change, U. S. A.,* April 19-
May 30.

1984
Hirshhorn Museum and Sculpture Garden,
Smithsonian Institution, Washington, D. C.,
Content: A Contemporary Focus, 1974-1984,
October 4-January 6, 1985.
New Museum of Contemporary Art, New York,
Difference: On Representation and Sexuality,
December 8-February 10, 1985, and tour to the
Renaissance Society at the University of Chicago,
March 3-April 7; Institute of Contemporary Arts,
London, July 19-September 1.

1985
Whitney Museum of American Art, New York,
1985 Biennial Exhibition, March 13-June 9.
Mary and Leigh Block Gallery, Northwestern
University, Evanston, Ill., *Picture Taking: Weegee,
Walker Evans, Sherrie Levine, Robert Mapplethorpe,*
November 1-December 22.

1986
Art Gallery of New South Wales, Sydney, *Origins,
Originality and Beyond: The Sixth Biennial of Sydney,
1986,* May 16-July 6.
Institute of Contemporary Art, Boston, *Endgame:
Reference and Simulation in Recent Painting and
Sculpture,* September 25-November 30.

1987
Los Angeles County Museum of Art, *Avant-Garde in the Eighties,* April 23-July 12.
The Aldrich Museum of Contemporary Art, Ridgefield, Conn., *Post-Abstract Abstraction,* May 31-September 6.

1988
Deste Foundation for Contemporary Art, Athens, Greece, *Cultural Geometry,* January 18-April 17.
Neuberger Museum, State University of New York at Purchase, *Photographs Beget Photographs,* January 31-March 27.
The Carnegie Museum of Art, Pittsburgh, *Carnegie International,* November 5-January 22, 1989.
Museum of Contemporary Art, Chicago, *Three Decades: The Oliver-Hoffmann Collection,* December 17-February 5, 1989.

1989
The Museum of Contemporary Art, Los Angeles, *A Forest of Signs: Art in the Crisis of Representation,* May 7-August 13.
Whitney Museum of American Art, New York, *1989 Biennial Exhibition,* April 27-July 9.
National Museum of American Art, Smithsonian Institution, Washington, D. C., *The Photography of Invention: American Pictures of the 1980s,* April 28-September 10.

Selected Bibliography

The Best of Both Worlds: Sherrie Levine's 'After Walker Evans.' Exhibition brochure. Evanston, Ill.: Mary and Leigh Block Gallery, Northwestern University, 1985. Essay by S. David Deitcher.

Cameron, Dan. "Absence and Allure: Sherrie Levine's Recent Work." *Arts Magazine* 58 (December 1983): 84-87.

_____. "Sherrie Levine: Ein Interview. . . ." *Wolkenkratzer Art Journal* 3 (May-June 1987): 68-73. English translation, 109-10.

Carr, Cindy. "Sherrie Levine." Interview in ". . . What is Political Art . . . Now? . . . What is Political Art. . . ." *Village Voice,* October 15, 1985, p. 81.

Galligan, Gregory. "Praying with a Paintbrush." *Art International* 2 (Spring 1988): 41-46.

Grimes, Nancy. "Sherrie Levine." *Artnews* 86 (November 1987): 191-92.

"Insert: Sherrie Levine 'After Jan Vermeer.'" *Parkett* 16 (July 1988): 123-34.

Johnson, Ellen H. "Appropriation: Are These All

Originals?" *Dialogue* 11 (March-April 1988): 23-27.

Jones, Ronald. "Even Picasso: Sherrie Levine." *Artscribe* 72 (November-December 1988): 50-52.

_____. "Slow Time: Ronald Jones Discusses Sherrie Levine's New Work." *Artscribe* 67 (January-February 1988): 45.

Krane, Susan, and Phyllis Rosenzweig. *Art at the Edge: Sherrie Levine.* Exhibition catalog. Atlanta: High Museum of Art, 1988.

Kuspit, Donald B. "Sherrie Levine." *Artforum* 26 (December 1987): 110-11.

Levine, Sherrie. "David Salle." *Flash Art* 103 (Summer 1981): 34.

_____. "Five Comments." In *Blasted Allegories,* edited by Brian Wallis, 92-93. New York: New Museum of Contemporary Art, 1987; Cambridge: MIT Press, 1987.

Malcolm, Janet. "Girl of the Zeitgeist—II." *New Yorker* 62 (October 27, 1986): 47-48.

Marzorati, Gerald. "Art in the (Re) Making." *Artnews* 85 (May 1986): 90-99.

Melville, Stephen. "Not Painting: The New Work of Sherrie Levine." *Arts Magazine* 60 (February 1986): 23-25.

Morgan, Robert C. "Sherrie Levine: Language Games." *Arts Magazine* 62 (December 1987): 86-88.

"Post-Modernism: A Symposium with Christian Hubert, Sherrie Levine, Craig Owens, David Salle, and Julian Schnabel." *Real Life Magazine* 6 (Summer 1981): 4-10.

Salvioni, Daniela. "Spotlight: Sherrie Levine—Humor Is Added to Probing Precepts of Modernism." *Flash Art* 145 (March-April 1989): 109.

Schwartz, Dieter. *Sherrie Levine.* Exhibition catalog. Vienna: Galerie nächst St. Stephan, Rosemarie Schwarzwälder, 1988.

Sherrie Levine/Matrix Ninety-Four. Exhibition brochure. Hartford: Wadsworth Atheneum, 1987. Essay by Andrea Miller-Keller.

Siegel, Jeanne. "After Sherrie Levine." *Arts Magazine* 59 (Summer 1985): 141-44. Reprinted in *Artwords 2,* 244-55. Ann Arbor, Mich.: UMI Research Press, 1988.

Smith, Roberta. "Art: From Sherrie Levine, a Mini-

Retrospective." *New York Times,* September 18, 1987, sec. C, p. 22.

Sturtevant, Alfred. "Sherrie Levine." *Arts Magazine* 60 (March 1986): 124.

Taylor, Paul. "Sherrie Levine Plays with Paul Taylor." *Flash Art* 135 (Summer 1987): 55-59. Interview.

Yood, James. "Sherrie Levine." *Artforum* 27 (April 1989): 170.

Yasumasa Morimura

Born Yasumasa Morimura, June 11, 1951, in Osaka. Education: Kyoto City University of Arts, 1971-78, B. A. 1975; Research Course of Visual Design, 1978. Lives and works in Osaka.

Selected Solo Exhibitions

1986
Haku Gallery, Osaka, *Mon amour violet et autres (Morimura),* November 24-29.

Selected Group Exhibitions

1986
Haku Gallery, Osaka, *Art different-scène differentible de peinture,* June 9-14.

1987
Galerie 16, Kyoto, *Trans-Art-Scene II: Biomaps,* February 24-March 8.
Sagacho Exhibit Space, Tokyo, *Yes Art Deluxe,* July 7-25, and tour to Haku Gallery, Osaka, August 10-15.
Tochigi Prefectural Museum of Fine Arts, Utsunomiya, Japan, *Photographic Aspect of Japanese Art Today,* December 20-January 31, 1988.

1988
Gallery Coco, Kyoto, *Secret Promise of the Image,* January 12-24.
Forty-Third Venice Biennale, *Aperto 88,* June 26-September 25.
Art L. A. '88, Los Angeles, *East Meets West: Japanese and Italian Art Today,* December 10-14.

1989
San Francisco Museum of Modern Art, *Against Nature: Japanese Art in the Eighties,* June 15-August 6, and tour to Akron (Ohio) Art Museum, September 8-November 5; Massachusetts Institute of Technology, List Visual Arts Center, Cambridge, December 9-February 11, 1990; Seattle Art Museum, March 22-May 13; Contemporary Arts Center, Cincinnati, June 8-July 27; Grey Art Gallery and Study Center, New York University, September 10-October 27; Contemporary Arts Museum, Houston, November 16-February 12, 1991.

Selected Bibliography

Against Nature: Japanese Art in the Eighties. Exhibition catalog. New York: Grey Art Gallery and Study Center, New York University, 1989.

Kimmelman, Michael. "Japanese Artists Forgo Lotus Blossoms for Urban Blight." *New York Times,* August 6, 1989, sec. 2, pp. 31, 33.

Kohmoto, Shinji. "'A Secret Agreement,' Coco, Kyoto." *Flash Art* 140 (May-June 1988): 120.

Koplos, Janet. "Yasumasa Morimura at NW House." *Art in America* 77 (June 1989): 189.

Morimura, Yasumasa. "Bijutsu wa ai kara umareru." *Wave* 22 (1989): 138-45. Interview.

_____. "Morimura Yasumasa: Ningen no songen, kore wa chi to ase o tsukatta tetsugaku." *Bijutsu techo* (July 1989): 40-41.

Nakamura, Keiji. "Torimidashinami . . . Morimura Yasumasa ni tsuite: Creators in Japan." *Atorie* (April 1989): 44-49.

Photographic Aspect of Japanese Art Today. Exhibition catalog. Utsunomiya, Japan: Tochigi Prefectural Museum of Fine Arts, 1987.

Shinohara, Motoaki. "Katsujinga wa ima 'Morimura Yasumasa ten.'" *Gendaishi techo* (February 1989): 184.

_____. "Morimura Yasumasa: jikan o tabisuru karada." *Bijutsu techo* (August 1989): 114-21.
Tatehata, Akira. "Kannen no kanosei: Morimura Yasumasa ten 'mata ni, te.'" *A & C* 9 (January 1989): 22-23.

Reinhard Mucha

Born Reinhard Mucha, February 19, 1950, in Düsseldorf. Education: Staatliche Kunstakademie, Düsseldorf, 1972-73, 1975-82; nominated "Meisterschüler," winter semester 1980. Awards include: Annemarie-und Will-Grohmann-Stipendium, 1981. Lives and works in Düsseldorf.

Selected Solo Exhibitions

1977
Verwaltungs- und Wirtschafts-akademie, *Düsseldorf, . . . sondern statt dessen einen Dreck wie mich,* April 18-May 7.

1980

Galerie Annelie Brusten, Wuppertal, *Reinhard Ullrich Mucha: Kopfdiktate,* February 19-March 20.

1982

Galerie Max Hetzler, Stuttgart, *Reinhard Mucha: Wartesaal,* June 26-August 31.

1983

Kabinett für aktuelle Kunst, Bremerhaven, West Germany, *Reinhard Mucha: Feuer und Leben,* August 13-September 11.

Galerie Max Hetzler, Cologne, *Reinhard Mucha: Alleingang,* October 22-November 19.

1985

Galerie Philip Nelson, Lyons, *Reinhard Mucha,* January 25-March 9.

Galerie Bärbel Grässlin, Frankfurt, *Reinhard Mucha: Hagen-Vorhalle,* April 20-May 18.

Galerie Max Hetzler, Cologne, *Reinhard Mucha: First Go Gerresheim—Glashütte,* May 18-June 8.

Württembergischer Kunstverein, Stuttgart, *Reinhard Mucha: Das Figur-Grund Problem in der Architektur des Barock,* June 19-July 28.

1986

Galerie Micheline Szwajcer, Antwerp, *Twee Werken van Reinhard Mucha,* February 8-22.

Galerie Max Hetzler, Cologne, *Mucha: Berichterstattung der zweiten Hälfte,* August 30-October 4.

Musée National d'Art Moderne, Centre Georges Pompidou, Paris, *Reinhard Mucha: Gladbeck,* September 24-December 14.

1987

Kunsthalle Basel, *Reinhard Mucha: Nordausgang,* January 24-March 1.

Kunsthalle Bern, *Reinhard Mucha: Kasse beim Fahrer,* January 24-March 15.

1989

Lia Rumma, Naples, *Reinhard Mucha: Mutterseelenallein,* June 29-September 21.

Selected Group Exhibitions

1980

Jürgen Ponto-Stiftung, Karmeliter-Kloster, Frankfurt, *1. Ausstellung der Jürgen Ponto-Stiftung zur Förderung Junger Künstler 1980,* January 25-February 17.

1981

Staatliche Kunsthalle, Baden-Baden, West Germany, *Annemarie-und Will-Grohmann-Stipendium 1981,* May 8-31.

Kunsthalle Bielefeld, *Ars Viva 81: Skulpturen und Installationen von Preisträgern des Kulturkreises im Bundesverband der Deutschen Industrie,* August 30-October 4.

1982

Kunstmuseum Düsseldorf, *(0211): 22 Künstler in Düsseldorf,* March 21-May 9.

Galerie Schellmann & Klüser, Munich, *Reinhard Mucha/Jürgen Drescher,* July 16-late September.

1983

Kunsthalle Bern, *Burton, Gerdes, Huber, Klingelhöller, Luy, Mucha, Schütte: Konstruktierte Orte 6xD+1xNY,* October 29-November 27.

1984

Messegelände, Halle 13, Düsseldorf, *Von hier aus,* September 29-December 2.

1985

Art Gallery of Ontario, Toronto, *The European Iceberg: Creativity in Germany and Italy Today,* February 8-April 7.

La Grande Halle du Parc de la Villette, Paris, *Nouvelle Biennale de Paris 1985,* March 21-May 21.

Galerie Peter Pakesch, Vienna, *Günther Förg, Georg Herold, Hubert Kiekol, Meuser, Reinhard Mucha,* October 13-November 9.

1986

Kölnischer Kunstverein, Cologne, *Sieben Skulpturen,* April 26-June 1.

Art Gallery of New South Wales, Sydney, *Origins, Originality, and Beyond: The Sixth Biennale of Sydney,* May 16-July 6.

Wiener Festwochen, Vienna, *De Sculptura,* May 16-July 20.

1987

Galerie Grässlin-Ehrhardt, Frankfurt, *Dreiundzwanzigste ausstellung,* April 25-May 30.

Moderna Museet, Stockholm, *Implosion—A Postmodern Perspective,* October 24-January 10, 1988.

1988

Museum Boymans-van Beuningen, Rotterdam, *Het Meubel Verbeeld=Furniture As Art,* April 24-June 5.

Städtische Kunsthalle, Kunstsammlung Nordrhein-Westfalen, Kunstverein für die Rheinlande und Westfalen, Düsseldorf, *The BiNationale: German Art of the Late 80's,* September 24-November 27, and tour to Institute of Contemporary Art and Museum of Fine Arts, Boston, December 16-January 29, 1989.

Hamburger Bahnhof, Berlin, *Zeitlos,* June 22-September 25.

1989

Museum van Hedendaagse Kunst, Antwerp, *Het Postmoderne: Aan Kinderen Verklaard,* March 18-April 23.

Museum of Contemporary Art, Chicago, *Object, Site, Sensation: New German Sculpture,* April 29-June 18.

Selected Bibliography

Ammann, Jean-Christophe, and Ulrich Loock. *Reinhard Mucha: Kasse beim Fahrer/Nordausgang.* Exhibition catalog. Bern: Kunsthalle Bern; Basel: Kunsthalle Basel, 1987.

Annemarie-und Will-Grohmann-Stipendium 1981. Exhibition catalog. Baden-Baden, West Germany: Staatliche Kunsthalle, 1981.

Celant, Germano. "Stations on a Journey." *Artforum* 24 (December 1985): 76-79.

Damme, Leo van. "Reinhard Mucha: De bouwer van de aanschouwelijke onzichtbaarheid." *Artefactum* 3 (September-October 1986): 17-23.

Frey, Patrick. "Reinhard Mucha: Verbindungen." *Parkett* 12 (March 1987): 104-12. English translation, 113-19.

Galloway, David. "Report from Germany." *Art in America* 73 (December 1985): 25-31.

Grasskamp, Walter. "Eintragung ins Klassenbuch." *Kunstforum International* 48 (February-March 1982): 134-39.

_____. *Der vergessliche Engel: Künstlerportraits für Fortgeschrittene,* 27-35. Munich: Verlag Silke Schreiber, 1986.

Heynen, Julian. "Reinhard Mucha." *Kunstwerk* 41 (January 1989): 143.

Javault, P. "Les états du lieu: Thomas Scüutte, Reinhard Mucha, Wolfgang Luy, Harald Klingelhöller." *Art Press* 90 (March 1985): 37-41.

Kerber, Bernhard. "Junge Kunst in der BRD." *Art International* 27 (April-June 1984): 47-55.

Locker, Ludwig. "Architektonische Aspekte in der Düsseldorfer Gegenwartskunst (2)." *Artefactum* 2 (February-March 1986): 2-9.

Miller, John. "Günther Förg, Reinhard Mucha, and Bernd and Hilla Becher." *Artscribe* 62 (March-April 1987): 82-83.

Monk, Philip. "Reinhard Mucha: The Silence of Presentation." *Parachute* 51 (June-July-August 1988): 22-28.

Mucha, Reinhard. "A Project for Artforum by Reinhard Mucha." *Artforum* 26 (October 1987): 96-99.

Puvogel, Renate. "Das imaginäre Museum der Gegenwart VI: Reinhard Mucha." *Kunstwerk* 39 (April 1986): 44-46.

_____. "Pflicht und Kür: Denk-Modelle Zwischen Skulptur und Architektur." *Kunstwerk* 38 (December 1985): 12-58.

Reinhard Mucha: Das Figur-Grund Problem in der Architektur des Barock. Exhibition catalog. Stuttgart: Württembergischer Kunstverein, 1985. Essays by Max Imdahl, Monika Maria Kraft, Ulrich Loock, Tilman Osterwold, and Denys Zacharopoulos.

Reinhard Mucha: Gladbeck. Exhibition catalog. Paris: Musée National d'Art Moderne, Centre Georges Pompidou, 1986. Essays by Catherine David, Ludger Gerdes, Gudrun Inboden, Ulrich Loock, and Paul Virilio.

Reinhard Mucha: Wartesaal. Exhibition catalog. Stuttgart: Max Hetzler, 1982. Essay by Gudrun Inboden.

Salvioni, Daniela. "Reinhard Mucha." *Flash Art* 131 (December 1986-January 1987): 96.

Schenker, Christoph. "Reinhard Mucha." *Flash Art* 135 (Summer 1987): 89-91.

Schmidt-Wulffen, Stephan. "Room As Medium." *Flash Art* 131 (December 1986-January 1987): 74-77.

Tazzi, Pier Luigi. "Reinhard Mucha." *Artforum* 25 (January 1987): 127.

_____. "Reinhard Mucha." *Wolkenkratzer Art Journal* 5 (November-December 1986): 40-45.

von Kageneck, Christian. "Neun Bewerber für das Annemarie-und Will-Grohmann-Stipendium 1981." *Kunstwerk* 34 (July 1981): 86-87.

_____. "Reinhard Mucha." *Kunstwerk* 40 (May 1987): 85-86.

West, Thomas. "Republic of Ready-Mades." *Art International* 1 (Autumn 1987): 82-88.

Julian Schnabel

Born Julian Schnabel, October 26, 1951, in New York. Education: University of Houston, 1969-73, B. F. A. 1973; Whitney Museum Independent Study Program, 1973-74. Lives and works in New York.

Selected Solo Exhibitions

1976

Contemporary Arts Museum, Houston, *Julian Schnabel,* February 20-March 7.

1978

Galerie December, Düsseldorf, *Julian Schnabel: Four Paintings,* June 22-July.

1979

Mary Boone Gallery, New York, *Julian Schnabel,* February 10-March 8.
Mary Boone Gallery, New York, *Julian Schnabel,* November 10-December 6.

1980

Galerie Bruno Bischofberger, Zurich, *Julian Schnabel,* June 14-July 5.
Young Hoffman Gallery, Chicago, *Julian Schnabel: Ornamental Despair,* October 17-November 18.

1981

Mary Boone Gallery, New York, and Leo Castelli Gallery, New York, *Julian Schnabel,* April 4-May 1.
Kunsthalle Basel, *Julian Schnabel,* October 3-November 15, and tour to Frankfurter Kunstverein, December 18-January 31, 1982.

1982

Stedelijk Museum, Amsterdam, *Julian Schnabel: Paintings,* January 28-March 15.
Los Angeles County Museum of Art, *Gallery Six: Julian Schnabel,* April 22-May 23.
Tate Gallery, London, *Julian Schnabel,* June 30-September 5.

1983

Leo Castelli Gallery, New York, *Julian Schnabel,* April 2-23.
Akron (Ohio) Art Museum, *Julian Schnabel,* June 18-August 28.
Waddington Galleries, London, *Julian Schnabel,* November 30-December 23.

1984

Akira Ikeda Gallery, Tokyo, *Julian Schnabel: The Aluminum Paintings,* March 5-31.
Akira Ikeda Gallery, Nagoya, *Julian Schnabel: Printed on Velvet,* September 1-29, and tour to Akira Ikeda Gallery, Tokyo, October 8-27.
The Pace Gallery, New York, *Julian Schnabel,* November 2-December 1.

1985

Galerie Bruno Bischofberger, Zurich, *Julian Schnabel,* May 5-June 1.

1986

Whitechapel Art Gallery, London, *Julian Schnabel:*

Paintings 1975-1986, September 19-October 26, and tour to Musée National d'Art Moderne, Centre Georges Pompidou, Paris, January 14, 1987-March 14; Städtische Kunsthalle Düsseldorf, April 30-June 17. United States updated version of tour, Whitney Museum of American Art, New York, November 6-January 10, 1988; San Francisco Museum of Modern Art, February 11-April 3; The Museum of Fine Arts, Houston, May 28-August 14.
The Pace Gallery, New York, *Julian Schnabel,* October 31-November 29.

1988

Israel Museum, Jerusalem, *Julian Schnabel,* January 12-April 30.
Galerie Yvon Lambert, Paris, *Julian Schnabel,* February 13-March 16.
Sarah Campbell Blaffer Gallery, University of Houston, *Julian Schnabel: Crows Flying the Black Flag of Themselves,* May 31-July 31.
Cuartel del Carmen, Seville, *Julian Schnabel: Reconocimientos,* October 20-March 1989, and tour to Kunsthalle Basel, May 20-July 23.
Waddington Galleries, London, *Julian Schnabel,* November 23-December 23.

1989

Musée d'Art Contemporain, Bordeaux, France, *Julian Schnabel: Oeuvres Nouvelles,* May 5-September 24.
Kunstmuseum Basel, *Julian Schnabel: Arbeiten auf Papier 1976 bis 1988,* May 20-July 17, and tour.
Osaka National Museum of Modern Art, *Julian Schnabel: Kabuki Paintings,* June 10-July 23, and tour to Setagaya Art Museum, Tokyo, September 16-October 22.

Selected Group Exhibitions

1974

Whitney Museum of American Art, New York, *Seventh Annual Exhibition of Student Work,* May 20-June 5.

1977

Holly Solomon Gallery, New York, *Surrogate/Self Portraits,* December 3-January 4, 1978.

1979

The Renaissance Society at the University of Chicago, *Visionary Images,* May 6-June 16.

1980

Thirty-Ninth Venice Biennale, *Aperto 80,* June 1-September 30.
Indianapolis Museum of Art, *Painting and Sculpture Today 1980,* June 24-August 17.

1981

Whitney Museum of American Art, New York, *1981 Biennial Exhibition,* January 2-April 12.

Royal Academy of Arts, London, *A New Spirit in Painting,* January 15-March 18.

Rheinhallen der Kölner Messe, Cologne, *Westkunst: Zeitgenössische Kunst seit 1939,* May 30-August 16. Organized by Museen der Stadt Köln.

1982

Stedelijk Museum, Amsterdam, *Sixty/Eighty: Attitudes/Concepts/Images,* May 9-July 11.

The Art Institute of Chicago, *Seventy-Fourth American Exhibition,* June 12-August 1.

Fortieth Venice Biennale, *Aperto 82,* June 13-September 12.

Kestner-Gesellschaft, Hannover, *New York Now,* November 26-January 23, 1983.

1983

Whitney Museum of American Art, New York, *1983 Biennial Exhibition,* March 15-May 22.

Tate Gallery, London, *New Art at the Tate Gallery 1983,* September 14-October 23.

1984

The Museum of Modern Art, New York, *An International Survey of Recent Painting and Sculpture,* May 17-August 19.

1985

Museum of Art, Carnegie Institute, Pittsburgh, *1985 Carnegie International,* November 9-January 5, 1986.

1986

The Museum of Contemporary Art, Los Angeles, *Individuals: A Selected History of Contemporary Art 1945-1986,* December 10-January 10, 1988.

1987

Whitney Museum of American Art, New York, *1987 Biennial Exhibition,* April 10-July 5.

Musée National d'Art Moderne, Centre Georges Pompidou, Paris, *L'Epoque, la mode, la morale, la passion,* May 21-August 17.

The Aldrich Museum of Contemporary Art, Ridgefield, Conn., *Post-Abstract Abstraction,* May 31-September 6.

1988

The Carnegie Museum of Art, Pittsburgh, *Carnegie International,* November 5-January 22, 1989.

Kresge Art Museum, Michigan State University, East Lansing, *Art of the 1980s: Artists from the Eli Broad Family Foundation Collection,* November 6-December 16, and tour to Kalamazoo (Mich.)

Institute of Arts, January 6-February 19, 1989.

Museum of Contemporary Art, Chicago, *Three Decades: The Oliver-Hoffmann Collection,* December 17-February 5, 1989.

1989

Rooseum, Malmö, Sweden, *Jean Michel Basquiat, Julian Schnabel,* April 8-May 28.

Rheinhallen der Kölner Messe, Cologne, *Bilderstreit,* April 8-July 2. Organized by Museum Ludwig, Cologne.

Selected Bibliography

Adams, Brooks. "'I Hate to Think': The New Paintings of Julian Schnabel." *Parkett* 18 (December 1988): 110-22.

Collings, Matthew. "Modern Art: Julian Schnabel." *Artscribe* 59 (September-October 1986): 26-31. Interview.

Herrera, Hayden. Interview in "Expressionism Today: An Artists' Symposium." *Art in America* 70 (December 1982): 58-75, 139, 141.

Hughes, Robert. "Julian Schnabel: The Artist As an Entrepreneur." *Modern Painters* 1 (Spring 1988): 35-39.

Julian Schnabel. Exhibition catalog. Basel: Kunsthalle Basel, 1981. Interview by Carter Ratcliff. Statements.

Julian Schnabel. Exhibition catalog. Jerusalem: Israel Museum, 1988. Essay and interview by Giancarlo Politi.

Julian Schnabel. Exhibition catalog. London: Tate Gallery, 1982. Essay by Richard Francis, statement by the artist.

Julian Schnabel. Exhibition catalog. London: Waddington Galleries, 1983. Essay by David Robbins.

Julian Schnabel. Exhibition catalog. London: Waddington Galleries, 1985. Essay by Donald Kuspit.

Julian Schnabel. Exhibition catalog. London: Waddington Galleries, 1988.

Julian Schnabel. Exhibition catalog. New York: Pace Gallery, 1986. Essay by Wilfried Dyckoff.

Julian Schnabel. Exhibition catalog. Rome: Gian Enzo Sperone, 1985. Statements by the artist and Francesco Clemente.

Julian Schnabel: Oeuvres Nouvelles. Exhibition catalog. Bordeaux, France: Musée d'Art Contemporain, 1989. Essay by Demosthène Davvetas.

Julian Schnabel: Paintings. Exhibition catalog. Amsterdam: Stedelijk Museum, 1982. Essay by Rene Ricard.

Julian Schnabel: Paintings 1975-1986. Exhibition catalog. London: Whitechapel Art Gallery, 1986. Essays by Thomas McEvilley, interview by Matthew Collings. Second edition includes essay by Lisa Phillips. French edition includes essays by Bernard Blistène, Alain Cueff, Wilfried Dickhoff, Thomas McEvilley, and Julian Schnabel. German edition includes essays by Thomas McEvilley and M. L. Syring.

Julian Schnabel: Printed on Velvet. Exhibition catalog. Nagoya: Akira Ikeda Gallery, 1984.

Julian Schnabel: Reconocimientos. Exhibition catalog. Basel: Kunsthalle Basel, 1989. Essays by Jean-Christophe Ammann, Diego Cortez, William Gaddis, and Kevin Power.

Julian Schnabel: The Aluminum Paintings. Exhibition catalog. Tokyo: Akira Ikeda Gallery, 1984. Essay by Julian Schnabel.

Kramer, Hilton. "Julian Schnabel." In *Art of Our Time: The Saatchi Collection,* 25-28. New York: Rizzoli; London: Lund Humphries, 1984, v. 3.

Kuspit, Donald B. "Julian Schnabel." In *Artwords 2,* edited by Jeanne Siegel, 152-58. Ann Arbor, Mich.: UMI Research Press, 1988. Interview.

————. "Julian Schnabel: Die Rückeroberung des Primitiven." *Wolkenkratzer Art Journal* 10 (December-January-February 1985): 44-53.

————. "Julian Schnabel's 'Profundity': Not an Apologia Pro Vita Sua." *C Magazine* 3 (Fall 1984): 16-19.

————. "The Rhetoric of Rawness: Its Effects on Meaning in Julian Schnabel's Paintings." *Arts Magazine* 59 (March 1985): 126-30.

Levin, Kim. "His Next Stage." *Village Voice,* November 18, 1986, p. 91. Reprinted in *Beyond Modernism: Essays on Art from the '70s and '80s,* 223-25. New York: Harper and Row, 1988.

Liebmann, Lisa. "About Julian Schnabel." *Flash Art* 140 (May-June 1988): 71-73.

Marzorati, Gerald. "Julian Schnabel: Plate It As It

Lays." *Artnews* 84 (April 1985): 62-69. Statements.

McGuigan, Cathleen. "Julian Schnabel: 'I Always Knew It Would be Like This.'" *Artnews* 81 (Summer 1982): 88-94. Statements.

Millet, Catherine. "Julian Schnabel l'impatient." *Art Press* 110 (January 1987): 4-9. Interview.

Morgan, Stuart. "Julian Schnabel Interviewed by Stuart Morgan." *Artscribe* 44 (January 1984): 15-21.

Oxlade, Roy. "Julian Schnabel." *Modern Painters* 1 (Winter 1988-89): 75-76.

Pincus-Witten, Robert. "Julian Schnabel: Blind Faith." *Arts Magazine* 56 (February 1982): 152-55. Statement.

Politi, Giancarlo. "Julian Schnabel." *Flash Art* 130 (October-November 1986): 45-53. Excerpts reprinted in *Julian Schnabel.* Jerusalem: Israel Museum, 1988.

Ratcliff, Carter. "Art to Art: Julian Schnabel." *Interview Magazine* 10 (October 1980): 55-57. Interview. Reprinted in *Julian Schnabel.* Basel: Basler Kunstverein, 1981.

Renton, Andrew. "Spotlight: Julian Schnabel—The Perpetual Task of Living Up to a Name." *Flash Art* 145 (March-April 1989): 107-8.

Russell, John. "Painting Is Once Again Provocative." *New York Times,* April 17, 1983, pp. 1, 31.

Schiff, Gert. *Julian Schnabel.* Exhibition catalog. New York: Pace Gallery, 1984.

Schnabel, Julian. *CVJ: Nicknames of Maitre D's and Other Excerpts from Life.* New York: Random House, 1987.

————. "Paint Job: My Life As an Artist." *Vanity Fair* 50 (August 1987): 107-12, 157-60.

————. "The Patients and the Doctors." *Artforum* 22 (February 1984): 54-59. Reprinted in *Julian Schnabel: The Aluminum Paintings.* Tokyo: Akira Ikeda Gallery, 1984.

Cindy Sherman

Born Cindy Sherman, January 19, 1954, in Glen Ridge, N. J. Education: State University of New York at Buffalo, 1972-76. Awards include: Guggenheim Fellowship, 1983; Skowhegan Medal for Photography, 1989. Lives and works in New York.

Selected Solo Exhibitions

1978
Hallwalls, Buffalo, *Cindy Sherman Performance,* June 17-18.

1979
Hallwalls, Buffalo, *Cindy Sherman,* March 2-29.
Artists Space, New York, *Cindy Sherman,* September 23-October 28.

1980
Contemporary Arts Museum, Houston, *Cindy Sherman: Photographs,* February 2-March 23.
The Kitchen, New York, *Cindy Sherman,* March 18-29.
Metro Pictures, New York, *Cindy Sherman,* December 6-January 7, 1981.

1982
Metro Pictures, New York, *Cindy Sherman: New Color Photographs,* October 16-November 16.
Déjà Vu, Dijon, France, *Cindy Sherman,* October 25-November 13.
Stedelijk Museum, Amsterdam, *Cindy Sherman: Fotowerken,* December 24-February 6, 1983.

1983
St. Louis Art Museum, *Currents Twenty: Cindy Sherman,* March 1-April 10.
Galerie Schellmann & Klüser, Munich, *Cindy Sherman,* March 3-31.
Art Gallery, Fine Arts Center, State University of New York at Stony Brook, *Cindy Sherman,* October 1-November 2, and tour to Zilkha Gallery, Center for the Arts, Wesleyan University, Middletown, Conn., November 9-December 16.
Metro Pictures, New York, *Cindy Sherman: New Color Photographs,* October 29-November 26.
Musée d'Art et d'Industrie, Saint-Etienne, *Cindy Sherman,* December-January 1984.

1984
Akron (Ohio) Art Museum, *Cindy Sherman,* June 23-September 2, and tour to Institute of Contemporary Art, University of Pennsylvania, Philadelphia, December 13-January 27, 1985; Museum of Art, Carnegie Institute, Pittsburgh, February 9-April 7; Des Moines Art Center, May 17-July 14; Baltimore Museum of Art, June 3-August 3, 1986.

1985
Bacardi Art Gallery, Miami, Fla., *Untitled Works by Cindy Sherman,* May 17-June 28.
Metro Pictures, New York, *Cindy Sherman,* October 5-26.

Westfälischer Kunstverein, Münster, *Cindy Sherman: Photographien,* December 7-January 26, 1986.

1986
Wadsworth Atheneum, Hartford, *Cindy Sherman/ Matrix Eighty-Eight,* January 18-March 9.
Portland (Oreg.) Art Museum, *Perspectives Four: Cindy Sherman,* February 5-April 6.
The Aldrich Museum of Contemporary Art, Ridgefield, Conn., *Cindy Sherman: Photographs,* December 6-February 15, 1987.

1987
Metro Pictures, New York, *Cindy Sherman,* May 2-30.
Whitney Museum of American Art, New York, *Cindy Sherman,* July 9-October 4, (expanded version of 1984 Akron exhibition) and tour to Institute of Contemporary Art, Boston, November 20-January 17, 1988; Dallas Museum of Art, March 6-April 24.

1988
Monika Sprüth, Cologne, *Cindy Sherman,* April-May.
Studio Lia Rumma, Naples, *Cindy Sherman,* April 21-May.

1989
Galerie Pierre Huber, Geneva, *Cindy Sherman,* February 2-March 4.
Metro Pictures, New York, *Cindy Sherman,* March 25-April 22.
Galerie der Wiener Secession, Vienna, *Cindy Sherman: Arbeiten seit 1977,* April 26-May 28.

Selected Group Exhibitions

1975
The Buffalo Fine Arts Academy, Albright-Knox Art Gallery, Buffalo, *Thirty-Fifth Western New York Exhibition,* May 9-June 15.

1976
The Buffalo Fine Arts Academy, Albright-Knox Art Gallery, Buffalo, *Thirty-Sixth Western New York Exhibition,* April 30- May 30.
Hallwalls, Buffalo, *Open Space: Bob Rothchild, Cindy Sherman, Randy Taylor,* August 17-28.
Artists Space, New York, *Hallwalls,* November 6-27.

1977
The Buffalo Fine Arts Academy, Albright-Knox Art Gallery, Buffalo, *In Western New York,* March 26-April 17.

1978

Artists Space, New York, *Group Exhibition,* September 23-October 28.

1980

ARC-Musée d'Art Moderne de la Ville de Paris, *Ils se disent peintres/Ils se disent photographes,* November 22-January 4, 1981.

1981

Allen Memorial Art Museum, Oberlin (Ohio) College, *Young Americans,* April 1-May 3.

1982

Fortieth Venice Biennale, *Aperto 82,* June 13-September 12.
Museum Fridericianum, Kassel, West Germany, *Documenta 7,* June 19-September 26.

1983

Hirshhorn Museum and Sculpture Garden, Smithsonian Institution, Washington, D. C., *Directions 1983,* March 10-May 15.
Whitney Museum of American Art, New York, *1983 Biennial Exhibition,* March 15-May 22.
The Museum of Modern Art, New York, *Big Pictures by Contemporary Photographers,* April 13-June 28.
Tate Gallery, London, *New Art at the Tate Gallery 1983,* September 14-October 23.

1984

Art Gallery of New South Wales, Sydney, *The Fifth Biennale of Sydney: Private Symbol—Social Metaphor,* April 11-June 17.
Hirshhorn Museum and Sculpture Garden, Smithsonian Institution, Washington, D. C., *Content: A Contemporary Focus, 1974-1984,* October 4-January 6, 1985.

1985

Whitney Museum of American Art, New York, *1985 Biennial Exhibition,* March 13-June 9.
The Museum of Modern Art, New York, *Self-Portrait,* November 7-January 7, 1986.

1986

Contemporary Arts Center, Cincinnati, *Jenny Holzer/Cindy Sherman: Personae,* February 7-March 15.
Centre Cultural de la Fundació Caixa de Pensions, Barcelona, *Art and Its Double: A New York Perspective,* November 27-January 11, 1987.

1987

Los Angeles County Museum of Art, *Avant-Garde in the Eighties,* April 23-July 12.
The Museum of Contemporary Art, Los Angeles, *Individuals: A Selected History of Contemporary Art 1945-1986,* December 10-January 10, 1988.

1988

Kresge Art Museum, Michigan State University, East Lansing, *Art of the 1980s: Artists from the Eli Broad Family Foundation Collection,* November 6-December 16, and tour to Kalamazoo (Mich.) Institute of Arts, January 6-February 19, 1989.
Whitney Museum of American Art Downtown at Federal Reserve Plaza, New York, *Identity: Representations of the Self,* December 13-February 10, 1989.
Museum of Contemporary Art, Chicago, *Three Decades: The Oliver-Hoffmann Collection,* December 17-February 5, 1989.

1989

Victoria and Albert Museum, London, *Photography Now,* February 14-April 30.
Bass Museum of Art, Miami Beach, Fla., *The Future Now,* March 10-April 30.
National Museum of American Art, Smithsonian Institution, Washington, D. C., *The Photography of Invention: American Pictures of the 1980s,* April 28-September 10.
The Museum of Contemporary Art, Los Angeles, *A Forest of Signs: Art in the Crisis of Representation,* May 7-August 13.

Selected Bibliography

Cathcart, Linda. *Cindy Sherman: Photographs.* Exhibition catalog. Houston: Contemporary Arts Museum, 1980.

Cindy Sherman. Exhibition catalog. Amsterdam: Stedelijk Museum, 1982. Introduction by Els Barents.

Cindy Sherman. Exhibition catalog. Dijon, France: Déjà Vu, 1982.

Cindy Sherman. Exhibition catalog. New York: Whitney Museum of American Art, 1987. Essays by Lisa Phillips and Peter Schjeldahl.

Cindy Sherman. Exhibition catalog. Saint-Etienne: Musée d'Art et d'Industrie, 1983. Essay by Christian Caujolle.

Cindy Sherman: Photographien. Exhibition catalog. Münster: Westfälischer Kunstverein, 1985. Essays by Cindy Sherman and Marianne Stockebrand.

Cloudman, Ruth. *Perspectives Four: Cindy Sherman.* Exhibition brochure. Portland, Ore.: Portland Art Museum, 1986.

Cowart, Jack. *Currents Twenty: Cindy Sherman.* Exhibition brochure. St. Louis: St. Louis Art Museum, 1983.

Crimp, Douglas. "Cindy Sherman: Making Pictures for the Camera." In *Young Americans,* 86-91. Exhibition catalog. Oberlin, Ohio: Allen Memorial Art Museum, 1981.

Danto, Arthur C. "Cindy Sherman." *The Nation* (August 15-17, 1987): 134-37.

De Margerie, Anne, and Alain Lopez. "Moi, Cindy Sherman." *Liberation,* August 11-12, 1984, p. 25. Interview.

Frascella, Larry. "Cindy Sherman's Tales of Terror." *Aperture* 103 (Summer 1986): 48-53. Interview.

Gambrell, Jamey. "Marginal Acts: Cindy Sherman's Role-Playing." *Art in America* 72 (March 1984): 114-19.

Grundberg, Andy. "The 80's Seen through a Postmodern Lens." *New York Times,* July 5, 1987, sec. H, p. 29.

Indiana, Gary. "Untitled (Cindy Sherman Confidential)." *Village Voice,* June 2, 1987, p. 87. Interview.

Jenny Holzer/Cindy Sherman: Personae. Exhibition catalog. Cincinnati: Contemporary Arts Center, 1986. Essay by Sarah Rogers-Lafferty.

Johnson, Ken. "Cindy Sherman and the Anti-Self: An Interpretation of Her Imagery." *Arts Magazine* 62 (November 1987): 47-53.

Jones, Alan. "Friday the 13th: Cindy Sherman." *New York Talk* (October 1985): 44-45. Interview.

Kallfelz, Andreas. "Cindy Sherman: Ich Mache Keine Selbsporträts." *Wolkenkratzer Art Journal* (September-October 1984): 44-49. Interview.

Kuspit, Donald B. "Inside Cindy Sherman." *Artscribe* 65 (September-October 1987): 41-43.

Larson, Kay. "Who's That Girl?" *New York,* August 3, 1987, pp. 52-53.

Marzorati, Gerald. "Imitation of Life." *Artnews* 82 (September 1983): 79-87.

Melville, Stephen W. "The Time of Exposure: Allegorical Self-Portraiture in Cindy Sherman." *Arts Magazine* 60 (January 1986): 17-21.

Nelson, Lisbet. "Q & A: Cindy Sherman." *American Photographer* 11 (September 1983): 70-77. Interview.

Perl, Jed. "Starring Cindy Sherman: Notes on the New Art World." *New Criterion* 4 (January 1986): 14-25.

Schjeldahl, Peter. "Shermanettes." *Art in America* 70 (March 1982): 110-11.

Schjeldahl, Peter, and I. Michael Danoff. *Cindy Sherman.* New York: Pantheon Books, 1984.

Siegel, Jeanne. "Cindy Sherman." In *Artwords 2,* 268-82. Ann Arbor, Mich.: UMI Research Press, 1988. Interview.

Sussler, Betsy. "An Interview with Cindy Sherman." *Bomb* 12 (Spring-Summer 1985): 30-33.

Tatransky, Valentin. "Cindy Sherman." *Arts Magazine* 53 (January 1979): 19.

Taylor, Paul. "Cindy Sherman." *Flash Art* 124 (October-November 1985): 78-79. Interview.

Thompson, Thom. *Cindy Sherman.* Exhibition catalog. Stony Brook, N. Y.: Art Gallery, Fine Arts Center, State University of New York, 1983.

Van Damme, Leo. "Cindy Sherman: 'I Don't Want to Be a Performer.'" *Artefactum* 2 (June-August 1985): 15-21. English translation, 69-71. Interview.

Jeff Wall

Born Jeff Wall, September 29, 1946, in Vancouver, British Columbia. Education: University of British Columbia, Vancouver, 1964-70, B. A. 1968, M. A. 1970; Courtauld Institute of Arts, University of London, 1970-73. Lives and works in Vancouver, British Columbia.

Selected Solo Exhibitions

1978
Nova Gallery, Vancouver, British Columbia, *Jeff Wall,* November.

1979
Art Gallery of Greater Victoria, British Columbia, *Jeff Wall: Installation of Faking Death (1977) . . .,* April 11-June 3.

1982
David Bellman Gallery, Toronto, *Jeff Wall,* November 20-December 18.

1983
The Renaissance Society at the University of Chicago, *Jeff Wall: Selected Works,* January 9-February 20.

1984
Institute of Contemporary Arts, London, *Jeff Wall: Transparencies,* May 9-June 24, and tour to Kunsthalle Basel, September 30-November 4.

1986

Galerie Johnen & Schöttle, Cologne, *Jeff Wall*, April 24-May 31.

Ydessa Gallery, Toronto, *Jeff Wall*, December 13-February 28, 1987.

1987

Museum für Gegenwartskunst, Basel, *Jeff Wall: Young Workers*, February 14-April 20.

Galerie Johnen & Schöttle, Cologne, *Jeff Wall*, June 13-August 1.

Galerie Ghislaine Hussenot, Paris, *Jeff Wall*, October 24-November 25.

1988

Le Nouveau Musée, Villeurbanne, France, *Jeff Wall*, March 5-May 15.

Westfälischer Kunstverein, Münster, *Jeff Wall*, June 11-August 7.

1989

Marian Goodman Gallery, New York, *Jeff Wall*, September 12-October 7.

Galerie Johnen & Schöttle, Cologne, *Jeff Wall*, October.

Selected Group Exhibitions

1969

Bau-Xi Gallery, Vancouver, British Columbia, *Focus '69*, March 18-29.

Seattle Art Museum, *557,087*, September 5-October 5, and tour in expanded version *955,000*, to Vancouver (British Columbia) Art Gallery, January 14-February 8, 1970.

1970

The Museum of Modern Art, New York, *Information*, July 2-September 20.

1973

Vancouver (British Columbia) Art Gallery, *Pacific Vibrations*, September 13-October 23.

1980

National Gallery of Canada, Ottawa, *Pluralities 1980*, July 5-September 7.

1981

Hirshhorn Museum and Sculpture Garden, Smithsonian Institution, Washington, D. C., *Directions 1981*, February 12-May 3.

Rheinhallen der Kölner Messe, Cologne, *Westkunst: Zeitgenössische Kunst seit 1939*, May 30-August 16. Organized by Museen der Stadt Köln.

1982

Museum Fridericianum, Kassel, West Germany, *Documenta 7*, June 19-September 26.

1984

New Museum of Contemporary Art, New York, *Difference: On Representation and Sexuality*, December 8-February 10, 1985, and tour to the Renaissance Society at the University of Chicago, March 3-April 7; Institute of Contemporary Arts, London, July 19-September 1.

1985

La Grande Halle du Parc de la Villette, Paris, *Nouvelle Biennale de Paris 1985*, March 21-May 21.

Third Eye Centre, Glasgow, Scotland, *Visual Facts: Photography and Video by Eight Artists in Canada*, June 8-July 6, and tour to Graves Art Gallery, Sheffield, July 27-September 1; Canada House, London, September 11-October 8.

1986

Frankfurter Kunstverein and Schirn Kunsthalle Frankfurt, *Prospect 86*, September 9-November 2.

1987

Würtembergischer Kunstverein, Stuttgart, *"Blow-up": Zeitgeschichte*, February 18-March 29, and tour to Haus am Waldsee, West Berlin, April 10-May 24; Kunstverein Hamburg, July 11-August 23; Kunstverein Hannover, September 5-October 25; Frankfurter Kunstverein, December 4-January 3, 1988; Kunstmuseum Lucerne, March 24-May 29; Louisiana Museum, Humlebaek, Denmark, July 9-August 7; Rheinisches Landesmuseum, Bonn, August 17-September 25.

Musée National d'Art Moderne, Centre Georges Pompidou, Paris, *L'Epoque, la mode, la morale, la passion*, May 21-August 17.

Museum Fridericianum, Kassel, West Germany, *Documenta 8*, June 12-September 20.

Rüdiger Schöttle, Munich, *Theatergarten Bestiarium*, October 23-November 22.

1988

Institute of Contemporary Art, Boston, *Utopia Post Utopia: Configurations of Nature and Culture in Recent Sculpture and Photography*, January 29-March 27.

Galerie Johnen & Schöttle, Cologne, *Katharina Fritsch, Michael Van Ofen, Jeff Wall: Krieg-Liebe-Geld*, April 29-May 28.

Art Gallery of New South Wales, Sydney, *1988 Australian Biennale: From the Southern Cross—A View of World Art c. 1940-88*, May 18-July 3, and tour to National Gallery of Victoria, Melbourne, August 4-September 18.

The Carnegie Museum of Art, Pittsburgh, *Carnegie International*, November 5-January 22, 1989.

1989

ARC-Musée d'Art Moderne de la Ville de Paris, *Images Critiques: J. Wall, D. Adams, A. Jaar, L. Jammes,* January 14-March 12.

P.S. 1, Institute for Art and Urban Resources, Long Island City, N. Y., *Theatergarden Bestiarium,* January 15-March 12, and tour to Lope de Vega Theater, Seville, June 22-July 30; Confort Moderne, Poitiers, France, September 29-November 29.

Galerie Roger Pailhas, Marseilles, France, *Dan Graham et Jeff Wall: Children's Pavillion,* January 21-February 28.

Marian Goodman Gallery, New York, *A Photo Show: A Selection,* May 16-June 10.

Selected Bibliography

Barry, Judith. "Spiegelbeeld: Notities over de achtergrond van Jeff Walls dubbel zelfportret." *Museumjournaal* (Amsterdam) 6 (1984): 354-63.

Beyer, Lucie. "Spotlight: Jeff Wall." *Flash Art* 136 (October 1987): 95.

Couderc, Sylvie. "Distance et possession: Les photographies de Jeff Wall et de Clegg et Guttmann." *Artefactum* 5 (September-October 1988): 6-10.

Decter, Joshua. "Robert Mapplethorpe, Richard Prince, Thomas Ruff, and Jeff Wall." *Arts Magazine* 64 (October 1988): 102-3.

Fones, Robert. "Jeff Wall: The Ydessa Gallery." *Vanguard* 16 (April-May 1987): 29.

Francblin, Catherine. "Jeff Wall, la pose et la vie." *Art Press* 123 (March 1988): 24-27.

Gale, Peggy. "Outsiders In: West-Coast Perspectives from Jeff Wall and Ian Wallace." *Canadian Art* (Toronto) 4 (Summer 1987): 56-61.

Graham, Dan. "The Destroyed Room of Jeff Wall." *Real Life Magazine* 3 (March 1980): 4-6.

Groot, Paul. "Gebalsemd Theatre: Over Jeff Wall's absurdistische Fotowerken." *Museumjournaal* (Amsterdam) 5 (1986): 285-88.

Holmes, Willard. "Jeff Wall." In *Pluralities 1980,* 115-20. Exhibition catalog. Ottawa: National Gallery of Canada, 1980.

Jeff Wall. Exhibition catalog. Chicago: Renaissance Society at the University of Chicago, 1983. Essay by Ian Wallace.

Jeff Wall. Exhibition catalog. Münster: Westfälischer Kunstverein, 1988. Essays by Andreas Thielemann and Jeff Wall.

Jeff Wall: Installation of Faking Death (1977) . . . Exhibition catalog. Victoria, British Columbia: Art Gallery of Greater Victoria, 1979. Statement by Jeff Wall.

Jeff Wall: Transparencies. Exhibition catalog. London: Institute of Contemporary Arts; Basel: Kunsthalle Basel, 1984. Essays by Jean-Christophe Ammann and Ian Wallace, interview by Els Barents, statement by Jeff Wall. "Jeff Wall: Movie Audience," by Jeff Wall, reprinted in *Kunstforum International* 81 (October-November 1985): 144-45. "Typology, Luminescence, Freedom: Selections from a Conversation with Jeff Wall," by Els Barents, reprinted in *Jeff Wall: Transparencies.* New York: Rizzoli, 1987.

Johnen, Jörg, and Rüdiger Schöttle. "Jeff Wall." *Kunstforum International* 65 (September 1983): 101-9.

Kirshner, Judith. "A Blinding Light." *Real Life Magazine* 11-12 (Winter 1983-84): 40-42.

Kuspit, Donald B. "Looking up at Jeff Wall's Modern 'Appassionamento.'" *Artforum* 20 (March 1982): 52-56.

Ledes, Richard C. "Dennis Adams, Alfredo Jaar, Jeff Wall." *Artforum* 27 (January 1989): 113-14.

Miller, David. "The Luminous Image: Transparencies." *Afterimage* 15 (February 1988): 20-21.

Perry, Art. "Faking Death, Jeff Wall at Nova." *Vanguard* 7 (December 1978-January 1979): 14.

Perry, Arthur. "Jeff Wall at Nova Gallery." *Artmagazine* 10 (February-March 1979): Artfocus, 14.

Rhodes, Richard. "Jeff Wall, Ydessa Gallery." *Artforum* 25 (April 1987): 138-39.

Stegmann, Markus. "Jeff Wall: Transparencies." *Kunstwerk* 41 (January 1989): 157-58.

Wall, Jeff. "Bezugspunkte im Werk von Stephan Balkenhol." In *Stephan Balkenhol.* Exhibition catalog. Basel: Kunsthalle Basel, 1988.

_____. "Dan Graham's Kammerspiel." In *Dan Graham,* 14-39. Exhibition catalog. Perth: Art Gallery of Western Australia, 1978. Reprinted in *Real Life Magazine* 14 (Summer 1985): 14-18; 15 (Winter 1985-86): 24-40.

_____. "Into the Forest." In *Rodney Graham,* 9-16. Exhibition catalog. Vancouver, British Columbia: Vancouver Art Gallery, 1988.

_____. *Landscape Manual.* Vancouver: Fine Arts Gallery, University of British Columbia, 1970.

_____. "La Melancolie de la rue." In *Ian Wallace: Selected Works 1970-1987,* 63-75. Exhibition catalog. Vancouver, British Columbia: Vancouver Art Gallery, 1988.

_____. "Stereo." *Parachute* 22 (Spring 1981): 56-57.

_____. "Unity and Fragmentation in Manet." *Parachute* 35 (Summer 1984): 5-7.

Wood, William. "Three Theses on Jeff Wall." *C Magazine* 3 (Fall 1984): 10-15.

Photo credits

Unless otherwise noted, photographs were supplied by the artists, their agents, or the owners of the works of art. The following photographers are acknowledged.

Archives of *Architecture Moderne* (Brussels), p. 133; Roberto Behar, p. 131 (bottom); Ben Blackwell, p. 93, courtesy MIT List Visual Arts Center; Mimmo Capone, p. 39; Tom Caravaglia, p. 25, 28–31; City of Bristol Record Office, p. 154; D. James Dee, p. 66, 67 (top), courtesy Paula Cooper Gallery; Thomas Delbeck/M. Tedeskino, p. 132; Galerie Max Hetzler, p. 95, 97–99; Marian Goodman Gallery, p. 54; Marianne Gurley, p. 127, 159; Bill Jacobson Studio, p. 73, courtesy Barbara Gladstone Gallery; Lisa Kahane, p. 71 (top), courtesy Barbara Gladstone Gallery; John D. Kramer, p. 67, courtesy Paula Cooper Gallery; Peter MacCallum, p. 47; Charles Mayer, Hansen/Mayer, p. 63, 65, courtesy Paula Cooper Gallery; Metro Pictures, p. 111–113, 155 (bottom); Andrew Moore, p. 81, courtesy Paula Cooper Gallery; National Aeronautics and Space Administration, p. 13; National Institute of Allergy and Infectious Diseases, National Institutes of Health, p. 7; Phil Ogle, p. 35 (bottom); Bill Orcutt, p. 72, courtesy Barbara Gladstone Gallery; Charles Orrico, p. 156 (bottom), courtesy Superstock and Gran Fury; Pelka/Noble Photography, p. 71 (bottom), courtesy Barbara Gladstone Gallery; Phillips/Schwab, p. 103–105, 106, courtesy the Pace Gallery; George Pope, p. 35 (top); F. Scruton, p. 155 (top), courtesy John Weber Gallery; Rik Sferra, p. 33; Sonnabend Gallery, p. 75, 77–79; François Spoerry, p. 131 (top); Sperone Westwater, p. 42 (bottom); Lee Stalsworth, p. 51, 57; Zindman/Fremont, p. 43 (top), courtesy Sperone Westwater, p. 83, 85–86, courtesy Mary Boone Gallery, p. 101, courtesy the Pace Gallery.

Front and back cover, details: HIV-infected T-cells, courtesy National Institute of Allergy and Infectious Diseases, National Institutes of Health; explosion of the space shuttle *Challenger*, courtesy National Aeronautics and Space Administration; Rasterops model 104, 24-bit video display card; 1,000 yen note.

This catalog was edited by B. J. Bradley and designed by Polly Sexton. Pages were composed using a Macintosh computer, an Aldus Pagemaker program, and Adobe typefaces designed specifically for electronic publishing. An edition of 2,000 was printed on L.O.E. Dull by Schneidereith & Sons.